❦

EXPLORING SCIENCE AND ART

❦

To my husband and my parents

PRAISE FOR
EXPLORING SCIENCE AND ART

"Exploring Science and Art *goes beyond pointing out that science and art are related in that they study things and are creative ventures. Boehm presents readers with engaging accounts of scientists and artists that will expand readers' understanding and appreciation of both disciplines.*"

— MARTHA ZARIKOW, LIBRARIAN, U.S. DEPARTMENT OF DEFENSE
DEPENDENT SCHOOLS, WÜRZBURG, GERMANY

"*The relationship of science and art is one of the more timely issues in the world today. Boehm addresses this challenging topic from her background as both a science teacher and docent and is a most impressive and important resource for a variety of audiences. Scholar and student, young and old, research scientist and abstract painter can all gain insights from her work.*"

— ROBERT FREELAND, ARTIST, TEACHER AND SUPERINTENDENT,
KENMORE-TOWN OF TONAWANDA UNION FREE SCHOOL DISTRICT

"*In an engaging manner, this book adroitly confronts the notion of being right-brained or left, to show the strong intersection between the sciences and the arts. It persuasively demonstrates the creativity and artistry–thus the art—in science, and the analytical and methodical—the science—in the world of art.*"

— WENDY M. IRVING, JD, ED.M., UNIVERSITY AT BUFFALO

EXPLORING SCIENCE AND ART

DISCOVERING CONNECTIONS

MARY KIRSCH BOEHM

A City of Light imprint

New Idea Press
A City of Light imprint

City of Light Publishing
266 Elmwood Ave. Suite 407
Buffalo, New York 14222

info@CityofLightPublishing.com
www.CityofLightPublishing.com

Cover design inspired by agar art created by Melanie Sullivan.
Book design by Ana Cristina Ochoa

ISBN 978-1-942483-89-2 (softcover)
ISBN 978-1-942483-90-8 (ebook)

Printed in the U.S.A.
10 9 8 7 6 5 4 3 2 1

Library of Congress Cataloging-in-Publication Data

Names: Boehm, Mary Kirsch, author.
Title: Exploring science and art : discovering connections / Mary Kirsch Boehm.
Description: Buffalo, New York : New Idea Press, a City of Light imprint, [2022] | Includes
 bibliographical references and index. | Summary: "What do Albert Einstein and Pablo
 Picasso have in common? Can we learn about science by studying art? There are many
 connections just waiting to be discovered between the natural world and artistic techniques
 that have been used for centuries. Author and retired science educator Mary Kirsch Boehm
 systematically guides readers through a look at science with an artistic eye, introducing an
 integrated and often overlooked view of the two disciplines. By exploring the materials and
 techniques of art and the science behind them, Boehm reveals just how interconnected our
 world really is"-- Provided by publisher.
Identifiers: LCCN 2022020231 (print) | LCCN 2022020232 (ebook) | ISBN 9781942483892
 (trade paperback) | ISBN 9781942483908 (ebook) | ISBN 9781942483908 (epub) | ISBN
 9781942483908 (kindle edition) | ISBN 9781942483908 (mobi) | ISBN 9781942483908
 (nook edition) | ISBN 9781942483908 (pdf)
Subjects: LCSH: Art and science. | BISAC: ART / History / General | SCIENCE / Philosophy
 & Social Aspects
Classification: LCC N72.S3 B635 2022 (print) | LCC N72.S3 (ebook) | DDC 701/.05--dc23/
 eng/20220709
LC record available at https://lccn.loc.gov/2022020231
LC ebook record available at https://lccn.loc.gov/2022020232

CONTENTS

AN INTRODUCTION VII

ABOUT SCIENCE AND ART 1
1 Getting Started 3
2 The Nature of Science 10
3 The Nature of Art 18
4 Contemporary Science / Contemporary Art 26

MATERIALS AND TECHNIQUES 35
5 The Science of Materials 37
6 Paint and Painting 45
7 Sculpture 52
8 Drawing and Printmaking 59
9 Glass and Ceramics 66
10 Architecture 74

RELATED PHENOMENA 85
11 Light and Color 87
12 Vision and Illusion 95

CONSERVATION 103

13 Into the Lab 105

14 As Time Goes By 114

15 To the Rescue 120

SUBJECT MATTER 131

16 The Body Human 133

17 Biodiversity 143

18 The Earth's Dynamic Landscape 151

19 Weather, Whether or Not 161

20 The Sky Above 169

IN CONCLUSION 179

ACKNOWLEDGMENTS 185

NOTES 187

INDEX 197

AN INTRODUCTION

"To know is nothing at all, to imagine is everything."
~ Jacques Thibault (aka Anatole France)

WHILE LIVING IN ARLES, Vincent van Gogh became enchanted with the night. He noticed the glowing gas lamps, the shimmering reflections and the array of glistening stars. When he studied the sky, he was able to locate the Ursa Major constellation and the smaller Big Dipper and watch their nightly procession around the North Star. Vincent was energized by all that he saw and decided to paint. He selected a site along the Rhône River, not far from his home, and with artistic flair began *Starry Night over the Rhône*. Using vigorous brushstrokes and contrasting hues, he painted a dark star-studded sky above a river alive with reflected light and placed a couple in the right foreground. Van Gogh was inspired by his observations and used color, gesture and imagination to record them, and by doing this he made a connection between science and art.[1]

Science and art are fascinating. They are activities of the mind and ways of thinking that shape and enrich the world. They are also specialized fields of study and well-established disciplines that often appear to be unrelated. Yet science and art are connected, but the connections between them are frequently hidden and await discovery. How and where this occurs is a fascinating story and the focus of this book.

Exploring Science and Art is a venture of discovery. The worlds of science and art are entered. Science is studied with an artistic eye, and art is probed with a scientific lens. As the chapters evolve, relationships are developed, connections are made and an integrated and often overlooked view of science and art is introduced. In conclusion, *ten connections* between science and art are proposed.

Five areas are explored. The first, *About Science and Art*, begins with the work of Einstein, Picasso, Leonardo da Vinci and others, and it includes a discussion of the nature of science, the nature of art, contemporary science and contemporary art. *Materials and Techniques*, as the title suggests, investigates the materials and techniques of art, those of painting, sculpture, drawing, printmaking, glass, ceramics and architecture, and the science behind them. *Related Phenomena* reviews the science of light, color, vision and illusion and the art related to them, and *Conservation* surveys the instruments and methods of science and their role in the preservation of art. The last, *Subject Matter*, considers the human body, biodiversity, landscape, weather and astronomy as both science and an influence and inspiration for the creation of art.

Within the five areas, the chapters are organized around unifying themes. They begin with appropriate quotations and are filled with stories and examples, some familiar and others less so. Many of the passages are based on personal knowledge and experience, and on occasion an observation or comment is inserted. Relationships are developed and connections are made with written descriptions. Illustrations, as such, are not included, but they are available on the internet. For specifics, the book has Notes and an Index.

I am an experienced educator. My subjects are science and art, and I have always pursued them with great enthusiasm. At first, I have to admit, I viewed the two as separate and never considered the possibility of connections between them. But gradually I learned that they did not exist in a vacuum and were indeed related and in many ways. For me, this was a different and very interesting approach, and it was one that added to my understanding and appreciation of science and art. When I shared this, I discovered others were interested as well, so I decided to put my thoughts in writing. I collected and organized materials, and I wrote and rewrote many times. Then, after many years of very careful work, *Exploring Science and Art: Discovering Connections* came into being.

An impressive metal sculpture, *look and see*, by Jim Hodges, sets the stage for this book. It is a substantial nine-ton sheet of stainless steel twisted into an S shape. It is the product of a foundry, and it is moved from place to place on a flatbed trailer and hoisted into position using the leverage of a crane. The

piece is large, and when installed in a place, it takes command of the space by interacting with it. Some portions of it are cut out, and others are polished to a high reflective luster or painted with white and black enamel. The result is a surface covered with patterns suggesting camouflage and picture puzzle pieces and one offering a visual challenge.[2]

This contemporary sculpture is about looking and seeing, and it invites people to participate. This book is also about looking and seeing, about looking at science and art and seeing connections, and it beckons readers to become involved.

Exploring Science and Art offers a fresh perspective. It provides a view that adds depth and a degree of sophistication to the understanding and appreciation of science and art. I hope you will welcome this approach and find this book an interesting, insightful and enjoyable read. And now I invite you to join me on an incredible venture of discovery. *Bon voyage!*

ABOUT
SCIENCE AND ART

CHAPTER 1

GETTING STARTED

"Art and science are two equally important ways
of looking at the natural world."
~ Rachel Carson

I MAGINE A CONVERSATION between Albert Einstein and Pablo Picasso, when both were young and beginning their careers. What would they talk about? What would they say to each other? What would they share? With perhaps similar questions in mind, Steve Martin, the versatile actor, writer, musician and serious art collector, wrote a play, *Picasso at the Lapin Agile*, that created a situation for Einstein and Picasso to meet and engage their wit. The setting Martin selected was the Lapin Agile, a café in the Montmartre section of Paris, and the time was 1904. It was one year before Einstein published his *Special Theory of Relativity* with its new ideas on space, time, matter and energy and three years before Picasso painted his *Les Demoiselles d'Avignon* with its new ways of representation. While Martin's zany script provided the occasion, the actual encounter never occurred. In 1904 Einstein was in Switzerland, and Picasso was in France. Nevertheless it is interesting to consider an exchange between these two great minds. Science and art were about to change, and the world would never be the same.[3]

As a young man, Albert Einstein studied physics and mathematics. He considered teaching but was unable to secure a suitable position, so he accepted a job as a patent office clerk. In his spare time, he did thought experiments and

solved the problems he devised with creativity. He investigated phenomena with mathematics and discovered them to be unlike their appearance, and he formulated theoretical ideas that were original and revolutionary. Einstein was an intellectual, and his *annus mirabilis* was 1905. He began the year by earning his doctorate and then went on to publish four significant papers in the scientific journal, *Annalen der Physik*. In the first article, he explained the photoelectric effect by viewing light as a particle and showed light to have the properties of both particles and waves. With the next, he explored the size and movement of atoms in liquids. In the third, *On the Electrodynamics of Moving Bodies*, he introduced his *Special Theory of Relativity* and explained space and time as a continuum dependent upon the shifting perspective of the viewer. With the fourth, *Does the Inertia of a Body Depend upon Its Energy Content?*, he presented a statement on the equivalence of matter and energy. The article was short, only three pages long, and derived mathematically from his *Special Theory*. The actual proof came decades later with the atomic research of the 1930s and 1940s and the detonation of the atomic bombs in 1945. In 1916, Einstein proposed his *General Theory of Relativity*. In it, he described the universal nature of gravitation and the curving of space-time and predicted gravitational waves. Validation came from measurements of starlight taken during an 1919 solar eclipse and the detection of gravitational waves in 2016. Einstein's equations indicated the universe was either expanding or contracting, but scientists, including Einstein, believed the universe was static. He continued his calculations and added a cosmological constant, a factor opposing gravity. When it was discovered the universe was expanding, the constant was unnecessary. If he had stayed with his original equations, he could have predicted the expanding nature of the universe. In 1999, *Time* magazine honored Einstein and named him *The Person of the Century*: "He was the preeminent scientist in a century dominated by science."[4] Einstein's work was pivotal: it changed the way people thought about science.

Pablo Picasso was the precocious and talented son of a painter. He studied and quickly absorbed styles, keeping the ones he preferred and retiring those he disliked. Picasso's early works were realistic, but then in 1907 he completed *Les Demoiselles d'Avignon*, a much different painting. It was about the prostitutes in a brothel on Avignon Street in Barcelona and showed five nudes near a table with fruit. Two had wide eyed expressionless faces, two reflected the influence of African masks and one displayed a solemn profile. *Les Demoiselles* was important because it led the way from realism to the world of abstraction with its fragmented figures and shallow space. A few years later, Picasso and Georges Braque invented cubism,

a new way of representation, with forms reduced to their essentials and perspective dismissed. The objects were fractured and flattened to permit viewing from a single angle, but they were never totally abstract and always included something of the subject. Just as Einstein described space in new and different ways, Picasso presented space in new and different ways. As Picasso's career flourished, his creativity and originality grew. He expanded his range of materials and techniques, and he investigated, experimented and used them all. He painted in oil and watercolor and produced sculptures in bronze, wood, wire, tin, string, paper and clay. He did drawings, made prints of every kind and assembled collages. Picasso's work asked questions and was diversified and complex, often revealing personal feelings of confidence, insecurity, happiness, sadness and always his maleness. He stood at the cusp of modernity and presented modern art as serious art. The Museum of Modern Art in New York City honored Picasso in 1980 by devoting their entire exhibition area to a retrospective that displayed over nine hundred of his works. This was the first time the Museum recognized a single artist in this manner and stated: "Picasso shaped his century... He was the most influential artist of his own time."[5] Picasso's work was pivotal: it changed the way people thought about art.

Centuries before Einstein and Picasso, Leonardo da Vinci pursued both science and art. He was born near the Tuscan town of Vinci and was the illegitimate son of Piero and Caterina. At birth his full name was just Leonardo, but in time he became known as the Leonardo from Vinci, the remarkable Leonardo da Vinci. He was a person of the Renaissance and embodied its very essence. As a young man, he was apprenticed to the studio of Andrea del Verrocchio in Florence, where he learned the fine arts of painting, drawing and sculpture. His artistic ventures included a number of religious paintings, one of which, *The Last Supper*, was done on the wall of a monastery in Milan between 1495 - 1498. With this work, Leonardo paid special attention to light, color, line and form and organized the composition to convey the emotional drama of the moment, and by doing this created an all time masterpiece. Another of his paintings was the enigmatic *Mona Lisa*, created around 1503. Leonardo was also curious and asked questions and made observations. He possessed an inquisitive mind and wanted to discover the governing laws behind the things he investigated. He kept detailed records in notebooks with writing done in an unusual fashion, from right to left, with his left hand. As a draftsman, he filled his notes with drawings that serve as testimony to his diverse interests in botany, light, optics, hydrology, paleontology, mechanics, astronomy and military engineering. In the process,

he conceived designs for many new and unusual machines and devices; however the actual models of his inventions were not constructed until recent years. He also studied human anatomy and made careful drawings from over thirty dissected cadavers. Unfortunately the illustrations were scattered following his death and not discovered until many centuries later, so they did little to advance the understanding of bodily structure.[6]

Over the years, many people, including Edwin Hubble, Wallace Hume Carothers, James Watson and Francis Crick, became involved with science, while others, like Rembrandt van Rijn, Vincent van Gogh, Chuck Close, Paul Cezanne, and Claude Monet, pursued art.

In the 1920s it was believed the Milky Way Galaxy was the extent of the universe. Edwin Hubble led the way to a new understanding of the universe with his original and creative thinking. For research, he selected a Cepheid variable star in the Andromeda nebula. He collected data and showed the star was almost a million light years away and far beyond the Milky Way. This work established the universe was vast and the Milky Way was relatively small. Then Hubble and his assistant investigated the light coming from receding nebulae and discovered the universe was not only large but it was also expanding and expanding at an ever increasing rate. This offered proof for the original equations in Einstein's *General Theory of Relativity*.[7]

Following World War I, the chemical company, E. I. du Pont de Nemours, wanted to diversify its product line from gunpowder to synthetic materials. At the time, not much was known about large molecules, like those that compose cellulose, silk and Bakelite, a man-made plastic material. So in 1928, DuPont equipped a special laboratory and hired Wallace Hume Carothers to study this group of molecules and determine how they were put together. To do this, Carothers developed a fresh and original approach, one that applied the ideas of quantum mechanics to the existing theories. (Quantum mechanics is a mathematical system that describes the behavior of the electrons in atoms and explains how atoms join or bond to form molecules.) This method allowed Carothers to determine the large molecules were polymers, long chains of smaller molecules bonded together. With this understood, the DuPont company went on to make a number of synthetic polymers, materials that were new and never existed before. They formulated a rubbery material, neoprene, and an artificial silk fiber. The silk was a polyamide polymer made from the bonding of diamines and dicarboxylic acids, the versatile DuPont fiber known as nylon.[8]

Before James Watson and Francis Crick began their work much was known about DNA (deoxyribonucleic acid). It was recognized as the

large molecule that stores genetic information in a chemical code and the one involved with heredity and life processes. Previous experiments established that it contained phosphate and a type of sugar (deoxyribose) and equal amounts of adenine and thymine and equal amounts of cytosine and guanine, but its molecular structure, how it was put together, was unknown. To fully understand how DNA or any other molecule functions within a living system, this must be known. (Molecular structure refers to the organization of the atoms within a molecule, to the actual shape of the molecule and to the arrangement of the atoms in three-dimensional space.) Watson and Crick decided to solve the problem of DNA structure by constructing a physical model of the molecule. Model building was a new and different approach, and their preliminary efforts failed. At the same time, Rosalind Franklin and Maurice Wilkins were studying DNA by taking x-ray pictures of DNA crystals. (Crystals are solid units with characteristic shapes. When x-rays are directed at them, the x-rays are diffracted in patterns that indicate the arrangement of atoms within the crystals. The technique is known as x-ray crystallography, and it provides information useful in determining molecular shape.) Wilkins shared one of the x-rays, taken by Franklin, with Watson. This allowed Watson and Crick to notice a symmetry that suggested a helical arrangement of the atoms within the DNA molecule. They returned to their physical model and began reassembling it. After several tries, the pieces fit together to form a ladder-like structure with double chains of sugar and phosphate and cross rungs of adenine with thymine and cytosine with guanine, twisted into a helical shape. *Voilà!* There it was, the double helix of DNA. The originality of Watson and Crick allowed them to determine the shape of the DNA molecule, and they, along with Wilkins, were awarded a Nobel Prize in Physiology/ Medicine for their work. Franklin died several years before the award was given, and her work was not honored by the Nobel Foundation.[9]

Artists often produce portraits of themselves. Sometimes the self portraits are serial studies, that is, sets of images that address or investigate an issue. Rembrandt used his likenesses to make personal statements about his life and to record his passage from a vigorous youth to a resigned old man. They were autobiographical studies and analytical in nature, and they conveyed their meaning with light and shadow and facial expression. Van Gogh used his portraits to examine his feelings, his growing self awareness and his intense personality. They were emotional studies with vibrant colors and strong brushwork, and they expressed his personal struggle with life and his tortured soul.

Chuck Close used his image to explore and experiment with different artistic materials and techniques, and he used his likeness as a constant from one work to the next. By doing this, he pushed the genre of portrait painting. Close began with a candid photograph of himself, one that he overlaid with a grid to form a maquette. Then square by square, using a very exact and time-consuming technique, he transferred the image from the smaller maquette to a larger canvas with a grid. His early self portraits were realistic and done in black and white with acrylic paint on canvas. Then he began to experiment. He filled the squares with abstract ovals and lines, added color to his palette and converted to oil paint. He made portraits by air brushing, thumb printing and weaving silk, and he worked with charcoal and colored paper pulp. He made etchings, linoleum block prints, wood cuts and screen prints. In addition he captured his image with regular photos, Polaroid photos, large scale Polaroid photos, old style daguerreotypes and holograms. At first he presented full frontal images of his face, then he changed to three-quarter views and profiles. For decades, he used his image. His works reflected his advancing age and perhaps his attitude, but they were not autobiographical studies of his life. His portraits were experiments and experiences with the different media of art.[10]

Paul Cezanne had a favorite subject. It was Mont Sainte Victoire, a small mountain near his home in Aix en Provence. He studied this mountain from every possible angle and carefully analyzed what he saw and experimented with ways to represent it. As he separated its shapes into simple forms with flattened areas of color and illuminated the spaces, he presented his special mountain in many different ways.[11]

Claude Monet was interested in light and color, and to capture them on canvas, he often painted outdoors, *en plein air*. He carefully studied how light and color were affected by the season of the year, time of day and current atmospheric conditions, and he showed this diversity in serial paintings of country hay racks, London's Waterloo Bridge and the front of the Rouen Cathedral. When he moved to Giverny, he had ponds constructed near his home and had them filled with water lilies. As he drifted about in his studio boat, he observed his special flowers under different lighting conditions and rendered them in a multitude of ways.[12]

Thus, this incredible venture of discovery gets started. It begins with the science of Einstein, the art of Picasso and the versatile endeavors of Leonardo, and it includes the efforts of Carothers, Hubble and Watson and Crick in science and those of Rembrandt, van Gogh, Close, Cezanne and Monet in art. When their work and their methods are compared, some very

basic connections between science and art are discovered. Both science and art are creative and original, both produce things that are new and never existed before and both study things, ask questions and experiment.

CHAPTER 2

THE NATURE OF SCIENCE

*"The future belongs to science
and those who make friends with science."*
~ *Jawaharlal Nehru*

SCIENCE IS ABOUT MANY THINGS. Energy and matter. Atoms and molecules. Observations and experiments. Hypotheses and theories. Elements and compounds. DNA and cells. Living things and the environment. Weather and climate. Rocks and plate tectonics. Stars and the universe. But what exactly *is* science and what makes it *so* special?

Science is an activity that studies things. To do this, it asks questions. It wants to know how, in what way or manner or by what means, are things put together or structured? How are things made? How do things work or function? How do things happen? To answer the questions, experiments are set up, and observations are made.

In earlier times, this was not the case, and natural phenomena were explained in other ways. Aristotle, the respected philosopher from antiquity, used logical exposition to describe things and based his answers on experience and not on actual experimentation. When he considered objects falling toward the Earth, he reasoned that light objects fell slower than heavy ones. This explanation was accepted for centuries without challenge because Aristotle was Aristotle. Then along came Galileo Galilei, someone who was interested in a variety of things, including motion and falling bodies. He asked

questions about how they functioned and devised intricate experiments to answer his questions. Using this approach, Galileo concluded that light and heavy objects dropped at the same rate. (If the light object is a feather and the heavy one a stone, the structure of the feather will offer more resistance to the air than the stone, and the feather will flutter slowly to the ground. However in a vacuum, where there is no air, both will fall at the same rate.) People scoffed at Galileo's contradiction of Aristotle, and it is said Galileo provided further proof by staging a public demonstration of falling bodies from the Leaning Tower of Pisa. Galileo's methods for investigating the phenomena of nature were the beginnings of modern science.[13]

Science is based on experimentation. The experiments begin with questions to be answered and problems to be solved. Research is conducted using a systematic process of inquiry known as the scientific method:

1 The question to be answered is clearly stated, and the problem to be solved is defined.

2 Scientific information related to the problem is collected. Pertinent references, data, scientific journals, and other materials are reviewed to discover what is already known about the problem.

3 An hypothesis is formed. An hypothesis is a tentative solution to the problem. It is a proposal (an educated guess) formulated at the beginning of the experiment concerning the outcome of the experiment.

4 An experiment is devised to test the hypothesis. A variable is tested against a control, a standard used for comparison. The control demonstrates the consequences of the variable.

5 The experiment is conducted, observations are made and data are recorded.

6 The data are studied and interpreted. A tentative conclusion is formulated.

7 The experiment is repeated to verify the results.

An excellent example of the scientific method in action is the historic research of Frederick Banting and his assistant, Charles Best. Their work made a major contribution toward the understanding and treatment of the serious metabolic disorder, diabetes mellitus.

When Banting and Best began their research, scientists knew diabetes mellitus was the result of faulty sugar metabolism. They knew the pancreas, an organ with both glandular and islets of Langerhans tissue, was involved. They knew the glandular tissue produced digestive juices, and they thought the islets were involved with diabetes. But how were they involved? This question became the starting point for Banting and Best, and it was the problem they investigated with their experiments. They began by surveying the literature of earlier investigations and learned the removal of pancreases from research animals produced symptoms similar to diabetes and caused the animals to die within a few weeks. They hypothesized the islets produced something involved with sugar metabolism. To investigate this, Banting and Best prepared an extract from the islets tissue, using techniques developed by other scientists. This extract was the substance tested, the variable in their experiments. Sugar injections were given to dogs, their research animals. Blood samples were taken and analyzed, and blood sugar levels were recorded. Then injections of the extract were given to the dogs, and more blood work done. Records were kept, both before and after the injections, and the data were studied. The sugar levels dropped following the injections. Then the extract was given to diabetic dogs with high blood sugars, and their sugar levels also dropped following the injections. Some dogs from both groups served as the control animals. The control dogs did not receive the active extract, and their blood sugar levels did not change. The experiments were repeated to verify the results. Banting and Best concluded the extract from the islets tissue contained something that lowered the sugar level in the blood of the experimental animals. That something, of course, was insulin, the hormone responsible for regulating sugar metabolism.[14]

This was an important discovery because it changed the way diabetes mellitus was treated and offered control of this metabolic disorder. Annually the Nobel Foundation presents awards to people who make contributions that provide the greatest benefits to mankind. They are international honors marking significance, and they confer prestige on the recipients. There are Nobel Prizes for chemistry, physics, physiology/medicine, literature, economics and peace. The science awards acknowledge the importance of the discoveries within their fields, and they are the very highest recognitions scientists receive. The prizes are medals, personal diplomas and cash awards. A Nobel Prize in Physiology/Medicine was awarded to Frederick Banting and John MacLeod, another scientist involved the research, for the discovery of insulin. Their assistants, Charles Best and John Collip, were not honored, but the winners shared their bounty.[15]

Science builds on the science that precedes it. Banting, Best, MacLeod and Collip isolated insulin, and their success depended upon earlier scientific work. The first insulin used for the treatment of diabetes came from animals, from the pancreases of cows and pigs. The bovine and porcine varieties were similar to human insulin and were able to control sugar metabolism, but some people developed sensitivities to them. Research continued. Insulin was found to be a protein, composed of smaller amino acid molecules, and it was the first protein to have the sequence, the exact order, of its amino acids determined. This, in turn, led to the development of genetically engineered microorganisms capable of making insulin. Today, with the help of these microorganisms, pharmaceutical companies are able to make large quantities of insulin in generating tanks and are no longer dependent upon the animal sources. The research on insulin continues and new methods of producing are being developed.

Science proposes theories to explain phenomena. A theory is an explanation that fits the evidence. It is the best possible explanation for the information presented and is subject to change as new information develops. Over two hundred years ago, John Dalton developed a theory of atoms based on what was known from experiments. As time passed, more experimentation was done and more was learned about atoms. Dalton's theory, while acceptable for a while, was proven inadequate and other theories were necessary. Atomic research continues today, and as new evidence is gathered, new theories are proposed.

Science discovers some things by chance. While studying *Staphylococcus*, a bacterium responsible for serious infections in humans, chance favored the prepared mind of Alexander Fleming. His work involved growing (culturing) colonies of this microorganism in petri dishes filled with agar. One day in 1928, while cleaning up and discarding old cultures, he noticed a dish contaminated by a large mold colony, one that probably grew from an air borne spore that landed on the agar. This had happened before, but this time Fleming's careful eye saw something different, something very different. The *Staph* colonies near the mold were transparent, and their growth was being inhibited. Something was destroying the bacteria. Fleming saved the dish for further study. The mold was identified as *Penicillium,* and the mysterious something from the mold was penicillin. Fleming had discovered penicillin, the first of the antibiotics. It was chance that a *Penicillium* spore landed on the *Staphylococcus* colonies he was studying. It was chance the contaminated dish was not discarded. It was chance the dish was observed by someone as astute as Fleming and saved for further study. The research continued, and

Howard Florey and Ernst Chain developed penicillin into a medicine for the treatment of infectious diseases. Fleming, Florey and Chain were honored with a Nobel Prize in Physiology / Medicine.[16]

Science uses specialized instruments to make observations. There are telescopes for observing distant objects, balances for determining mass, thermometers for measuring temperature, barographs for recording air pressure, oscilloscopes for viewing wave motion, voltmeters and ammeters for studying electricity, gas chromatographs and mass spectrometers for analyzing the composition of materials, computers with programs for compiling and analyzing data with incredible speed and the list goes on. Perhaps the most familiar is the microscope, an instrument that makes things appear larger than they are in reality. Microscopes are not *just* microscopes, they are highly specialized scientific instruments. Some have lenses that use light, ordinary light, to magnify objects, and others use polarized light or ultraviolet. Some have electromagnets and use beams of electrons to enlarge things for study. Some magnify objects tens, others hundreds, and still others thousands of times. Some are fitted with cameras, projectors or televisions. Some are used in laboratories and classrooms, and others are employed in industry, surgery, art conservation and many other places where magnification is required.

Science depends upon measurement. Scientific measurements are made using the standards of the metric system, a system of numbers based on units of ten. The most common of the many metric measuring units are the meter, the gram and the liter. The meter measures length and distance, the gram measures weight and mass and the liter measures volume. Prefixes are used to form additional units. When the prefix *kilo* is added, the unit is multiplied by 1000. Thus a kilometer is 1000 meters and a kilogram is 1000 grams. The prefix *centi* divides the unit by 1/100, so a centimeter is 1/100 of a meter. When *milli* is added, the unit is divided by 1/1000, and a millimeter is 1/1000 of a meter and a milliliter is 1/1000 of a liter. Very small measurements use the prefix *nano* to denote one billionth of the unit, and the nanometer, a unit used to measure the length of light waves, is one billionth of a meter. In 1790 the metric system was established in France, and a revised metric system, the International System of Units (SI), was adopted by worldwide agreement in 1960. Science and most countries of the world use the metric system (the SI), while the United States continues to use the English system. (When measurements are used in this book, the English system units are given first followed by their metric equivalents in parentheses. The abbreviation *m* is used for meter, *cm* for centimeter, *g* for gram and *kg* for kilogram.)

Science uses scientific notation, a system of exponents, to work with very large and very small numbers, that is, numbers with many zeros. The number, 1,000,000,000,000 (with 12 zeros), becomes 10^{12} in scientific notation, and .00000001 (with 8 decimal places), becomes 10^{-8}. The very small nanometer measures .000000001 or 10^{-9} meters. Comparisons between extreme numbers are facilitated with this exponential system. Thus without having to count the zeros, it is obvious 10^{11} is smaller than 10^{12} and 10^{-7} larger than 10^{-8}.

Science has a vocabulary. It is a precise vocabulary, and each term has a specific meaning. Consider the words *weight* and *mass* and what they mean in science. Both are measured in ounces and pounds (milligrams, grams, and kilograms), but they have very different scientific meanings. Weight is a measure of the quantity of matter *and* gravity, and it depends upon the gravitational force exerted on the object. Weight is measured with a scale, like a bathroom or produce scale. Mass is a measure of the quantity of matter *only* and is measured using a balance that corrects for gravity. There are many kinds of balances for massing very small to very large quantities, but they all work in the same manner. The object being massed is placed on the balance, and equalizing masses (incorrectly called weights) are counter balanced against it. The masses are moved until the beam swings freely and stops at midpoint to indicate the mass of the object.

Gravitational force varies slightly from place to place on Earth, but for practical purposes the differences are small, so the terms weight and mass are often used interchangeably for earthly measurements. On the Moon the situation is different because the gravitational force is only 1/6 of that on Earth. Someone with an mass and weight of 140 pounds (63.6 kg) on Earth has a lunar mass of 140 pounds but has a lunar weight of only 23 pounds (10.5 kg), Thus the astronauts, who landed on the Moon in the late 1960s and early 1970s, were able to bound about the lunar surface with the greatest of ease.

Scientific work is often categorized as pure science, theoretical science or applied science. Pure science solves problems and answers questions about the nature of things, just to find out about them. It searches for information and is interested in uncovering everything. Discoveries are made for the sake of discovery and not for application, although they often lead to that end. Scientists engaged in pure science may be determining the structure of a molecule or analyzing core samples from the polar ice caps or studying the formation of antibodies within the blood. Theoretical science attempts to understand and describe the basic aspects of the observed world. It suggests possible explanations for observations and develops unifying ideas to determine "the big picture". Theories on the unpredictability of the subatomic

world, the nature of time and the forces of the universe are in the realm of theoretical science, and mathematics is the language of expression. Applied science or technology solves practical problems for the everyday world. It invents and develops new materials and devices and builds the "better mouse trap". Radio, television, cell phones, computers, sports equipment, medicines, vaccines, synthetic materials, modern farming methods, weather forecasting, automobiles, airplanes and rockets are the products of applied science.

Pure science, theoretical science and applied science are often connected. Henri Becquerel discovered that pitchblende, an ore of uranium, emitted radiation. Then Pierre and Marie Curie determined the radiation came from the nuclei of the uranium atoms and called the phenomenon, radioactivity. Their work was the beginning of pure research into the nature of the atomic nucleus. The investigation continued, and radium and polonium, two new radioactive elements, were discovered. Other scientists determined that uranium atoms can split or fission into smaller atoms and under certain conditions will continue to do this in a self-contained chain reaction and cause other uranium atoms to split. Fission and chain reaction release energy, and the energy released comes from the matter that is lost or destroyed as the fission and chain reactions occur.

In 1905 Albert Einstein presented a statement on the equivalence of matter and energy, one that is expressed by the equation $E = m\,c^2$. The equation explains the relationship between energy and mass and the energy released when matter is lost or destroyed. The E represents energy, m stands for mass and c^2 for the speed of light squared or multiplied by itself. The speed of light is 186,000 miles per second (300,000,000 m or 3×10^8 m per second). This is a large number, and when it is multiplied by itself, it becomes a very large number. So if a small amount of mass (m) is destroyed, and this amount (m) is multiplied by the speed of light squared (c^2), a tremendous amount of energy (E) is released. The mass after fission, when compared with the mass before fission, is less because some of the original mass is transformed into energy—a whole lot of energy! Stating this another way, the mass of a body is a measure of its energy content, and matter and energy are interchangeable. Einstein's work was theoretical, and its tangible proof came from laboratory work and the detonation of atomic bombs in 1945. Other technology followed, and many applications were developed to harness the energy held within nucleus of an atom. Nuclear reactors were built to generate electricity, power submarines, and make radioactive materials for the diagnosis and treatment of diseases.[17]

Becquerel and the Curies received a Nobel Prize in Physics for their work on radioactivity, and Marie Curie received a second Nobel Prize in Chemistry for her discovery of radium and polonium. Einstein was awarded

a Nobel Prize in Physics for his explanation of the photoelectric effect, the release of electrons from certain materials in the presence of light, but unfortunately his *Special Theory of Relativity* and his century shaping $E = mc^2$ equation were never recognized by the Nobel Foundation.

Science has three main branches: the physical sciences, the life sciences and the earth sciences. The physical sciences deal with questions related to the study of matter and energy, and the main divisions are physics, chemistry and astronomy. Physics is concerned with matter and energy and their transformations, and chemistry is involved with the composition of matter and changes in the composition of matter. Astronomy studies the solar system, the stars and the universe. It is also concerned with matter and energy, the matter and energy of the universe, and because of this, astrophysics is a more contemporary name for this science. The life sciences focus on living things. Biology is the general name for the study of everything related to life and living organisms. Zoology specializes in the study of animals, including human beings, and botany concentrates on plants. While microbiology examines microscopic forms, ecology looks at the relationships living things have with their environments. Geology, meteorology and oceanography are the earth sciences. Geology studies the Earth, both its surface and interior, meteorology concentrates on the atmosphere, weather and climate, and oceanography examines the world's seas and oceans.

Within the scientific world, the sciences often join forces and combine. This occurs in biochemistry, physical chemistry, biophysics, geophysics and of course, astrophysics. The sciences also specialize, and some are new and cutting-edge. Genomics is the study of genes and how they function to build proteins, and proteomics is concerned with the cataloging of proteins within an organism to investigate their interactions. Some, like biostatistics and bioinformatics, depend upon super computers, capable of high-speed computations, to manage and analyze the mega amounts of data collected during research.

To recap, science is an activity that studies things. To do this, it asks questions. It wants to know in what way or manner or by what means are things put together or structured? How do things work or function? How do things happen? To answer the questions, experiments are set up and observations are made. Science is based on experimentation. It builds upon preceding developments, proposes theories to explain phenomena and discovers some things by chance. It uses specialized instruments to make observations, depends upon measurement and has a specific vocabulary. It is pure, theoretical or applied, and it has three main branches (physical, life and earth) and many combinations and specialties. Science is indeed very special.

CHAPTER 3

The Nature of Art

"Art is not what you see, but what you make others see."
~ Edgar Degas

A
RT IS ABOUT MANY THINGS. Pigments and paint. Painting and sculpture. Drawing and printmaking. Glass and ceramics. Architecture and buildings. Portraits and landscapes. Realism and abstraction. Light and color. Vision and illusion. Preservation and conservation. But what exactly *is* art and what makes it *so* special?

Art is an activity that creates things. It begins with an idea, an inspiration, and it continues until something new and something that never existed before is created.

Michelangelo Buonarroti was a talented sculptor and painter. When he looked at large blocks of marble and chiseled into them, he envisioned living figures and was able to transform the cold hard stone into the fleshy forms of *David, Moses,* the *Slaves* and the *Pietas.* As a painter, he designed and painted colossal frescoes for the Sistine Chapel and with them told his version of stories from the Old Testament and the Last Judgment. Pablo Picasso had a fertile mind and used an extensive range of materials and techniques to produce his art. When he painted, sculpted, assembled, collaged, modeled and sketched, he used his hands to channel creative thoughts and ideas into tangible objects.

Art is a visual means of communication. It is a way to share thoughts, express feelings and convey meaning. A classic example is *The Scream*, by Edvard Munch, a painting which shows a loosely brushed figure on a bridge with two others. Its gender is not discernible, but its eyes are open, its mouth is gaping and its hands protectively cover the sides of its head. The panic of the moment and the mood are relayed by the facial expression, the body language, the undulating brush strokes and the selected colors. Words are unnecessary. This painting, with its display of angst, has become a popular icon for the anxiety associated with the human condition.[18]

Art requires an audience. It needs people to view it and to become involved and think about its meaning. The way an art object is viewed or *read* can influence its interpretation. The painting, *Cupid as Link Boy*, by Sir Joshua Reynolds, illustrates this point. When people look at this painting, the first thing they notice is the figure of a young boy. They note his delicately modeled face, the wings on his back and the lighted torch in his hand. Who is this child? What is he doing? Then they see other things. They notice the boy has tattered and torn clothing, dark wings rather than white feathery ones and a sling over his shoulder that suggests a quiver filled with arrows, perhaps like Cupid. They observe the boy's gaze is downward and not directed toward the viewers and the torch is held in an obscene gesture. They also note the poorly lit city street and dark buildings in the background. This is a painting of a link boy, a child who made his way in life by lighting the lonely lanes of night for others. Sometimes, like Cupid, he deceived, took advantage of those he served and robbed them, and sometimes he was the one who was deceived and abused by his patrons. This young boy was well seasoned in the rough ways of street life, and Reynolds used the irony of this painting to tell his audience about life in eighteenth century London.[19]

Art has a great diversity of form, and it can be anything, anything at all, the artist does and says is art. It is painting from the prehistoric images on cave walls to the frescoes of Giotto di Bondone, to the scrolls of Eastern Asia, to the colorful Polynesian scenes of Paul Gauguin, to the gestural paintings of Willem deKooning, to the distorted portraits of Francis Bacon. It is sculpture from the figures of antiquity to the classical statues of ancient Greece, to the carved ceremonial objects of Africa, to the modeled forms of Auguste Rodin, to the reclining figures of Henry Moore, to the gigantic spiders of Louise Bourgeois. It is architecture from the Great Pyramids of Egypt, to the Parthenon on the Acropolis, to Hagia Sophia in Istanbul, to the Taj Mahal in India, to the Eiffel Tower of Paris, to the thrusting cantilevers of Frank

Lloyd Wright, to the looming multifaceted forms of Frank O. Gehry. Art is drawings, prints, works made from glass and ceramics, photography, jewelry, objects of cloth, collages of cut paper and other materials and assemblages of assorted objects. Art also includes installations, computer enhanced materials and videos.

An installation is site-specific. It is planned for a particular space, a room, a hall, a stairwell, a building, a park or even a city, and it is designed to involve viewers. The process of installation begins when the artist examines the site and decides on a plan of action, and it continues as the artist paints and/or fills the space with objects and materials that transform it into an environment. It is temporary and will eventually be removed. One Saturday morning, I watched Judith Pfaff climb a ladder and roll paint onto walls at the Albright-Knox Art Gallery in Buffalo for her installation, *Rock / Paper / Scissors*. The place selected for the installation was the stairwell between the first and second floors of the museum, and the inspiration came from the artist's experience with the Gallery's large collection of Abstract Expressionist paintings. Pfaff changed the space by painting the walls with vibrant colors and attaching plexiglas, wood, metal and wire forms to the floor, the walls and the ceiling. As visitors climbed the stairs from the first to second floors, they had to pass through this carefully designed environment, a colorful and energetic maze, and they were forced to view the installation and become involved with it. After several months, everything was dismantled and removed from the stairwell. The walls were repainted an off-white museum color and returned to their previous state.[20]

Computers are used to enhance art. John Pfahl worked with a computer and the tools of the digital age to create to original photographs. He started with a photo he had taken, perhaps one reminiscent of an eighteenth century landscape painting by J.M.W. Turner. Then he used the technology of a computer program to manipulate the image and added, subtracted, and moved parts of the photo. At first his photographs appear to be picture perfect scenes, but careful inspection reveals the pixels of the digital world.[21]

Video art involves the recording and viewing of visual images. *The Greeting*, by Bill Viola, is a large scale projected video based on Jacopo Pontormo's *The Visitation* of 1528 - 1529. The original painting tells the story of the Virgin Mary's visit with her older cousin, Elizabeth, and the shared joy of their pregnancies. Viola's video begins with two women talking, and then a third woman, perhaps also pregnant, appears and interrupts the conversation by whispering to the older woman. At first she is ignored, but later she is allowed to join the other two. The video has a haunting quality. It is shown on

the wall of a darkened gallery, and the resulting image is larger than life and is in slow motion with distorted sound, The women in the video are any women, not just those of the story, engaged in dialogue, and the viewer is invited into their space and encouraged to enter their conversation. *The Greeting* was exhibited in the American Pavilion at the Venice Biennale, the oldest and most prestigious of all the international contemporary art exhibitions.[22]

Art is realistic or abstract or somewhere in between. Francisco Goya, Robert Motherwell and Pablo Picasso created paintings related to Spanish history, ones that dealt with war and loss of life. The paintings have emotional qualities, but their method of presentation is quite different. *The Third of May, 1808* by Goya is a realistic or representational depiction of the impending execution of a Spanish peasant by a military firing squad. The scene shows some of the peasant's comrades lying dead in their own blood, and others in despair and fearful of losing their lives. The central figure has acknowledged his fate and stands with outstretched arms and an anguished expression.[23] The paintings in Motherwell's *Spanish Elegy* series are based on the Spanish Civil War and Francisco Franco's destruction of the Spanish Republic during the 1930s. Abstraction is used to tell the story. Shapes and colors are employed to describe the human spirit and the bloodshed and the death caused by this war.[24] Picasso's *Guernica* relates the savage bombing of a peaceful village during the same Spanish Civil War. The overwhelmingly large painting is done with a somber gray palette and conveys the terror of the moment with somewhat abstracted human and animal figures and fragmented forms.[25]

Art is a product of its time and place. Robert Delaunay lived in Paris at the beginning of the twentieth century and painted images of the Eiffel Tower, ferris wheels, electric street lights and Louis Bleriot's plane, the first to cross the English Channel. To describe the excitement of this city, he reduced the forms to their basics and added discs and wedges of radiant color.[26] Faith Ringgold recounts her life as an African-American and recalls black history through her paintings, soft sculptures, collages and story quilts. Her works are reflective of being a black person in the United Sates and tell the stories of racism, violence, oppression and the civil rights movement.[27] In 1982, Maya Lin designed the Vietnam Veterans' Memorial for The National Mall in Washington, DC. It is a long horizontal structure that cuts a corner in the landscape with its two walls of polished black granite. Engraved on the wall are the names of those who lost their lives in this war.[28] Its very simplicity creates a dignified space for remembering and honoring all who gave their most precious gift, including Ken, one of my former students, who was killed while serving as a marine.

Art is an experience. People often comment: "I don't know much about art, but I know what I like." Perhaps they mean: "I don't know much about art, but I like what I know." The art of Vincent van Gogh is very popular in today's world, but that was not the case while the artist was alive. His canvases with their vibrant colors and staccatoed brushstrokes were generally unappreciated and only one was sold during his lifetime. However in the years following his death, his genius was acknowledged, and his paintings with their unique use of color and strong brushwork were a profound influence on the art of the twentieth century. Today van Gogh's paintings and drawings are widely recognized and collected by museums and individuals. Not only are the paintings popular, they are also valuable and sell for millions of dollars.

Art is a personal experience. A particular art work may have special meaning for one individual and absolutely no meaning for another. Perhaps this happens because of the subject, the colors, the lighting, the composition, the setting, the memory recalled, the questions asked or something else. It's hard to say *why* a particular work of art becomes significant, but most viewers know *when* it happens. The play, *Art* by Yasmina Reza, is based on this thought. It deals with the friendship of three men, their taste in art and the recent purchase of an expensive, all- white painting. The owner of the painting is ecstatic and extols the greatness of this newly acquired work to his friends. One friend, who sees himself as very art literate, is unappreciative of the painting and finds nothing redeemable in it. The other is in the middle and is, for the most part, disinterested. What follows is a discussion of the meaning of art, the very personal nature of art and friendship. Was there something *there* for the viewer or was the canvas blank and without meaning?[29] The exchange is reminiscent of Hans Christian Andersen's story, *The Emperor's New Clothes*. Was the emperor wearing a fine new suit or was he naked?

The white painting in *Art* is a monochromatic work. In today's art world, a number of paintings are single color or what appear to be single color pieces. The reductive works are not as simple as they appear and are often quite complex in their composition. The brilliant blue paintings of Rudolf DeCrignis have multiple layers of paint, sometimes as many as forty. They begin with coatings of gesso (a mixture of plaster of Paris and glue) and continue with many layers of color, not always blue, sometimes white, orange, red, yellow, gold or silver. The richness of the DeCrignis ultramarine, a color that appears to glow from within, comes from the reflection of light from the multiple layers of the painting.[30]

Art can be controversial. When *Le Déjeuner sur l'herbe (The Luncheon on the Grass)* by Edouard Manet was first displayed, it caused a stir because

of its innovative use of color, its loose brushwork *and* its subject matter. It showed three figures sitting on the ground, two well- dressed men and an unclothed woman, and a partially clothed woman in the background. It was picnic scene in a Parisian park with real people as its characters. *Déjunier* was based on earlier paintings with similar subject matter, but it was a sharp departure from them. In the nineteenth century, nudes were familiar and acceptable subject matter for art, but this one was different. She was not a goddess and lacked the mythological connections of the previous nudes. She represented a real person in a public park, and she was looking directly at the viewer.[31] She was confronting the viewer as the viewer was ogling her, and this created an air of indecency. In the 1860s, this was shocking and generated controversy.

Art can be challenging. Some art is difficult to understand and may provoke the comment: "Is *that* art?!" Jackson Pollock developed a technique for dripping and pouring paint onto a canvas. Some saw Pollock's work as messy and covered with dribbled paint, some referred to him as "Jack, the Dripper" and some took great pleasure in proclaiming their children capable of making similar pieces. Others grasped the significance of Pollock's work and recognized it as an abstract form of expression with carefully planned gestures, coming from the mind of the artist. His canvases were fields of energy and color and filled with personal feelings. In the years following World War II, the work of Pollock and other Abstract Expressionists, most of whom lived in or near New York City, exerted a major influence on art and shifted the focus of the art world from Paris to New York.[32]

Art can be familiar, sometimes too familiar. Leonardo da Vinci's *Mona Lisa* is hailed as one of the great masterpieces of the western world and is regularly included in books that deal with art, history and travel. The painting shows a well modeled figure, with eyes directed at the viewer, placed against a subtly lighted landscape. It has a haunting and enigmatic quality, but it is so well known that it is difficult to be objective when viewing it. For many years it was believed to be the portrait of a Florentine woman, but recent scholarship has challenged this. The true identity of the figure remains in question and adds to the mystery of the painting. *Mona Lisa* is also a painting others are fond of using and misusing. Marcel Duchamp added a mustache and goatee to a reproduction and created one of his "assisted readymades," and later Salvador Dali altered another reproduction and substituted his face and hands for hers. Scores of satirists, cartoonists and greeting card designers have also taken liberties with the Renaissance painting and have produced many exaggerated and humorous versions of it.

Art asks questions. A case in point is the work of Ai Weiwei, a contemporary artist from China. He uses art to raise questions about his native country and what is happening there. He has photographed himself dropping a 2000 year old Han Dynasty urn. He has displayed metal rods salvaged from buildings that collapsed during an earthquake, and he has assembled a collection of bicycles and turned them into a sculpture. What do the images mean, especially in terms of China? What are they saying about China? What issues are they addressing? Ai Weiwei's art is provocative, so much so that Chinese authorities took action against him in 2001. He was arrested and held prisoner for eighty-one days. He was kept under government surveillance, and he was not allowed to speak in public and not permitted to leave China. However with the help of assistants, he was able to express his views and exhibit his thought provoking and politically charged art in other counties, including the United States. In 2015, his passport was reinstated, and in 2016, he reproduced scenes of his incarceration for an exhibition.[33]

Art experiments. Joseph Albers was interested in color and how colors interact. He created a series of paintings, entitled *Homage to a Square*, all with colored squares within other squares. By changing the colors and varying their sequence, he studied the effects colors have on each other. Using this work as a foundation, Albers developed a theory of color and explained his findings in a book, *Interaction of Color*.[34]

Art has a vocabulary. Consider the words *line* and *color* and what they mean in art. Both are elements of art, along with shape, form, space, value and texture. Line is used to define space and create the illusion of mass and volume. It involves edge, outline, form, shape and drawing. Color is used for description, to illustrate things and to show what they are like. It is also used for expression, to indicate feelings and to create emotional responses. Color has three qualities, hue, intensity and value. Hue refers to the name of the color (red, blue, etc.), intensity means the purity and strength of the color (bright red v. dull red) and value relates to the lightness or darkness of the color (light red v. dark red). Line and color are essential in art, and the works of Jean Dominique Ingres, Eugene Delacroix and Henri Matisse demonstrate their use. Ingres was a draftsman and interested in line and shape. His figures were centered, and the contours of their bodies were carved with lines of great precision. Delacroix was a colorist and concerned with the effects of color. His canvases were saturated with exuberant, flamboyant and expressive hues that gave his paintings and the stories they told an emotional quality. Matisse was involved with both line and color and created figures and forms with flowing lines and arabesques and filled them with vibrant color.

As Matisse aged, he was confined to a wheelchair and was no longer able to paint on canvas, but he continued to make art. Using sheets of paper colored by his assistants, he carefully cut them into graceful shapes with scissors and literally sculpted them into linear forms, much like a sculptor shapes stone or wood.

Art builds upon the art that precedes it. During the nineteenth century and for a good portion of the twentieth century, there was great interest in the expressive use of color. It began with Delacroix and was followed by the rich and intense use of color by Vincent van Gogh, Paul Gauguin and Edvard Munch. It continued with the strong and bright colors of Matisse, Andre Derain, Franz Marc and Vasily Kandinsky, and it influenced the emotional and energetic colors of Jackson Pollock and Willem deKooning.

To recap, art is an activity that creates things. It begins with an idea, an inspiration, and continues until something new and something that never existed before is created. It is a visual means of communication and a way to share thoughts and express feelings. Art requires an audience, and it invites its viewers to become involved and think about its meaning. It has a great diversity of form, and it can be anything, anything at all, the artist does and says is art. It is realistic, abstract or somewhere in between, and it is a product of its time and place. It is also an experience, a personal experience, and it can be controversial, offer a challenge and be familiar, sometimes too familiar. Like science, art asks questions, experiments, has a vocabulary and builds upon previous developments. Art is indeed very special.

CHAPTER 4
CONTEMPORARY SCIENCE
CONTEMPORARY ART

"con-tem-po-rar-y adjective or noun
1. existing, occurring or living at the same time;
belonging to the same time;
2. of the same age or date;
3. of the present time;
4. one belonging to the same time or
period with another or others."
~ Webster's New Universal Unabridged Dictionary

CONTEMPORARY SCIENCE AND CONTEMPORARY ART are the science and art of today's world, and they are based on the science and art that preceded them. What they present is new and often very different, so much so the uninitiated frequently respond: "I don't understand this. I just don't get it!"

The science of Galileo Galilei, Louis Pasteur, Charles Darwin and Albert Einstein was contemporary science when it was introduced. It was new and very different, but with time it was accepted and given much recognition. Today's science offers a special challenge because of its inherent complexity. It involves teams of highly educated scientists and technicians at work in well equipped laboratory situations. It relies on sensitive high-tech instruments to extend the range of its observations from the subatomic to the expanse of the universe, and it depends on super computers to gather and analyze large amounts of sophisticated data. In the process, it constructs

theoretical models and uses a language of unfamiliar words and mathematics to explain its findings.

To develop the nature of today's science, five examples of contemporary science are reviewed (the fundamental nature of matter and energy, the expanding universe, the dynamics of the Earth's crust, the manipulation of life and human heredity).

The fundamental nature of matter and energy is elusive. What is known about matter and energy comes from the study of atoms and the subatomic universe. This research shows the atom to be largely empty space, with a tightly compacted nucleus of protons and neutrons in the center and electrons in energy levels at comparatively great distances from the nucleus. Protons have a positive charge, electrons are negative and neutrons have no charge. This is the realm where matter behaves like a particle and a wave and where energy behaves like a particle and a wave also. It is where theoretical physics and mathematics are necessary. It is where matter is studied with powerful accelerators and where particles are propelled toward each other, collide and create positrons, quarks and other subatomic particles. A positron is similar to an electron, but it has positive charge and is like a positive electron. When an electron and positron collide, they are annihilated, and energy is released. A positron is a particle of antimatter, and scientists believe every particle has an antiparticle or counterpart. Protons and neutrons are made of quarks, and some scientists think quarks and electrons are not particles but are multidimensional vibrating entities, known as "strings" and "branes". This idea is known as the "string theory" or "theory of everything," and it strives to bring together all forces, from the subatomic to the universal, to unify everything. It is mathematical in nature and suggests electrons and quarks are determined by the way the strings vibrate. It proposes the existence of perhaps eleven different dimensions, as compared to the currently accepted four dimensions of length, width, depth and time.[35]

The universe is vast and ever expanding. It began about 13.8 billion years ago as an event of tremendous energy, a gigantic explosion, the so-called "Big Bang," and came from a single point where everything was highly compressed and very hot. The circumstances were in order for energy to convert into matter, in other words, the conditions were right to create matter. (This is the opposite of matter producing energy, as it does during fission.) Within a fraction of a second, a rapidly expanding fireball created a mixture of electrons, quarks and other particles. With the rapid expansion, cooling occurred, and quarks formed into protons and neutrons. It was still very hot, but no longer hot enough to create more matter. At three minutes

after the Big Bang, the universe was a hot fog with no light. At 300,000 years, the conditions were right for the protons, neutrons and electrons to join into atoms, mainly hydrogen and helium, and light appeared. At one billion years, the hydrogen and helium gathered into large clouds that became galaxies and the first stars. Stars died and new ones formed.

The Sun and the solar system came from a rotating disc of gas and dust. The Sun is only one of hundreds of millions of stars in the Milky Way Galaxy, and the Milky Way is only one of billions of galaxies in the universe. The other galaxies are moving away from the Milky Way, and the more distant a galaxy is, the faster it is receding from the Milky Way. It would seem that cosmic gravity would pull the universe together, but this is not the case. Something, a negative gravity, a repulsive pressure, acts against gravity and causes the expansion to increase.[36] The repulsive force comes from within the vacuum of space and speeds up the process. The nature of the "dark energy" behind this force is unknown, however its effects are known. It is the energy of empty space. The universe is expanding at an ever accelerating rate and the other galaxies are receding into the far reaches of space. Billions of years from now, when the creatures of the Earth look skyward, they will see the Milky Way, *only* the Milky Way, surrounded by the endless void of space.[37]

The Earth's crust is in a constant state of change. At first this may seem strange, because casual observation seems to indicate otherwise. The changes are usually slow and occur over long periods of time, inches per year for hundreds, thousands and millions of years. They are caused by large plates that move slowly across the surface of the Earth, and as they move, they separate, come together or slide past each other. This phenomenon is known as plate tectonics. About two hundred million years ago, the Earth had one large continent, a single landmass, known as Pangaea, surrounded by ocean waters. Gradually the plates making up this supercontinent separated, and the present continents, mountain ranges and bodies of water formed. Today the boundaries between the plates are the sites of volcanic activity, earthquakes, mountain building and ocean trenches. The ocean floors have large ridges where molten rock or magma rises and hardens into new crust, and as this happens, the ocean floor separates and moves away from the ridges. Along the large Mid-Atlantic Ridge, new crust is accumulating and parting the plates on either side of this ridge. This activity is causing the land masses of South America and Africa to move away from each other at the rate of about one inch (2.5 cm) per year. On the western coast of South America, an oceanic plate is moving under a continental plate and forming a trench along the coast and pushing the Andes Mountains upward.

If the plate movements are abrupt, the results can be devastating. Sliding plates along the California's San Andreas fault regularly produce tremors and sometimes cause damaging earthquakes.[38] In 2010, a sudden shifting of rocky plates in Haiti created a massive earthquake. Almost a hundred thousand people lost their lives, and the capitol city of Port-au-Prince was destroyed. Sudden movements of the sea floor, from earthquakes, landslides or volcanic eruptions, generate huge waves that travel out in all directions. When the waves approach shallow water, they grow in size and become giant walls of water or tsunamis and wreak havoc along coastal areas. In December 2004 over two hundred thousand people were killed and extensive damage was done by tsunamis formed from movements along crustal plates under the Indian Ocean near Sumatra. In March 2011, a massive earthquake off the coast of Japan, followed by tsunamis, created a nuclear disaster. Reactors went into meltdown, explosions occurred, generators broke, buildings collapsed and roads and railways were destroyed. Thousands were killed, and many more were injured and exposed to radiation.[39]

Life can be manipulated. One procedure enables the nucleus of a body cell, also known as a somatic cell, to grow into an embryo. First an egg cell is taken from one animal, and its nucleus is removed. Then the nucleus of a cell from second animal is transferred into the egg cell. Following this, the reconstructed cell (the egg cell with its newly transferred nucleus) is stimulated, to start its cell division and growth into an embryo. When the embryo reaches a certain stage, it is implanted into a surrogate female and brought to term. The procedure is known as somatic cell nuclear transplant or cloning.[40] The first successful cloning of a mammal occurred in 1996 with the birth of a sheep, named Dolly. It used an egg cell from one sheep, and a nucleus, with its DNA, from a mammary gland cell (an udder cell) of an another sheep. Dolly was an identical twin of the second animal. As an adult, she was bred several times and produced six offspring, but in time she developed serious health problems and was euthanized in 2003. The procedure used to produce Dolly was high-tech and expensive, and it was inefficient considering the fact that she was the only sheep to survive to adulthood after 277 attempts.[41] Since then the technique has become more efficient, and a number of pigs, cows, goats, rabbits and sheep have resulted. Perhaps someday the cloning of livestock will provide food for the growing world population and save endangered species. In 2017, after nearly two decades of work, scientists succeeded in cloning the first nonhuman primates (two cynomolgus monkeys or macaques) using this technique. Primates like these are evolutionarily close to humans and are common research animals, and

their use in lab work would eliminate genetic variation from experimental studies.[42] However this success also raises the issue of human cloning and some serious ethical questions.

Human heredity is an involved process. People inherit their ability to be alive and carry on life processes and to be a human rather than a maple tree or a grasshopper. They also inherit their distinguishing characteristics like eye color, hair color, skin color, facial features, blood type and body build. DNA is involved in the process. Specific portions of DNA, known as genes, are responsible for the production of specific proteins and the expression of traits. In 2003, a team of international scientists completed the Human Genome Project and successfully determined the sequence of the nitrogen base pairs (the adenine-thymine and cytosine-guanine pairs) making up DNA and pinpointed the locations of the 20,000 - 25,000 genes associated human heredity. The research continued, and a number of surprises showed up. Some portions of the DNA make several kinds of protein, and some are rearranged to make other proteins. Some portions may influence heredity and others may have absolutely no function at all. Some may even be remnants of viruses that entered the DNA of our ancestors and were passed from generation to generation. Of special interest are the portions that direct the production of molecules that cling to the outside of the DNA and are inherited with the DNA. They are molecules that enable and disable the genes, that is, they turn them on or turn them off. They are involved in embryonic development and the differentiation of early cells into nerve, muscle, bone and other types of cells, and they cause cancers and death when they operate incorrectly. Research has shown that they can be stressed by environmental factors and diet. In other words, environmental factors and diet can affect DNA and influence what is passed to the next generation.[43]

The art of Edouard Manet, Vincent van Gogh, Pablo Picasso and Jackson Pollock was contemporary art when it was created. It was new and very different, but with time it was accepted and given much recognition. Today's art, like today's science, offers a special challenge because of its inherent complexity. The art itself is without limit. It is referred to as the artist's practice and can be anything, anything at all, the artist does and says is art. It can incorporate a wide range of techniques and be made from a great variety of materials, some that are very new and nontraditional. It can involve assistants, teams of assistants, and high-tech instruments. It can be layered, ambiguous, open ended and looking for interpretation. The art invites the viewer to become involved and respond, and just as the work is a personal creation so is the reaction of the viewer.

To develop the nature of today's art, the work of five contemporary artists is reviewed (Julie Mehretu, Jeanne Silverthorne, Matthew Barney, Ken Price and Anselm Kiefer).

Julie Mehretu is a painter who uses a visual vocabulary of marks in her practice. Her personal language evolves from a close examination and careful dissection of the gestures she uses. The marks she makes become signs and symbols in her paintings, along with maps, urban planning grids and architectural forms. To manage the images, she works with a computer. Her paintings are done in layers separated by resins, and they are layered in significance, like rock strata or archaeological sites. They present personal stories that are meaningful and ambiguous, figurative and abstract, orderly and chaotic, historical and fictional. Mehretu was born in Ethiopia, raised in Michigan, and educated in Senegal and Rhode Island. She travels the globe in pursuit of her art, but calls New York City her home. Her nomadic ways make her a citizen of the world and one who is conversant with the twenty-first century. Mehretu uses her dynamic visual vocabulary to examine space, place and time and to create her "story maps of no location". Through her paintings, she invites the viewer to discover the interconnections of our world.[44]

Jeanne Silverthorne is a sculptor who creates her works using rubber casts and other materials. Photomicrographs of cells and diagrams of molecules from science books often become the starting points for her art. Claiming no particular knowledge of science, she uses what she sees as a reservoir of uninhibited ideas. She fashions large models of molecules and cells and makes small models of people in various states of emotion, thus producing super size molecules and miniature humans. With Silverthorne's work, size is transposed: the small becomes large and the large becomes small. She gives titles to her work that invite the viewer to think macroscopically versus microscopically as compared with the human body and its emotional states. Her works can be happy and sad, pleasant and unpleasant, humorous and anxious, or whatever the viewer wants them to be.[45]

Matthew Barney constantly tests his creative and physical energy by pushing his own artistic limits. His highly imaginative practice consists of sculpture, drawing, music, photography, video and film. When creating films, he takes an active part in planning, preparing and performing, and his assistants help, both on and off camera. His films have imaginative figures involved in compound narratives, and his stories unfold through richly filmed sequences, specially constructed sites, carefully selected music and elaborately costumed actors. His *Cremaster Cycle* is a series of five feature length films and deal with his interest in biology, the potential of the embryo to be male or

female and the struggle to resist definition into male and female. As they are viewed, many levels of meaning emerge, and the viewer is invited to decipher their message.[46]

Ken Price created sculptural pieces that were abstract amorphous forms, made of clay and fired in a kiln. Instead of using traditional glazes, he covered the exteriors with layers of metallic and acrylic paints and carefully sandblasted and scoured them to produce delicately speckled surfaces. Price knew and understood ceramics. He selected clays that would not explode in the intense heat of a kiln and limited size to that of his kiln. Objects made of ceramics are often considered craft pieces rather than art, and as such they are placed on shelves and tables. Price's work is exhibited as sculpture and displayed on pedestals and illuminated with spotlights. His droopy sculptures may offer special meaning and/or aesthetic enjoyment. They may entice the viewer to think about the meaning of sculpture and art, to think about what they represent, if anything, or to think about anything else or perhaps nothing at all.[47]

Anselm Kiefer creates art that is open ended and invites interpretation. His *die Milchstrasse (The Milky Way)* is an impressively large work, 150 x 200 inches (3.8 x 5.1 m), in two sections, and weighs several hundred pounds. It has a rough surface covered with emulsion paint, shellac, oil, acrylic, wires and lead, and it appears to be an abstracted scene of a field with planting rows. The predominant colors are shades of brown and tan. Furrows guide the eye upward, from the darker browns to the lighter tans, and to the slash in the central area bearing the words, *die Milchstrasse*. Two ropes of lead swag from the upper left corner to the upper right corner and hold a lead funnel. The slender conduit has *alkahest* written on its side and points to the central slash. Kiefer was born in Germany near the end of World War II, and he frequently references war in his art. His use of lead alludes to medieval alchemy and its search for the magic solvent, alkahest, the elixir of life. This work is rich in symbolism, and it invites the viewer to become involved and think about its meaning. Perhaps the painting is a view of a recently harvested field with the promise of a new crop for the following season. Perhaps it is a scene of wartime devastation and the desire for rebirth. Perhaps it is about World War II, the Holocaust, the death of millions and the hope for transformation. Perhaps the funnel is directing attention to our galaxy, to the place in the universe where human beings live. Perhaps Kiefer is asking viewers to think about their place in the universe and what that means.[48]

In the musical play, *The King and I*, the king is faced with much that is new and very different, and he recalls his situation in a song. With a little

imagination, I think the clever lyrics of Oscar Hammerstein relate to the challenges presented by today's science and art.

There are times I almost think
I am not sure of what I absolutely know.
Very often find confusion
In conclusion, I concluded long ago.
In my head are many facts
That, as a student, I have studied to procure,
In my head are many facts
Of which I wish I was more certain, I was sure.
Is a puzzlement![49]

Contemporary science and contemporary art are the science and art of today's world. When they are compared, connections between them are discovered. Both contemporary science and contemporary art offer a special challenge because of their inherent complexity. Both propose ideas and advance perspectives that are new, sometimes confusing and outside the realm of ordinary experience. As a result, both may be difficult to understand and have unsettling qualities.

Materials
and
Techniques

CHAPTER 5

THE SCIENCE OF MATERIALS

———⟨⟨◇⟩⟩———

"I am among those who think science has great beauty."
~ Marie Curie

ATERIALS ARE THE "STUFF" OF OUR WORLD. They are the things of composition and the things used to create art. Science refers to materials as substances, while art calls them media. To fully understand and appreciate materials, that is, what they are like, how they work and how they function in art, it is necessary to enter the world of science for a review of the physics and chemistry behind them.

Materials are matter, and as such they have mass and take up space. Under ordinary conditions, they exist in one of three states or phases as either a solid, a liquid or a gas. When sufficient energy is added to a gas, an additional state, an electrically conductive gaseous plasma phase, develops. This happens inside fluorescent and other gas filled tubes, around electric discharges, on the surface of the Sun and other stars and within some television and computer monitors. Every material has properties, unique and distinguishing features, that set it apart from other materials. Physical properties describe the appearance of the material (state of matter, color, luster, hardness, density, melting point, boiling point, brittleness, ductility, solubility and electrical and thermal conductivity), and chemical properties describe how the material responds to other materials.

Copper is a good example of a material because it is well-known and has been part of the human experience for at least ten millennia. Its distinguishing physical properties set it apart from other materials and make it easy to recognize. It is a solid with a characteristic reddish orange color and luster and is classed as a metal. It is an excellent conductor of both heat and electricity and is easily drawn into wires and pounded or pressed into shapes. Like all solids, copper will melt and become a liquid, but copper does not melt until it is heated to 1981° Fahrenheit (1083° Celsius), its specific melting point. For comparison, ice melts and becomes water at a much lower temperature, 32° F (0° C), thus copper is a solid and water is a liquid at ordinary temperatures.

Copper has distinguishing chemical properties as well. It reacts with oxygen to produce copper oxides and with other materials to make sulfides, sulfites, sulfates, chlorides, hydroxides and carbonates. Copper forms alloys when mixed and fused with other metals. When it is mixed and fused with tin, it becomes bronze, a popular alloy for the casting of sculptures, and when it is mixed and fused with zinc, it forms brass, another alloy used by artists.

Changes in the physical properties of a material are physical changes. Physical changes alter the appearance of the material but do *not* change the composition of the material. A physical change occurs when water is cooled and freezes into ice and goes from the liquid state to the solid state or when copper is heated and melts and becomes liquid copper. Another physical change occurs when copper is pounded into a shape. The appearance of the copper changes, but its composition is not altered. The pounded copper has a different shape, but it is still copper.

Martin Puryear is well-known for his wooden sculptures, but he has also created pieces made of copper. For these, he started with sheets of copper and then cut, polished and assembled them into enigmatic shapes. In the process, the metal underwent a series of physical changes and its appearance changed, but its composition remained the same. The material started as copper and remained copper in the finished sculptures.[50]

Changes in the composition of a material are chemical changes. Chemical changes produce new materials with different physical and chemical properties. This happens when copper responds to the materials in its environment. Over time a statue or a roof made of copper will react with the materials in the atmosphere and develop a colorful green film, a verdigris or patina, on its surface. One of the compounds in the green film is copper carbonate, and it is the result of a chemical change. The copper, one material, reacted with the materials in the atmosphere and changed

into copper carbonate, another material. Copper and copper carbonate are different materials, and they have different physical and chemical properties.

Elements are the building blocks of matter. They are pure materials and can *not* be separated into simpler materials by ordinary physical and chemical means. Over 90 elements exist in nature, and another 25 or so can be created through advanced technology. Elements are represented by symbols. Copper is an element and its symbol is Cu. Other elements and their symbols are hydrogen H, helium He, carbon C, nitrogen N, oxygen O, sodium Na, aluminum Al, silicon Si, sulfur S, chlorine Cl, calcium Ca, iron Fe, zinc Zn, silver Ag, cadmium Cd, gold Au, mercury Hg, lead Pb and uranium U. Some of the symbols were derived from their Latin names, for example the symbol Cu came from *cuprum*, Na from *natrium*, Fe from *ferrum*, Ag from *argentum*, Au from *aurum*, Pb from *plumbum* and Hg from *hydrargyrum*.

Iron is a metallic element with magnetic properties, and sulfur is a nonmetallic element with a yellow color and characteristic odor. When iron filings are stirred into powdered sulfur, a grayish yellow substance is produced. When a magnet is passed through this material, the magnet attracts the iron filings and pulls them from the sulfur. The iron and sulfur separate because *no* chemical change occurred when the iron and sulfur were stirred. The iron filings are still iron, and the sulfur is still sulfur. The stirred iron and sulfur are a mixture.

iron and sulfur + stirring ----> iron and sulfur
Fe + S + stirring ----> Fe + S

A mixture is a blend of two or more materials that are not chemically combined.

When the mixture of iron filings and sulfur is heated for a few minutes, a grayish lump is created. When a magnet passes near the lump, the lump does not respond to the magnet, and the iron and sulfur do not separate. A chemical change occurred when the iron and sulfur were heated and a new material, iron sulfide, was formed. Iron sulfide is a compound with the formula FeS and has properties different from those of iron and sulfur.

iron + sulfur + heat ----> iron sulfide
Fe + S + heat ----> FeS

A compound forms when materials are put together and a chemical reaction occurs between the materials. The chemical composition of a compound is indicated by its formula. Water is a compound of hydrogen and oxygen and has the formula H_2O. Other compounds are carbon dioxide CO_2, table salt or sodium chloride $NaCl$, calcium carbonate $CaCO_3$ and copper carbonate $Cu_2(OH)_2CO_3$.

Solutions are mixtures with one material dissolved in another. They are clear and do not separate upon standing. A mixture of sodium chloride and water is a solution. The dissolved material (sodium chloride) is the solute, and the material in which it is dissolved (water) is the solvent. Water is often called the universal solvent because it dissolves many materials, but it does not dissolve everything, including oil and grease. Other solvents are alcohol, turpentine, mineral spirits, benzene and carbon tetrachloride, and some are capable of dissolving oil and grease. Solvents have many uses in art and are often employed as paint thinners or diluents. Suspensions are cloudy mixtures of dispersed particles that separate over time because the particles are too large to remain mixed. Cornstarch and water is a common suspension that slowly separates as the starch settles or precipitates. Colloids are mixtures of dispersed particles that do *not* separate over time because the particles are evenly dispersed. Some may appear cloudy or foggy. The glues, paints and aerosol sprays used by artists are colloids. Emulsions are mixtures of immiscible liquids and the emulsifiers that blend them. Oil and water do not mix, but when a detergent, an emulsifier, is added to the oil and water, they blend to make an emulsion of oil and water. Egg yolk is a natural emulsion of egg oil with the emulsifiers, albumen and lecithin, and it is one of the ingredients in egg tempera paint.

The smallest part of an element is an atom, and each element has a different atom. Atoms are very, very small and are composed of even smaller particles, known as protons, electrons and neutrons. Protons have a positive electrical charge, electrons have a negative electrical charge and neutrons are neutral and have no charge. The protons and neutrons make up the compact nucleus at the center of the atom, and the electrons are found in energy levels (also known as orbits, shells or electron clouds) located at relatively great distances from the nucleus. The number of protons in the nucleus determines the element. The element hydrogen has 1 proton, helium has 2 protons, carbon has 6, copper has 29, and uranium has 92. Simply stated, the difference between one element and another is the number of protons in the nucleus of its atom.

Atoms are electrically neutral because they have equal numbers of protons and electrons. The positive charges of the protons and the negative

charges of the electrons cancel each other and make the atoms neutral. Electrons move around, and when an atom gains or looses an electron, the atom develops an electrical charge and is known as an ion. When a neutral hydrogen atom looses an electron or negative charge, it develops a positive charge and becomes an H+ ion, and when a chlorine atom gains an electron it becomes a Cl- ion.

Around 450 B.C., the philosopher, Democritus, proposed the concept of atoms and the idea that everything was composed of them. His proposal was based on reasoning and had no experimental documentation, and eventually it was forgotten. As science developed, experiments were conducted and data accumulated, and the concept of the atom resurfaced. Today scientists use theories and the language of mathematics to describe the atom, and others create physical models to visualize them. Some of the representations are based on scientific theory, while others are pure conjecture. The atomic portraits of Kenneth Snelson came from the artistic tradition that attempted to illustrate the invisible. He started with an hypothesis to make sense of the atom as an object with electromagnetic and mechanical properties. Then he created models with great circles on imaginary spherical shells to visualize the structure. With these forms, he introduced structures which may or may not have anything to do with real atoms and may be just inventions of his mind. He represented electron pairings, the electronic states of hydrogen and helium, inert gas shells, diamond molecules, graphite molecules and complex atoms with many electrons. Snelson's art, with its graphic representations of the atom, was recognized and supported by The National Endowment for the Arts.[51]

Elements join other elements to form compounds. Specifically, the electrons in the outermost energy levels of atoms join with the electrons in the outermost energy levels of other atoms to form molecules. This is known as chemical bonding. Atoms bond with other atoms by loaning, borrowing or sharing their electrons. The forces of attraction between the electrons form bonds which hold the atoms together. How an atom will react or bond with other atoms is determined by the number of electrons in its outermost shell. In other words, the outermost electrons determine chemical properties. The sodium atom has one electron in the outermost shell of its atom. When sodium loans this electron to chlorine, the sodium and chlorine chemically bond and form sodium chloride (NaCl). When two hydrogen atoms and one oxygen atom share electrons, water (H_2O) is formed.

The properties of sodium chloride are quite different from those of sodium and chlorine. Sodium chloride is a crystalline solid. It is a common

ingredient in foods and essential for life processes in small amounts. Sodium, on the other hand, is a soft and highly reactive solid, and chlorine is a sharp-smelling poisonous gas with a greenish yellow color. The same can be said of water and its component gases. Water is the familiar solvent and the liquid necessary for life. However hydrogen is a highly flammable gas, and oxygen is a combustion supporting gas. A mixture of the two gases produces a potentially explosive gas. In 1937, the Hindenburg, a large passenger airship filled with hydrogen, burst into flames as it was landing at Lakehurst, NJ. Hydrogen, leaking from the craft's gas chambers, mixed with oxygen in the air and ignited. The airship caught fire and came crashing to the ground, and thirty- five of the ninety-seven passengers and crew were killed in the disaster.[52]

Molecules are held together by the forces of attraction between molecules. Cohesion is the attractive force between like or similar molecules, and adhesion is the attractive force between unlike or dissimilar molecules. Cohesion and adhesion have important roles in art. The forces of cohesion hold paints together and give them their properties, their thickness or thinness and ease of application, and the forces of adhesion explain the attraction of paint for a canvas or another surface.

Materials react with each other in three different ways: they combine, they break apart or they switch places with each other. Thus there are three basic chemical reactions: combination, decomposition and replacement.

A combination reaction takes place when materials combine and produce another material. When heated, iron and sulfur combine and form iron sulfide.

$$\text{iron} + \text{sulfur} + \text{heat} ----> \text{iron sulfide}$$
$$\text{Fe} + \text{S} + \text{heat} ----> \text{FeS}$$

A decomposition reaction takes place when a material separates into its component materials. When water decomposes, hydrogen and oxygen form.

$$\text{water} ----> \text{hydrogen} + \text{oxygen}$$
$$2H_2O ----> 2H_2 + O_2$$

A replacement reaction takes place when materials switch places with each other. When hydrochloric acid is added to zinc, the zinc and hydrogen switch places. Zinc chloride is produced and hydrogen gas is released.

hydrochloric acid + zinc ----> zinc chloride + hydrogen

$$2HCl + Zn ----> ZnCl_2 + H_2$$

In the above reactions, the numbers in front of H_2O, H_2 and HCl are balancing numbers, and they show proportions. All chemical reactions occur proportionately, and the amount of substances reacted, must equal the amount of substances released. The amount of water (H_2O) reacted must equal the amount of hydrogen and oxygen (H_2 and O_2) released. And the amount of hydrochloric acid and Zinc (HCL and Zn) must equal the amount of zinc chloride and hydrogen ($ZnCl_2$ and H_2).

In the eighteenth century, Antoine Lavoisier conducted meticulous experiments and established that chemical reactions occur proportionately and mass is neither created nor destroyed. This concept, known as the Law of Conservation of Mass, is important in science and explains the use of balance numbers in chemical equations. Lavoisier's wife, Marie Anne, assisted him and kept careful notes of their scientific work. In 1788 she commissioned her drawing teacher, the well-known Jacques Louis David, to paint a large portrait, *Antoine Lavoisier and His Wife*. It pictures Marie Anne standing next to a seated Antoine and shows the scientific attributes of their time. A barometer, gasometer, still and bell jar are on the table and a large round glass flask sits on the floor. While Lavoisier made significant contributions to science, he was also a tax collector for the French government and spent twenty years of his life extracting taxes from the public. During the French Revolution, he was arrested, brought to trial, convicted and guillotined. A few years later, he was exonerated and his wife received a note admitting the error of his execution.[53]

Compounds are classed as acids, bases and salts. Acids contain hydrogen (H^+) ions, have a sour taste and react with many materials. They also turn litmus indicator pink. (Litmus is one of a variety of chemical indicators that respond to the presence of acids and bases and change color.) Acids are used in the production of paper, paints and plastics and in the etching of metal and glass. Some common acids are hydrochloric, sulfuric, nitric, citric (in citrus fruits) and acetic (in vinegar). Bases or alkalis are compounds that contain hydroxide (OH^-) ions, have a bitter taste, have a slippery texture, react with many materials and turn litmus indicator blue. They are involved in the making of paper, cement, mortar, plaster and glazes. Some common bases

are sodium hydroxide (lye), potassium hydroxide, and ammonium hydroxide. Acids and bases vary in their strength, and some are strong while others are weak. The relative strength and weakness of acids and bases is determined by measuring the concentration of H^+ ions with a pH meter, and using a scale of numbers from 1 to 14. As the numbers go from 1 to 7, the strength of an acid (acidity) decreases, thus an acid with a pH of 2 is a stronger than one measuring 5. As the numbers go from 7 to 14, the strength of a base (alkalinity) increases, so a base with a pH of 11 is stronger than one with an 8. A material with pH of 7 is between an acid and base and is neutral. Distilled water has a pH of 7, hydrochloric acid has a pH of 1, lemon juice ranges between a pH of 2 - 3, tomato juice between 4 - 5, ammonium hydroxide 11-12, and concentrated sodium hydroxide 13 - 14.

When acids and bases react, they neutralize each other and produce salts and water. Examples of salts are sodium chloride, calcium carbonate and potassium nitrate.

Compounds are classed as either organic or inorganic compounds. Those with carbon (and hydrogen) are organic compounds, and those without are inorganic. Millions of compounds contain carbon and hydrogen, for example hydrocarbons, alcohols, ethers, esters, ketones, aldehydes, carbohydrates, proteins, lipids, steroids and DNA. Many organic compounds are found in living organisms and involved with life processes, and others are materials of the art world, including linseed oil, acrylics, resins, plastics, shellac and turpentine.

The carbon atom has four electrons in its outermost shell, and it is able to share its electrons with other atoms to build molecules. When carbon shares its electrons with other carbon atoms, it can form large molecules with hundreds, thousands and even millions of carbon atoms arranged in a variety of complex structures as long chains, branching chains, rings, clusters of rings, globules and helixes.

When repeating units of smaller organic molecules join, a larger molecule, a polymer, forms, and the process is known as polymerization. Starch is a polymer, a large molecule composed of repeating units of smaller glucose molecules. Polyurethane, polyester, polyvinyl acetate and nylon are other polymers. When oil and acrylic paints dry, the smaller molecules within the paints join, polymerization occurs and a paint film of larger molecules forms.

Materials are the things of composition and the things used to create art. Science studies them to determine their physical and chemical properties, and art uses them and their properties in its creative activities.

CHAPTER 6
PAINT AND PAINTING

———— ◈ ————

"Painting is silent poetry."
~ *Simonides of Ceos*

THE ART OF PAINTING BEGAN THOUSANDS OF YEARS AGO and continues to be popular with today's artists. It has a rich history and includes the materials and techniques of watercolor, gouache, encaustic, fresco, tempera, oil and acrylic. To understand the art of painting, it is necessary to explore the materials and techniques involved and the science behind them.

The principal material of painting is paint, and it consists of pigments suspended in a binding medium. To prepare paint, pigments are ground into particles and added to a binding medium, like gum arabic, linseed oil, wax, water or egg yolk. Binding media or binders hold the pigments together and attach them to painting surfaces. Pigments are the materials that give paints their color. They absorb and reflect light, and the color they have depends upon the wavelengths of light they absorb and reflect. (More on this in Chapter 11.) Some pigments are inorganic materials and others are organic. Titanium white, composed of titanium dioxide (TiO_2), is inorganic as is the old lead white pigment, which is no longer used because of its association with lead poisoning. Cobalt blue, favored by Pierre Auguste Renoir, is also inorganic, while pthalocyanine green, a bright blue-green pigment, is organic. Some colorants are natural and date back to

antiquity, like hematite or red ochre, burnt umber, cinnabar, lapis lazuli and malachite, while most of today's pigments are synthetic. Cadmium red, for example, is a synthetic pigment manufactured from cadmium sulfide and cadmium selinide. Some pigments are lightfast, that is, stabile and retain their color, while others loose their color and fade over time. The degree of lightfastness of a given pigment depends upon its chemical composition, its concentration and its binding medium.[54]

Paint is applied to a surface called a support, often made of paper, canvas, wood, stone or metal. Before painting, the surface is traditionally prepared to receive the paint, and a coating of ground or primer is added to give the surface a uniform texture and reduce the absorption of paint. Canvas is coated with a dilute glue or resin sizing, often followed by a covering of gesso (a mixture of plaster of Paris, chalk or whiting with glue), and wood is coated with a covering of gesso. After hardening, the surface is sanded to a smooth finish. The sized / gessoed surface is the ground on which the painting is done. The preparation before painting is important, and if it is not done properly or not done at all, it can affect the longevity of the work.

Paper is a felted mass of cellulose fibers from wood and other plant materials. The process of making paper involves pulping the fibers, blending them with water, adding sizing, removing water, pressing and drying. The paper forms as fibers align with other fibers into a felted mass, with texture and absorbency determined by the particular method of paper making. Sizing controls the absorbency of the paper. Originally sizing was rosin mixed with alum, but both affected the permanence of the paper. The rosin darkened the paper and caused it to become brittle, and the alum made the paper acidic. Current sizings have a neutral pH and do not harm the paper. Older papers produced from raw wood pulp contained lignin, and over time they turned yellow, but the newer ones are more stable. Varieties of paper are prepared from other materials. Papyrus comes from the pith and stems of the papyrus plant, vellum from specially processed calfskin and parchment from goat or sheepskin.

Canvas is a woven fabric made of linen, cotton, polyester or other material and has a variety of textures and weaves. Linen is a natural fabric produced from the long fibers of the flax plant and is a strong, durable and stable material for painting. Cotton, another natural fabric, is made from the fibers of the seed pod or boll of the cotton plant. Both linen and cotton fibers are composed of cellulose, a natural polymer made of repeating units of $C_6H_{10}O_5$. Polyester, on the other hand, is a "man-made" fabric produced from the fibers of a synthetic polymer, and it is more durable than linen or cotton, absorbs little moisture and holds its shape. To make a canvas support for painting, the fabric is pulled

tightly over a wooden stretcher and firmly attached to it. A taut canvas is a good support for painting, while a flexible one can damage the paint surface.

Wood provides a rigid support for paint, but it responds to moisture and changes shape. It expands when it absorbs water and shrinks when it looses water, and this movement can crack brittle paint layers and cause other damage. To prevent this, wood is dried or seasoned before it is used. Freshly cut wood or green wood contains a great deal of water and is dried to reduce its water content to that of the surrounding air. The seasoning is accomplished by placing the wood in a kiln and using heat or by stacking the wood and allowing it time to dry.

Watercolor is a painting technique that applies thin layers of paint mixed with water to a paper support. The paint consists of powdered pigments dispersed through several water soluble materials, with gum arabic for binding and glycerine to delay drying. It also contains a wetting agent, a plasticizer, a preservative and sometimes a thickener. A specially produced handmade paper is often used, one that has texture and sizing to reduce the absorbency of water. Working with watercolor involves mixing the paint with water and applying it to paper in thin layers. Watercolor dries by evaporation, a physical change. As the water evaporates, the paint adheres to the paper. Color can be built by adding more thinly painted layers, and the dried paint can be reworked by adding water. This allows the painting to be changed and modified with more paint and water, water washes and sponges. Watercolor is a technique that involves the overlaying of thin transparent layers of color on paper. When light is absorbed and reflected by the pigments, it is highlighted by the color and texture of the paper.[55] Winslow Homer was an artist who fully understood the subtle nuances possible with watercolor. He painted what he saw of the Civil War and the sea and rendered scenes filled with rhythm, energy, boldness, excitement and luminosity. They were vibrant compositions with colors emanating from the paint and the underlying paper. Charles Burchfield's watercolors took advantage of the colors and transparency of the medium. He created mysterious buildings, trees, flowers and insects that were surrounded by auras and shrouded with dark jagged lines.

Gouache is similar to watercolor and made from the same substances. Both watercolor and gouache are water based and dry by evaporation, but watercolor is transparent and gouache is opaque. To remove the transparency, white materials, like barium sulfate ($BaSO_4$) or chalk ($CaCO_3$), are mixed with the watercolor, and other materials are used to thicken and change the consistency of the paint. Gouache colors provide flat uniform areas of color and are often used to create body or flesh tones.[56] James Tissot painted with

gouache and did a series of illustrations, in rich life-like colors with precise detail, based on stories from the Old and New Testaments.

Encaustic is a painting technique using melted wax and dates back to antiquity where it was used to color statues and buildings. Pigments are stirred into molten wax and mixed. (Wax is a lipid produced by bees and other living things. Paraffin is a petroleum based hydrocarbon.) The colored wax is applied to a primed surface while hot, built up in layers and worked with tools. When the surface is heated, the wax colors fuse and adhere to it. Heating and cooling are physical changes. The hardened surface of the finished encaustic is unaffected by atmospheric changes and is quite permanent if not subjected to high temperature, but it is delicate and requires protection from abrasion. The transparent properties of the wax give the painting a radiant quality. Romans living in Egypt had encaustic portraits painted on wooden panels. They were handsome images of people in their prime and were displayed in homes, and upon death they were attached to mummy cases.[57] The contemporary artist, Jasper Johns, has used the wax technique to create textured surfaces and painted targets, numbers, flags and abstractions.

Fresco is a technique for applying paint to a freshly plastered wall. The pigments are mixed with water or limewater and painted onto a thin layer of *wet* plaster. The paint and the plaster chemically combine to form a colorful and durable surface that resists aging. Fresco is an exacting technique, and assistants are often enlisted to help with the process. Before the painting begins, the wall is prepared. Several thin layers of a lime plaster composed of lime putty, sand and sometimes marble dust are applied. (Lime putty is a soft paste of slaked lime or calcium hydroxide made from lime (CaO) mixed with water.) Each layer is allowed to dry before the next one is laid down. Then the compositional drawing or cartoon is transferred to next to last layer. The final plaster layer or paint layer is applied daily as the painting progresses, and only enough plaster for a day's work is put on the wall. Because the plaster contains lime and is caustic and alkaline, the pigments must be alkali fast. When the day's painting is finished, the unpainted portions of plaster are removed from the wall. Fresh plaster is added for every painting session, and the joins between the plaster are carefully planned to follow the lines of the composition. As the paint is absorbed into the wet plaster, the pigments bond with the plaster to form lime carbonates, a chemical change. This technique is known as *buon fresco* or true fresco and is not the same as *secco fresco* where the pigments are applied to *dry* plaster. Fresco painting is a time- honored way of painting that reached its zenith with the Italian masters. Some of the best known are those by Giotto di Bondone in the Arena Chapel in Padua,

Masaccio in the Santa Maria del Carmine in Florence, Raphael Sanzio in the Stanza of the Vatican and Michelangelo Buonarroti in the Sistine Chapel.[58]

Tempera is a technique using a paint with pigments dispersed in an emulsion. Tempera paintings are meticulously executed, with paint applied in small brush strokes that are layered and cross-hatched. The colors retain their integrity and do not blend with each other. When egg yolk is mixed with pigments and water, it forms a water soluble tempera that holds pigments together and attaches them to the ground. Freshly applied tempera dries quickly by water evaporation and forms a fragile film. Over time the oils and proteins in the egg yolk undergo chemical changes and harden into a durable surface. Tempera is usually painted on a support primed with gesso and buffed to a soft finish when dry. It is best applied to a rigid support like a wooden panel rather than a canvas which can be too flexible to hold the paint film. A layer of color or underpainting is often added, and the transparent properties of the tempera allow the underpainting to add color shading to the finished work. Egg tempera is the most common type of tempera, but there are other emulsions with oils, resins, gum arabic, glycerine and glues, and each one is different. For instance, the use of oils and resins in tempera slow the drying process and permit more time for paint manipulation. (Sometimes poster or show card colors are incorrectly called tempera paints. They are instead opaque colors with water soluble binders and have none of the properties of real tempera.) Egg tempera painting originated in medieval Europe and was a popular technique until the development of oil painting.[59] *The Birth of Venus* by the Florentine, Sandro Botticelli, is an egg tempera on canvas instead of the usual wood. It is a delicate, detailed and sensitive representation of a story from classical mythology. Andrew Wyeth worked with tempera, and in 1948 he painted *Christina's World*, a realistic painting with light reflecting brilliance and a mysterious quality.

Oil painting is a technique using pigments suspended in oil. It was developed in Northern Europe over a period of about a hundred years between the fifteenth and sixteenth centuries. Because of its versatility, it quickly became the medium of choice for artists. Oil paint is made by grinding pigments into particles and mixing them with a drying oil like linseed, walnut, poppy or safflower oil. A drying oil is an oil which will dry into a film. The paint surface, the canvas or wood panel, is coated or primed. Then the colors are mixed and blended with each other to produce the desired effects and added to the surface with a brush or palette knife. The paint is applied thinly and built into layers or thickly with strokes of impasto. Oil paint is insoluble in water, so it is thinned with mineral spirit

or turpentine.(Mineral spirit is a petroleum product, and turpentine comes from pine trees.) The color of the ground, white or toned, contributes to the color mix of the painting. The oils envelop and protect the pigments and act as an adhesive to hold them to the ground, and they give the oil paint its characteristic depth of color and luminosity. Time is required for drying, and in the interval, the wet paint can be worked and reworked, and the volatile materials released. Slowly the oil paint changes from a liquid to a solid and forms an irreversible film, one that can not be returned to its former liquid state. The separate molecules of oil join and form a film.[60] Drying oils are unsaturated oils, polyunsaturated oils, and they combine with oxygen and become saturated. The smaller oil molecules become linked by oxygen atoms and form larger molecules (polymers) and then crosslink with others to form a network of molecules. The process is polymerization, specifically auto-oxidative polymerization. Wow! How's that for vocabulary?

Polymerization is a chemical change, and it creates a film with physical and chemical properties different from the original ingredients in the paint. This film, in turn, gives the oil painting its unique characteristics. Thus an oil painting dries by polymerization and not evaporation. After drying a protective varnish is often applied over the paint.[61] The paintings of Jan Vermeer and Rembrandt van Rijn illustrate the complexities possible with oil paint. Vermeer developed a mastery of light by subtly varying color and created a play of natural light across his paintings. His spaces were softly lit, and his shadows filled with gentle color. The pearls adorning his subjects were a study in shimmering luminosity, with a radiance and luster of their own. Rembrandt was interested in light and shadow and their combined effect to create space. He handled paint boldly to build surfaces with thick layers of paint that he scraped, worked and reworked, and he used paint gently to produce delicate laces and jewelry.

Acrylics are made from paints with pigments suspended in an acrylic polymer resin. Acrylic paints came into existence in the 1950s and are the product of modern chemistry. Sometimes they are called polymer paints, because they form films by polymerization. The films are flexible, waterproof and non-yellowing and are permanent and not subject to chemical changes. They are also sturdy and can be scraped, mixed with fillers, textured and layered. Acrylics dry quickly, and this property limits the time they can be manipulated. However they are versatile art materials and are used in washes like watercolor and in thick applications like oil paint.[62] Helen Frankenthaler worked with acrylics and created a number of impressive paintings using them. She started with large pieces of unprimed canvas and placed them on the floor.

She thinned the paint she used and applied it generously, sometimes even pouring it onto the surfaces. Then she got down on her knees and worked the paint with sponges, brushes and squeegees. The paint behaved like a stain and soaked into the canvas. In places where the patches came together, the colors mixed and blended in a manner similar to watercolor. Sylvia Plimack Mangold produced a series of paintings that show meticulously rendered wooden floors. Using acrylic paints, she was able to create the illusion of real floors with thick applications of paint. The detail and tactile quality of her work in acrylic is comparable to that of fine oil painting. Linda Besemer uses acrylics to create glossy sheets of color. She applies layers of the material to smooth surfaces and allows time for drying. Then she peels the films from the surfaces and displays her "support-free" sheets on rods or floors.

The art of painting involves the use of materials and techniques related to science. When the materials and techniques of painting and the science behind them are explored, connections between them are discovered.

CHAPTER 7
SCULPTURE

"The marble not yet carved can hold the form
of every thought the greatest artist has."
~ Michelangelo Buonarroti

SCULPTURE, LIKE PAINTING, BEGAN THOUSANDS OF YEARS AGO. It continues to be popular and includes the materials and techniques of carving, modeling, assembling and casting. To understand the art of sculpture, it is necessary to explore the materials and techniques involved and the science behind them.

Granite, limestone and marble are stone materials that can be carved with special tools and assembled into sculpture. Stone materials are the result of geologic activity and are quarried from the Earth. Granite forms when molten rock solidifies and is composed of feldspar and quartz, minerals rich in silicon and oxygen compounds. While limestone is the result of sedimentation and has the crystalline structure of calcium carbonate ($CaCO_3$) or calcite. When limestone is subjected to heat and pressure over a period of time, it can transform into marble, also made of calcium carbonate.

Wood can also be carved and/or assembled into sculpture. It comes from the trunks and branches of cedar, pine, elm, oak and mahogany trees, and each variety has a characteristic appearance and grain that reflects its pattern of its growth.

Metals of all kinds are used for sculpture. They are malleable and can be bent and shaped into different forms, and they can be melted and cast into forms. They can also be assembled into compositions and welded with intense heat. Some metals are elements, like iron, copper, lead, and gold, and others are combinations of elements or alloys. Bronze is a strong and hard alloy of copper and tin, and it is a popular choice for casting sculpture. Varieties of bronze are made when the ratio of copper and tin is varied and when small amounts of zinc and phosphorus are added. Another alloy of copper is brass, a mixture of copper with zinc. Steel is an alloy of iron with carbon, and stainless steel is an alloy of steel with chromium and nickel added to the mix.

Waxes, plaster and clay are also used for sculpture. Waxes are natural materials produced by a variety of plants and animals, most commonly bees. They are lipids and have a chemical composition different from paraffin, a petroleum-based hydrocarbon. Waxes melt at low temperatures and solidify easily, and because of this they are used in the casting of sculpture. Plaster, specifically plaster of Paris, is made from gypsum, a hydrated form of calcium sulfate. First the gypsum is gently heated to remove most of its water and ground into a powder. Then water is added to the powder to form a paste. As the paste sets, it becomes plaster, a solid mass of interlacing gypsum crystals. Plaster of Paris sets without shrinkage and produces a firm hard material, good for casting and carving sculpture. Clay is a material composed of complex silicon and aluminum compounds bound together with water and comes in many varieties. Moist clay is soft and plastic and can be modeled into shapes. As it dries, it hardens and is then fired in a kiln.

Amber is soft sculptural material that can be carved or cut into thin sheets and polished to a high luster. It is the fossilized resin of trees and often contains the remains of ancient insects. *(Jurassic Park,* the popular science fiction novel, written in 1990 by Michael Crichton and later a sci-fi film, dealt with dinosaurs cloned from DNA preserved within the bodies of mosquitoes imbedded in amber.)* In the early 1700s, Prussian King Frederick William I gave the Russian Czar, Peter the Great, panels of wood covered with sheets of intricately carved and inlaid amber. The sheets were installed onto the walls of a room in the Catherine Palace near Leningrad (now St. Petersburg). This room, with its rich adornment of amber, became known as the Amber Room and was considered by some to be the eighth wonder of the world. During the World War II German occupation of Leningrad, the amber was stripped from the walls of the Palace and disappeared. The sole record of this once glorious space was a few photographs. Years later a resourceful restoration team, with high-tech equipment, used the photos as guides and created a

reproduction of the Amber Room.[63]

Cloth is an everyday material, and it is used to fashion not only clothing but also sculpture. Cloth is cotton from a plant, wool from an animal, silk from an insect and felt from a process. It is woven, cut, sown or embroidered, and it is plain, painted or printed. Claes Oldenburg, the pop artist, worked with cloth and created large soft sculptures of cakes, breads, hamburgers and bathroom fixtures. As a young person, Louise Bourgeois often assisted in her family's tapestry business and was familiar with cloth. Then she went on to become an artist and painted, constructed wooden sculptures, carved marble and cast metal. In her later years, she returned to cloth and stitched figures with ambiguous meanings. Robert Morris used cloth and created a series of works that followed the industrial tradition of minimalism. They were cut from heavy-duty black felt, folded and attached to walls.

Antler, ivory and jade are other materials used for sculpture. Antler is a bony material produced by male deer that is shed annually. The cave dwellers of prehistoric Europe collected the antlers and cut them into animal figures with flint tools. Ivory is a hard calcareous material from the tusks of animals and requires sharp tools for carving. In the nineteenth century, sailors made delicate scrimshaw objects from whale ivory. Jade is an exceptionally hard material composed of silicon bearing minerals, either jadeite or nephrite. It is difficult to carve, but the skillful artists of Asia and Mesoamerica managed to shape it into intricate pieces.

Sculpture is carved. Carving is a subtractive process that removes pieces of the original material as the sculpting takes place. It involves the use of chisels, gouges, knives, rasps, files and mallets that cut, chip and pound directly into the material. In ancient Egypt sculptors made statues of their royalty from granite and limestone blocks. They worked in teams. First draftsmen applied grids of horizontal and vertical guidelines to the sides of stone blocks. Then stonemasons chiseled and worked the views into each other and produced figures with stiff block-like appearances. As the work progressed, details were added, and the figures were smoothed and polished. Many were coated with a thin layer of gesso and painted and/or decorated with gold leaf, much of which did not stand up to the test of time. Michelangelo Buonarroti carved *David* from a large block of marble, one that was allotted to but abandoned by another sculptor as too difficult to carve. Marble is a hard stone, but as the artist chipped away, the block yielded and gradually a young David emerged from the cold white crystalline stone. From a single piece of Carrara marble, the artist created a realistic figure filled with the restless energy and confidence of youth. He used his skill as a sculptor and his knowledge of anatomy to tell the story

of a Biblical hero. The statue is over 13 feet (4 m) high and is monumental in both size and spirit.[64] Fifty years earlier, Donatello sculpted *Mary Magdalene* from a chunk of wood. It is a representation of a woman with a gaunt face and figure. who appears to be tormented and filled with pain and sorrow. The sculpture is life-size, just a little over 6 foot (1.9 m) tall, carved from the wood of a white poplar tree and covered with gesso. It is a Renaissance sculpture, over five hundred years old, but it is interesting to consider this piece in the context of twenty-first century contemporary art. It is a sculpture with dramatic and unsettling qualities, and it invites the viewer to ponder its meaning.[65]

Sculpture is modeled. Modeling is an additive process that builds and enlarges form as the sculpting progresses. Clay, wax and other plastic materials are pushed and manipulated into shapes that are often built around a skeleton or an armature of wire or other rigid supporting material. Alberto Giacometti pressed clay onto armatures and made thin elongated forms with tactile surfaces. The emaciated figures he created have a quality, an individual loneliness, and seem to inhabit a world of their own. Edgar Degas is known for his paintings and pastels, but he was also a sculptor. In the 1881 Impressionist Exhibition, he displayed *Little Dancer, Aged Fourteen*, a tinted wax sculpture adorned with a dancer's costume and wig. The work was sharply criticized, and as a result, he never exhibited sculpture again. However Degas did continue to sculpt and share his work with friends and colleagues. The sculptures were small and delicate forms, modeled in soft wax over armatures of cork, wood or metal. They were studies and never intended to be statues. Following the artist's death, authorization was given by his heirs, and the fragile wax horses, dancers and women bathers were cast into bronze statues.[66]

Sculpture is assembled. Materials of any sort, including random and discarded objects, are gathered and combined into three dimensional compositions. The assembled parts become a sculpture that is greater than the sum of its parts. Anthony Caro created metal constructions from industrial objects, such as tubes, girders, beams, plow blades, plates, tank sections and the like. He arranged the metal pieces into integrated compositions, welded them together and painted them with a single color. Louise Nevelson collected materials from her environment and assembled them into large wall-sized sculptures. She stacked boxes and filled them with chair legs, table pedestals, cash register drawers, felt hat blocks and scrap, and then she spray-painted them either black, gold, red or white. Her use of a single color unified the assembly of tell-tale objects and gave them elegant and majestic qualities.

Sculpture is cast. Casting involves making a mold of an original

sculpture, then creating a cast from the mold. The process is done in a foundry by metal workers under the supervision and assistance of the artist. The most common method of casting is the lost wax process or *cire perdue*. It is a very time consuming and expensive process, but one that produces high quality hollow metal casts, usually made of bronze. First a plaster cast of the original stone, wood, plaster, clay or wax sculpture is made, and then a hollow mold, a negative mold, of the plaster cast is made. The inside of the mold is coated with wax to form a hollow wax model, the thickness of which determines the thickness of the finished cast. The interior is filled with a core of foundry sand or clay, and tubes are attached. The figure is encased or invested in clay or plaster, and the entire form is baked in an oven. As wax melts and flows out through venting tubes, it is "lost" from the mold. The mold is covered with sand and bricks for support, and molten metal is poured through tubes into the space previously occupied by the wax. When the molten metal cools and solidifies, the mold is opened, and the cast is removed. The remnants of the sand and the tubes are cleared away, and the cast is hand finished or chased. For protection and artistic effect, a chemical finish or patina is added to the surface of the bronze. The finish applied varies from foundry to foundry, and it can be an antique or colored finish or one that duplicates the greenish color of the naturally occurring corrosive patina.

Auguste Rodin modeled his figures in clay, a technique which enabled him to capture the vitality and emotion of his subjects. Then the clay figures were translated into plaster models for casting. When orders were placed, bronze casts were made from the plaster models using the *cire perdue* method. Rodin's sculpture was popular, and various foundries produced casts of his work to satisfy the demand. During the nineteenth century, Rodin was regarded as one of the greatest sculptors, and an entire pavilion at the 1900 Paris World Exposition was dedicated to his work.[67]

Many of Rodin's works were issued as either enlargements or reductions of the original sculpture. Initially *The Thinker* was one of the figures in the ensemble, *The Gates of Hell*. It was only 28 inches (71 cm) high, but it was enlarged and made into a freestanding statue. The enlargements and reductions of Rodin's work were made using a Collas machine, a device with turntables and adjustable rods for enlarging and reducing scale. The original was placed on one turntable, a blank roughly resembling it was placed on the other, and the turntables were rotated. A technician traced the original with a needle, and its scale was enlarged or reduced by adjusting rods to a larger or smaller size. The measurements were transferred to the blank, and a series of profiles were cut with a sharp instrument. When all the cuts were made, the

piece was carefully finished to the artist's satisfaction.[68]

Many consider Henry Moore to be the most important sculptor of the twentieth century. His work ranged from realistic to abstract as he investigated the relationship between mass and space and the influence they had on each other. When artists design sculpture, they often start with sketches or models, carved from plaster or modeled in clay or wax. Moore produced plaster maquettes, small three dimensional models. Then assistants made large plaster versions of the maquettes, and from these, they cast the bronze statues. Moore was a versatile sculptor and created statues from wood and stone also.

Some sculpture is freestanding. It has form on all sides (front, back, left and right) and is planned for view from all sides. This is known as sculpture in the round. The Egyptian statues, *David, Mary Magdalene, Little Dancer, Aged Fourteen*, Caro's steel constructions and Giacometti's emaciated figures are examples of sculpture in the round.

Other sculpture is flat with projecting figures. This is relief sculpture, and the degree of projection varies from relief to relief. Those with little projection are low relief or *bas* relief, while those with great detachment are high relief. The ancient Assyrian limestone and alabaster panels are low relief and show images of kings, deities, campaigns, conquests, hunts and rituals locked in stone. Using a language of stylized forms and stiff figures in profile, they tell stories of people in feathery costumes with wavy hair and beards, winged beasts with human heads and chariots drawn by teams of multi-legged horses. The Chartres Cathedral in France is lavishly decorated with relief sculpture, much of it carved from stone in high relief. The portals or door ways and the arches and tympana above them are covered with figures from the Old and New Testaments. On the Yucatan Peninsula, the pyramids and temples of Mesoamerica are richly adorned with the reliefs of people, plants and animals, and some have huge serpent heads that leap from the stone. The reliefs from the Amarna Period in ancient Egypt have figures cut *into* the stone, and many of the temples have incised images of King Akhenaten and Queen Nefertiti.

The Baptistery is located in the center of Florence and is part of a complex of buildings near the Cathedral or Duomo. A competition was held to design a set of doors for the Baptistery, and Lorenzo Ghiberti was the winner. The doors took a number of years to complete, and the Florentines were pleased with the results. Then Ghiberti was asked to design another set of doors, this time for the east entrance to the Baptistery, the one directly across from the Cathedral and the most important entry into the Baptistery.

Ghiberti selected stories from Genesis and represented them in ten panels, five on each door. The panels were only an inch deep but had the illusion of depth created by the combination of perspective and low relief. The gilded bronze doors were provocative, and it was said Michelangelo proclaimed them "so fine that they might fittingly stand at *the Gates of Paradise*." Thus the doors became known as *The Gates of Paradise*.[69]

The art of sculpture involves the use of materials and techniques related to science. When the materials and techniques of sculpture and the science behind them are explored, connections between them are discovered.

CHAPTER 8
DRAWING AND PRINTMAKING

"Art is born of the observation and inspection of nature."
~ Marcus Tullius Cicero

DRAWING IS AN ART FORM concerned with the placing of marks on a surface. It involves line, an element of art that deals with edge, outline, shape and form and is used to define space and create the illusion of depth. Drawing is done on a variety of surfaces that offer color and texture, including paper, cloth and wood, and when finished, it may be a complete work, a study for another work or an underdrawing for a painting. Sometimes it is spontaneous and rapidly executed and used by the artist to record observations of people, things and phenomena. The art of drawing involves the use of materials and techniques related to science.

Drawings are made with pencil, most commonly a "black lead" pencil. This pencil is made of graphite and not lead, but it acquired the name because graphite was originally called black lead. Graphite is a soft crystalline form of the element carbon and has a layered structure. Weak bonds between the layers give the graphite its greasy texture and allow it to slide over surfaces and be a good material for drawing. To make pencils, clay is mixed with the graphite to provide hardness and hold it together. The proportion of clay to graphite determines hardness: the more clay added, the harder the pencil. The graphite and clay mixture is then extruded into thin cylindrical sticks, fired in a kiln, dipped in wax for smoothness and encased in a holder for use. Pencils come in

a variety of sizes, shapes and hardness for the drawing of lines and creating the effects of cross-hatching and shading. Colored pencils are made with sticks of lightfast pigments mixed with a filler, a binder and wax. The colored sticks are not fired because heat damages pigments.[70]

Drawings are made with pastels and crayons. Pastels are sticks of powdered pigment mixed with chalk and binder, and they come in a variety of sizes, shapes and degrees of hardness. Sometimes pastels are called chalk, but strictly speaking chalk is just calcium carbonate with nothing added. The pastel is applied directly to a surface, built up in layers and blended by rubbing. When finished, it is powdery and fragile and needs the protection of a gentle fixative spray to prevent it from dusting away. It also requires proper framing under glass with a mat thick enough to prevent contact with the glass. Oil pastels are mixtures of pigments, hydrocarbon waxes and animal fat. The oil pastel mix is heat sensitive, and its application is affected by temperature. A pastel stick is often called a crayon, the generic term for any drawing material in stick form. Conté crayons are a special brand that features square sticks in a variety of colors. They are composed of compressed pigments and binders, and they are firmer than pastels and produce less dust.[71] Edgar Degas worked with soft pastels and created delicate and colorful scenes with ballerinas. The powdery quality of the pastels and the ease with which the colors blended allowed him to capture the beauty of ballet in gentle shades.

Drawings are also made with charcoal, ink and metalpoint. The charcoal sticks for drawing come from wood, specifically willow twigs, that are heated to a high temperature in containers with sand to exclude air. As the volatile materials are released, charcoal, a non- crystalline amorphous form of carbon, is produced. (Heating a substance in the absence of air is known as destructive distillation. A similar process is used to make coke from the softer varieties of coal.) Charcoal lends itself to strong and soft lines, to the blending of light and dark and to erasing and reworking. Like pastel, the surface is fragile. It smudges easily and needs the protection of a fixative spray, usually a resin in a rapidly evaporating solvent, and protective framing. Drawing ink has fine carbon particles dispersed in an aqueous binder with a wetting agent and a preservative. When ink drawings are made with pens, they have sharp lines, and when they are done with brushes, they have fluid contours. Metalpoint is a drawing technique that uses a metal wire made of silver, gold, copper or tin to make colored marks and lines on a surface or piece of paper. Over time, colored lines tarnish (oxidize) and change color.[72]

Our ancestors, those who lived 30,000 years ago, covered the walls of Northern European caves with representations of bison, deer and horses.

They drew figures with lines that gave shape and defined form, and they filled them with color and spots. The early materials were natural and came from the environment. The black pigments were made of manganese and the red, yellow and brown ochres came from iron bearing ores. Before application, the pigments were sometimes moistened and held together with animal fat.

Leonardo da Vinci's cartoon, his full size drawing, *The Virgin and Child with St. Anne and the Infant St. John*, is an example of skilled draftsmanship. The piece was drawn on brown paper using charcoal highlighted with chalk. The properties of the charcoal permitted the artist to add detail and softness as he modeled the delicate features of his subjects, and it enabled him to create a refinement comparable to that of a painted masterpiece.[73]

Sol LeWitt was interested in ideas, and he created instructions for large-scale wall drawings that he himself almost never executed. They were straightforward directions for assistants, art students, artisans and others to follow, and they depended upon the skill of the people carrying out the work. They involved the drawing of curves and the placing and spacing of lines multiple times. The concept for the drawing was LeWitt's, but the interpretation was that of others with plenty of room for individual draftsmanship. The assistants usually worked in teams, and every drawing was a unique presentation of the idea. LeWitt's wall drawings have been installed hundreds of times and are currently on display in a long-running retrospective at the Massachusetts Museum of Contemporary Art (MASS MoCA) in North Adams.[74] In 2006 LeWitt was commissioned to create a wall drawing for the Albright-Knox Art Gallery. He sent representatives from his studio to the museum to take photographs and then selected the stairwell between first and second floors with its 2200 square feet of wall space for his drawing. (This was the same site that Judith Pfaff used for her 1982 installation, *Rock / Paper / Scissors*.) LeWitt died in 2007, and the actual installation, the massive graphite drawing or "scribble drawing," as it became known, was created in 2010 by a team of 16 people who worked on scaffolds for 54 days and over 5000 hours.[75]

Robert Mangold is also interested in ideas and expresses them with line and color. He starts with an idea and does experimental sketches to see if it will work. As the project continues, he makes further sketches, adds to them and eventually progresses to more detailed drawings. The drawings are done on paper with graphite and black pencil. He begins with a penciled grid to define the space and then intuitively draws lines that glide across the surface, guided but not controlled by the grid. When this is finished, he adds soft pastel color and blends it with a paper towel. Mangold's finished

drawings on paper are complete works of their own, but they may also serve as studies for future paintings.[76]

Ingrid Calame is interested in the marks and stains left by people in public places. She begins by studying a variety of places in search of a specific location with a distinct character, perhaps a parking lot or the floor of an industrial site. Then she works with a team of assistants to carefully trace the lines, shapes, marks and stains of the place onto sheets of architectural mylar, a polyester based tracing film. When this is completed, she goes to her studio and transfers the tracings to another sheet of mylar. The tracings are placed one on top of the other, and each one becomes a layer of the finished work. She draws the images on the final sheets with colored pencils, and each layer has a different color. When finished, the piece has the appearance of an abstraction, even though it represents the markings of a specific location and perhaps recalls the memory and the history of the site. Calame's work is about drawing, line and shape, and it defines space with layers of colored lines.[77]

Printmaking is an art form that produces multiple impressions from a master image. It became popular in the fifteenth century with the arrival of rapid low cost printing methods, the invention of movable type and the manufacture of less expensive papers. As the techniques of printing advanced, illustrations were produced with speed and economy. Craftsmen were the first to cut wood blocks and make prints, but soon artists became interested and added creativity and originality to the process. The art of printmaking involves the use of materials and methods related to science, and it includes the techniques of relief printing, intaglio (engraving and etching), lithography and serigraphy.

Albrecht Dürer used his artistic talents to make intricately designed and carefully executed woodcuts, engravings and etchings based upon Biblical stories. His work had a profound influence on printmaking, and he became one of the greatest printmakers of all time. His work was popular and purchased by both the rich and not-so-rich of Europe. Dürer's prints were easily recognized because they often bore his initials as a signature logo, an A with a smaller D inscribed below it.

Prints are made by artists or under the supervision of artists with the help of professional printmakers. Prints or impressions are sometimes called proofs and are often numbered and signed by artists. They are considered to

be original works of art, and they have become very popular in today's art market. Prints are less expensive than paintings, thus more people can afford them and become owners of original art.

Relief printing is printmaking from a block with a raised surface. The block is made of wood, linoleum or some other smooth surface. It is carved with tools, and areas are cut and gouged from it. The printing surface or relief is the raised part of the block that is left after the carving. Ink is rolled onto the raised surface. Paper is placed over the inked block and pressed, and the image is transferred to the paper. Relief printing pushes the raised surface with the ink into the paper and produces a printed image with a slightly recessed appearance. It is the oldest form of printmaking, and it was used by the ancients to transfer designs to textiles.[78] Hans Holbein, Paul Gauguin, Emil Nolde, Ernst Kirchner, and Kathe Kollwitz were important woodcut and relief printmakers.

The colorful woodcut or woodblock relief prints from Japan's Ukiyo-e period, with their everyday scenes, are well-known, especially those of Katsushika Hokusai and Utagawa Hiroshigi. This type of woodcut begins with the transfer of a picture to a block of fine mountain cherry wood by a woodcutter. The image is on a thin sheet of paper, and it is transferred in reverse. (In most printmaking techniques, the transferred image is reversed with right and left sides switched to make the printed picture correct.) The raised portion of the block is inked with a mix of watercolor and rice paste, and a moist sheet of handmade paper is placed on top of the block and padded down. The ink transfers to the paper, then the paper with the print is carefully pulled from the block. Every color within the print requires a separate woodblock, and sometimes a set with as many as ten different blocks is necessary. To keep the colors clear and separate from each other, the blocks are carefully aligned or registered. The blocks wear out with use, so the number of prints from a given block is limited.[79]

Intaglio is printmaking from the recessed areas of metal plates and includes the techniques of engraving and etching. Engraving is a physical or mechanical process for inscribing grooves into plates of copper or zinc using a variety of tools to incise the surfaces. When a sharp point is used, the lines are burred and produce a characteristic softness known as drypoint. When the surface is uniformly abraded, mezzotint, an effect with velvety tones, is created.

Etching is a chemical process for inscribing grooves into a metal plate. The plate is usually of copper or zinc, but other metals can be used. The plate is covered with a waxy ground or resist that literally resists the action of

the etching chemicals. The image is cut into the waxy ground with a special needle until the underlying metal is exposed. Then the metal plate is placed into a bath of dilute chemicals, and the chemical action of etching or biting begins. There is a varnish on the sides and back of the plate, so the etching materials only react with the image side of the plate. The etching chemical or mordant is any of a number of dilute acids and chemical mixtures that will react or "bite into" the plate. As the chemicals react with the exposed metal, lines are etched into the plate. If the plate is copper and the mordant is nitric acid, the chemical change forms copper nitrate, nitrogen oxides and water. The longer the plate stays in the bath the deeper the lines become, so during the etching process, the plate is removed from the bath and checked for progress. Varnish is used to stop the action in areas sufficiently etched, and subtle tones are rendered when the varnish is applied delicately. Other tonal qualities are created with the aquatint technique that places powdered resin on the plate before etching to produce finely textured tones that imitate a watercolor wash. When the chemical reactions of etching are finished, the plate is cleaned and made ready for printing.

Both engraving and etching produce plates with inscribed grooves, and the prints are made from the incised surface or the intaglio. Ink is rubbed across the plates and into the grooves, and the excess ink is wiped from the plate. Paper is placed on top of the inked grooves and rolled through a press. The pressure pushes the paper into the grooves where it picks up the ink, then the finished print is pulled from the plate. The intaglio printmaking technique lifts ink from grooves and produces a printed image with a slightly raised appearance.[80] Andrea Mantegna, William Hogarth, Mary Cassatt, and James Tissot are known for their engravings, and Edvard Munch, Rembrandt van Rijn and Francisco Goya for their etchings.

William Hogarth was a painter and an engraver who found fame and fortune depicting the colorful world of eighteenth century London. He was also a champion of British art and fought for copyright laws and exhibition space to advance the cause of English artists. His work usually started with a painting or a series of paintings based on a social theme, and his plates for engraving were created from these. His art was witty, satirical and moralizing, and his engravings were popular. Over the years countless numbers of his prints were made and sold.

Lithography is printmaking that produces a printed image with a flat appearance. Traditional lithography uses a stone to make prints, hence the name. The stone is usually a very fine grained limestone that is flat, ground smooth and free of grease. A drawing is made on the stone with a special

greasy crayon, and a weak solution of acid and gum arabic is applied to hold the greasy image to the stone. The stone is flooded with water, and the water is absorbed by the porous non-greasy portions and repelled by the greasy drawing. An oil based ink is rolled onto the stone, and the greasy image takes hold of the ink. (The ink is attracted to the greasy drawing and repelled from surrounding water soaked areas.) Paper is placed on the inked stone and rolled. The ink transfers to the paper, and the print is pulled from the stone. Multiple stones and printings are used to produce prints with more than one color. The technique works because grease and water do not mix. Specifically the molecules of the ink adsorb to the fatty acid molecules of the greasy crayon used for the drawing. (Adsorption is an attraction between molecules causing a thin layer of one substance to adhere to another substance.) Modern lithography uses an image made of a polymer coating on a flexible aluminum plate. The image can be printed directly or offset (transferred) to a rubber sheet for mass printing.[81]

Lithography was popular at the end of the nineteenth century, and Eugene Delacroix, Honore Daumier and Henri de Toulouse-Lautrec were the artists responsible. Using gentle caricature, Toulouse-Lautrec portrayed the personalities of those who frequented dance halls, theatres, brothels and cafés and created lithographs for the kiosks of Paris.

Serigraphy or screen printing is printmaking from stencils. A fine mesh, often of silk, is stretched over an open frame, and a stencil is applied to the mesh. Paper or another surface is placed under the mesh, and printing ink is squeezed through the mesh with a squeegee and onto the paper. Then the frame is lifted, and the print removed. Multiple screens are necessary for multiple colors. Screened prints are known as serigraphs and have a printed surface with a flat image.[82] In the mid part of the twentieth century, serigraphs became popular, and they were made by a number of artists including Andy Warhol, Richard Anuszkiewicz, and Victor Vasarely. Serigraphs are also printed on the T-shirts and sweat shirts for sports teams and special events.

Andy Warhol was the veritable icon of Pop Art. His paintings based on Campbell soup cans, Brillo boxes, flowers, Marilyn Monroe, Elvis Presley, Jackie Kennedy, Chairman Mao, the *Last Supper* and the *Mona Lisa* were well-known, and many of the images were transferred to serigraphs and issued in large numbers.

The art of drawing and the art of printmaking involve the use of materials and methods related to science. When the materials and techniques of drawing and printmaking and the science behind them are explored, connections between them are discovered.

CHAPTER 9
GLASS AND CERAMICS

"All the arts are brothers; each one is a light to the others."
~ Francois Voltaire

G LASS IS AN INTERESTING MATERIAL with unusual properties. It is firm like a solid, but in many ways it resembles a liquid. Ordinary solids, like copper, marble and sodium chloride, have molecules that are packed together and vibrate around fixed points. Liquids, on the other hand, are fluid and have molecules that move freely. Glass has molecules randomly arranged in an amorphous form, and because of this it is sometimes called a supercooled fluid. Many solids have a crystalline structure, but liquids do not. When glass is heated, it softens, and as it cools, it returns to its solid state without crystallizing. In its softened state, it is supple and easy to manipulate. This property allows glass to be blown, drawn and cast into different shapes. It is also very hot when it is in this state and must be cooled slowly or it will shatter. To reduce the strain of cooling, hot glass pieces are placed in special annealing ovens, where the temperature is gradually lowered. Some large pieces require several weeks to cool.

Glass is made from a basic mixture of sand (silicon dioxide or silica), soda ash (sodium carbonate) and lime (calcium oxide) that is heated to very high temperatures. Ordinary glass is clear and colorless, but when certain materials are added its properties change. Metallic substances add color. Cobalt oxide produces a blue glass, chromium and iron oxides create green

varieties and selenium yields a red one. Very fine particles (nanoparticles) of gold give rise to colors that range from yellow-orange to ruby red to purple. The addition of boric oxide produces borosilicate, a glass with a low heat expansion. This glass is resistant to sudden changes in temperature and is used for cookware and encasing radioactive materials. Crystal, a material known for the way it bends and refracts light, is formed when lead salts are added.

Because of its composition, glass is a relatively inactive material. It does however respond to the presence of hydrofluoric acid and is etched or frosted by the chemical action of this acid. Glass is also a hard material, and something harder than glass is needed to cut and engrave it. One material that does this is diamond, and industrial grade diamonds are often used to make tools capable of working with glass and other hard substances.

Glass is a material that finds use in both science and art. It is cast into bottles for storing chemicals, it is blown and shaped into glassware for experiments and it is etched or engraved with numbers for measurement. It is ground and polished for optical instruments, it is drawn into fibers for fiber optic systems capable of transmitting data faster than copper wire and it is used to vitrify radioactive waste before storage in isolated sites. It is also drawn, blown and cast into original art forms and cut and assembled into stained glass windows.[83]

The process of making a stained-glass window begins with a small colored sketch or design. The sketch is enlarged to a full size drawing that becomes the template for the window. Pieces of colored glass are selected and cut to match the template, and detail and gentle nuances are added to the glass by etching and/or painting with dark vitreous enamels. The paint is a mix of ground iron oxide and powdered glass and must be fused to the surface of the glass by firing in a kiln. Following this, strips of lead with grooves on both sides (H-shaped cames) are cut and carefully fitted around the glass pieces, and the joints between them are soldered and sometimes cemented. Then the window is strengthened with an armature of metal bands and installed into a permanent site.[84]

The making of stained glass windows began during medieval times. It was a way to admit light into the dark spaces of the churches and great cathedrals. The light streaming through the windows created an atmosphere of brightness and color, one that changed with the season, the time of day and the weather. Stained glass is a medium that allows an artist to paint with light. Its visual effects are produced by the transmission of light through the glass, whereas those of a painting are determined by the reflection of light. Marc Chagall created stained glass windows with brightly colored

transparent glass. Some were installed to take advantage of natural lighting and respond to the changing conditions, while others were illuminated with artificial light. Louis Comfort Tiffany fashioned his windows with opalescent and iridescent glass. Before Georges Rouault became a painter, he started an apprenticeship in stained glass. Many of his paintings reveal his early training and have figures surrounded with dark outlines that resemble the lead cames of stained glass windows.

A piece of fine glass begins as a design, then the plan is transferred to a hot shop where a glassblower fashions molten glass, fresh from an oven, into the desired shape. First, a gather, a gob of soft red hot glass, is picked up on the end of a long blowpipe, blown into a bubble, rolled and shaped. The bubble is reheated, enlarged, rolled and shaped again, and the process is repeated until the piece is finished. Then it is inspected for stray air bubbles and other imperfections and destroyed if any are found. Following this, the piece is placed in an annealing oven and allowed time to cool, Later it is etched or engraved with designs, finished and polished.[85] Steuben of Corning, Orrefors of Sweden and Waterford of Ireland are known for the quality of their fine crystal pieces.

Dale Chihuly is a glass artist who designs large colorful pieces that are assembled into wall arrangements, hung from ceilings and placed on canopies and pedestals in museums and other public places. His work is displayed and lighted in ways that take full advantage of their color and the transfer of this color to adjacent spaces. Decades ago, Chihuly lost an eye in an accident, so the actual making of a glass piece is done by a team at his glassworks. Chihuly designs the original piece and then directs the glassblowing process and supervises its assembly.[86]

Howard Ben Tré created free standing translucent sculptures, ones that delicately scatter light. The glass pieces were cast from molds into columns, benches and other forms and sometimes have surfaces blackened with lead or other metal oxides and bands made of weathered copper or brass. Ben Tré's sculptures are displayed in public places and collected by museums.[87]

The word, ceramics, refers to objects made from clay and to the process of making objects from clay and hardening them with heat. In today's scientific world, ceramics have a role and are used as laboratory ware, filters, electrical insulators, computer components, spacecraft tiles, superconductors

and turbine blades. They are sturdy materials and stand up well against the test of time. The pottery shards found at archeological sites are among the oldest articles associated with civilization and are often the starting points for unraveling the secrets of past cultures. The early ceramic objects were functional in nature and used to hold water and grains, but many were also decorated with creative designs and have made their way into museums as pieces of art.

Clay is a natural material that is dug from the earth. It is composed of complex aluminum and silicon compounds bound together by water and has flat plate-like crystals that give the material its plastic properties. Clay, fresh from the ground, is often filled with impurities and must be prepared for use. First it is dried, then it is soaked and sieved to remove foreign materials. Following this, a temper of sand, pulverized rock or crushed potsherds is added to prevent shrinking and cracking during drying and firing.[88] One of the finest varieties of clay is kaolin ($Al_2O_3 \cdot 2SiO_2 \cdot 2H_2O$).

Ceramic objects are created from clay using a number of techniques. To make a pot by coiling, ropes of clay are rolled and then looped around a flat base in circles. The coils are pinched together by hand and scraped with a tool to remove excess clay and attain uniform thickness. Then the pot is smoothed, and a slip, a watery clay mixture, is applied. The slip is polished while still wet and allowed to dry. To make a pot by throwing, a lump of clay is placed in the center of a potter's wheel that is turned by foot power or electricity. As the wheel turns, the clay rotates, and it is shaped by hand as the potter presses into the clay. When the desired form is reached, the pot is removed from the wheel and smoothed, and a slip is applied. The pot is then polished and allowed to dry. Clay can also be rolled to flat slabs, cut in pieces and assembled into shapes, and it can be pushed into molds and shaped into special forms.

Dried clay pieces or greenware must be heated to high temperatures to complete the ceramic process. The heating or firing takes place in ovens, furnaces or kilns. Firing is a delicate process, and experience does the teaching. The clay pieces are placed on racks, fuel is stacked around them and ignited. The fuel can be wood or any combustible material including animal dung. If there are imperfections and/or air bubbles in the clay, the pieces can explode, and the flying fragments can damage other pieces in the kiln. To provide protection from the flying debris and direct contact with the flames, special containers are used. Ovens have great variety. Some are simple and designed for use outdoors, and others are more elaborate. They come in many sizes, and some are lined with brick and stone. Some are powered by gas and others by oil or electricity. Some are automatic and have controls for setting

and regulating temperature, and others require the use of pyrometric cones or specialized pyrometers. The cones are made of materials that melt or sag and give approximate measurements of temperature, while the pyrometers are precise and provide accurate measurements. Some pyrometers gauge temperature using the intensity of light and emitted radiations, and others use a thermoelectrical devices.

After firing, a coating of glaze is applied by dipping, pouring, spraying or brushing, and the object is fired again. As the glazing materials melt and bond to the ceramic surface, they add color and texture to the finished object. The glaze also smoothes out surface roughness, adds decoration and waterproofs the object. Additional glazings and firings enhance the final appearance of the clay object.[89]

Ceramics are grouped as earthenware, stoneware and porcelain. The groupings are based on the type of clay or paste and the temperature of firing. (A prepared clay is sometimes called a paste.) Earthenware is an opaque, often red, clay fired between 1800 - 2160 °F (1000 - 1200 °C). It has a coarse and absorbent body and is frequently decorated and waterproofed by glazing. Pottery is earthenware. Stoneware is fired at a temperature higher than the earthenware, between 2160 - 2500 °F (1200 - 1390 °C). It has a hard and durable body, and it is impervious to most liquids and can be glazed. The finest of the ceramic wares is porcelain, made of clay, feldspar and flint. There are two types of porcelain. One is known as true porcelain or hard paste porcelain and made with kaolin clay. It is hard, glassy, smooth and impervious to water and is fired at the highest of temperatures, between 2250 - 2590 °F (1250 - 14000 °C). The other is soft porcelain or soft paste porcelain that is made from a ground glass and clay paste. It is fired at slightly lower temperatures and is translucent and often glazed. Excellent porcelains were produced in the kilns of China during the eighteenth century. A high quality white porcelain ware, *blanc-de-Chine*, was exported to Europe, where it became known as china. The name persisted, and today all fine porcelain is called china regardless of its origin.[90]

The use of ceramics for artistic purposes goes back thousands of years. The Pergamon Museum in Berlin has a reconstruction of ancient Babylon's Ishtar Gate with its processional walls. The gate and walls are covered with ceramic bricks that are richly colored with blue, yellow-brown and turquoise glazes. The bricks are organized to form a stately procession of silhouetted animals with tiers of lions, dragons and bulls in a triumphal march toward the Gate.[91]

Early Greek potters developed a special technique for decorating their pottery. First a vessel was made on a potter's wheel and allowed to dry.

Figures and designs were painted on the outside with a watery slip called an engobe. The clay and the slip were the same color, and both contained oxides of iron. Then the pot was fired in a three stage process. The first firing was in the presence of air or oxygen, and the pot and slip turned red. The iron oxides reacted with the oxygen in the oven and turned red. A chemical change (oxidation) occurred. The air supply to the oven was then cut off, and the pot was fired again. Both the pot and slip turned black. In the absence of oxygen, another chemical change (reduction) occurred. Air was readmitted to the oven, and the pot was fired again. This time the pot turned red, but the slip remained black. When the oxygen returned, the iron oxides in the pot underwent another chemical change and turned red (oxidation), while nothing happened to the slip. Oxidation-reduction reactions are reactions where electrons are gained and lost. Electrons are lost in oxidation and gained in reduction. The bottom line, the color changes occurred because of the loss and gain of electrons during the oxidation and reduction or redox reactions occurring within the kiln.[92]

The Greek potters created intricately decorated ceramic pieces with this technique, even though they had no understanding of electrons and redox reactions. The first pots had black figures on red backgrounds, and the later ones had delicate red figures on black backgrounds. The coloration on the Greek pots appears to be the result of colored pigment, but in reality it is the result of chemical changes in the iron oxides. Some Greek pots are signed just like paintings and bear the names of both the potter and the decorator.

Ninth century Islamic ceramicists made pots with an iridescent surface. They started with an earthenware pot fired with an opaque white tin glaze. They painted the surface with a mixture of silver sulfide and copper oxide and fired the pot in a kiln where the oxygen was removed. A chemical change occurred (reduction) and a shiny overglaze appeared. It was composed of silver (from the silver sulfide) and copper (from the copper oxide). Pots with this kind of iridescent lustrous surface were known as lusterware.[93]

Pottery making in the American Southwest began about a thousand years ago. It was a vital part of the Hohokam, Mogollon and Anasazi cultures, and it continues to be part of twenty- first century pueblo communities. The early pots were made by women using the coiling technique, and they are still made in this fashion by the women of today's pueblos. The early pots were utilitarian and served as containers for the preparation and serving of food and the storage of grain and water, and they were adorned with distinctive geometric designs and representations of mammals, birds, reptiles and insects. Today's pots are more decorative than utilitarian and have styles characteristic of their pueblos. Hopi pottery is made from clays

that change color during firing. The gray clay produces a yellow pottery, and the yellow variety creates a red. When this clay is polished, it has a soft luster, and no slip is necessary. The Acoma variety is thin walled and light weight and covered with designs and animals painted with hematite, a rich black iron pigment. The dark Taos pots have a special sparkle that comes from the mica-bearing clay used in their production.[94]

Luca della Robbia developed a technique for reproducing relief sculptures of the Madonna and Child. He made them with terra cotta, an earthenware clay, and applied vitrified glazes. The glazes gave color and creamy texture to the figures and added blue to their backgrounds. The reliefs were colorful, decorative and sturdy, and they were produced in number. They were inexpensive, and they were popular. They were a way for the ordinary person to have a piece of religious art, and they were the start of a successful business for Luca's family. Over the years, a number of the della Robbia reliefs have made their way into the collections of many art museums.[95]

The Prudential Guaranty Building in Buffalo is one of the best known architectural structures in the United States. It was designed by Louis Sullivan and Dankmar Adler in the 1890s. It is a thirteen story building with an exterior of terra cotta tiles that have the look and feel of carved stone. The tiles are red in color and unglazed, and they are both durable and decorative. They have reliefs of stylized foliage arranged in geometric designs reminiscent of the natural world. The richly ornamented tiles echo nature and the materials of the Earth and give the building its character.[96]

Mosaic is the technique of setting small pieces (tesserae) in a grout to form a picture or design. The tesserae are opaque or transparent bits of colored glass, ceramic, tile, stone, marble, wood or other non-perishable material. The grout is a wet mortar or cement or some other adhesive that holds the pieces together and fills the spaces between them. Mosaic began as a way to make inexpensive flooring by installing small stones in cement. The well-known Roman floors were made of cut stone, and they related stories from history and mythology with their elaborate designs. Later the technique was adapted to colored glass by Byzantine artists, and the walls and ceilings of churches were covered with small pieces of fractured glass. The tesserae are individual pieces of color, and when they are set close to each other, their colors often blend and give the appearance of a painting. Another effect is created when the tesserae are set apart and resemble the pixels of a digital print. The churches and mausoleums of Ravenna are especially known for their mosaics, and when light strikes them, they sparkle and radiate their own unique brilliance.[97]

Glass and ceramics are materials that find use in both science and art. The art of glass and the art of ceramics involve the use of materials and methods related to science. When the materials and techniques of glass and ceramics and the science behind them are explored, connections between them are discovered.

CHAPTER 10
ARCHITECTURE

"Architecture should speak of its time and place,
but yearn for timelessness."
~ Frank O. Gehry

A RCHITECTURE IS CONCERNED WITH THE planning and building of functional structures. It deals with the weight of the materials involved and the distribution of this weight, and it must stand up against gravity, or like Humpty Dumpty, it will have a great fall. In spite of this, it can be creative in its design and aesthetically pleasing. When compared with painting, sculpture, drawing, printmaking, glass and ceramics, the materials and techniques of architecture are considerably more complex.

Stone, concrete, brick, glass and alloys are the materials of architecture. Stone occurs naturally and is extracted from quarries, whereas concrete, brick, glass, and alloys are manufactured products. The materials are heavy and bulky, and they require transport from their points of origin to building sites and devices to assemble them into structures. To fully appreciate the complexities of architecture and the construction of buildings, a quick review of basics is in order. First of all, forces are involved. A force is a push or a pull applied to an object. When a force moves an object, work is accomplished. Machines are devices that multiply forces and make work easier. They increase the force applied, change the direction of the force

or do both, but they do *not* reduce the amount of work. Levers, inclined planes, wedges, screws, pulleys and the wheel and axle are simple machines that make work easier. Friction, an opposing force, interferes with the movement of objects in contact with each other and is reduced by decreasing the contact surfaces and/or lubricating them.

Gravity is a force that acts between objects. It is an attraction based on the relative masses of the objects and the distance between them. The more mass an object has and the closer it is, the greater its gravitational force. The earth is both massive and close, and objects are pulled to the Earth. Thus objects "fall down" or toward the Earth. To prevent the collapse of buildings, weight is distributed throughout the structure, and forces are balanced. Early buildings solved this problem with large bases and small upper levels, but as devices to distribute weight developed, the designs gradually changed. Today's architecture depends upon the properties of the materials, the science of construction and the creativity of the architect.

In a region known as Mesopotamia, archeologists have found the remains of ziggurats. They were large structures, built thousands of years ago by the people who lived in the valleys of the Tigris and Euphrates Rivers, and they served as temples for worship and perhaps sacrifice. One of them was the massive Ziggurat of Ur, built around 2100 BC. As stone was not readily available in the area, brick became the building material of choice. Mud and clay, from the nearby Euphrates, were mixed with plant fibers, shaped into bricks and allowed to dry in the sun. Then the sun-dried bricks were assembled into four solid tiers or levels, with long ramp-like stairways connecting them. The lower tiers were larger than the upper ones, and the weight of the upper levels was distributed to the larger lower levels. The bottom tiers were covered with a facing of glazed and fired bricks held together with bitumen, a tarry petroleum material. As the centuries passed, the lower levels more or less resisted the weather, and the upper exposed portions deteriorated. In their day, the ziggurats were large and majestic structures, but in reality they were only a few hundred feet high. Some scholars believe the biblical account of Tower of Babel referred to the ziggurat at Babylon.[98]

The pyramids of ancient Egypt were built as royal tombs for the pharaohs, and the first of the many was constructed at Saqqara around 2610 BC. It was made for King Zoser and designed by Imhotep, the first architect of recorded history. Local limestone was used for the mass of the pyramid, and a finer limestone, from Tura on the other side of the Nile River, supplied the facing. The pyramid consisted of six mastabas, flat tombs of cut stone, arranged one on top of the other to a height of about 200 feet (61

m). The tiers became smaller with each level and gave the tomb a step-like appearance, and because of this, the structure became known as the Step Pyramid. Imhotep's design distributed the weight of the upper levels to the lower ones in a manner similar to that of the ziggurats.[99]

The Great Pyramid of Khufu (aka the Great Pyramid of Cheops) is part of the complex of pyramids at Giza. It is a huge structure with a base of 775 feet (236 m) and a height of 450 feet (137 m) and consists of 2.3 million blocks of stone, each weighing an average of 2.5 tons (2.3 metric tons). It was a marvel of ancient technology and was built with the very simplest of tools and devices, those made of stone, wood and copper, as iron was unknown in ancient Egypt. The stone materials for its construction came from several sources, some close by and others farther away, and all had to be transported from the quarries to the building location. The desert around Giza supplied the limestone for the core, and the nearby cliffs of Tura provided the fine white limestone for the outer casing. However the granite used for the inner galleries and burial chamber came from Aswan, about 600 miles (970 km) south of Giza, and had to be floated northward on barges during times of Nile River flooding. At the quarries, the stone was separated from its bedrock by wedging wood into cuts, soaking it with water, and allowing time for it to expand, split the rock and detach it. Then the stone was sawed, chipped and chiseled into proper sizes and numbered for use. When the stone arrived at the building site, it was placed on sledges and rollers, with lubricated surfaces to reduce friction, and moved about by people working in teams. The blocks were pushed, pulled and shoved up long temporary ramps. (A ramp is an inclined plane, a simple machine that makes work easier by distributing the work over a greater distance.) From there, they were positioned one on top of the other, with smaller blocks near the top and larger ones below for support. For the most part, the pyramid was a solid mass of stone, except for its central chamber and supporting compartments, a few passageways, air shafts and smaller chambers. Over the years, the pyramids of Giza were pillaged, and most of the exterior stone was taken, except for some at the top of the Pyramid of Khafre (aka Chephren), and used for construction in Cairo. The Great Pyramid itself was stripped of all of its fine limestone coat and left to stand rough hewn and naked.[100]

The Great Pyramid was built as a tomb for the pharaoh, Khufu, and his queen and was completed around 2560 BC. It is oldest of the Seven Wonders of the Ancient World, and the only one in existence. Over the years, many people have traveled to Giza for a personal experience with the ancient wonder, and I am one of them. I arrived at the site early one morning and at a time when

few visitors were there. As I approached the structure, I was overwhelmed by its massive size and felt very small by comparison. I began my journey into the Great Pyramid by climbing the stone steps on its exterior to the entrance. Once inside, I walked through narrow and dimly lit passageways, then grabbed the wooden railing and ascended the ramp within the Grand Gallery. I bent down, crawled through several low spaces and got dust on my jeans. Finally I reached the royal burial chamber at the very center of the Pyramid. As I looked about, I could see the room had walls of granite and held a solitary stone sarcophagus. Suddenly the electricity failed and the lights went out, and for a brief moment I was entombed within the darkness of this ancient monument. When the lighting returned, I carefully worked my way to the exit. As I emerged, I saw others awaiting their experience with the great one.

The Greeks had access to an abundance of marble, and they used it for architectural purposes, especially the building of grand temples. The basic plan for a Greek temple consisted of a rectangular building on a podium. The structure was surrounded by a row of columns and topped with an entablature, a flat beam that connected the columns and supported the roof. The columns and entablature were a post and lintel device, and they distributed the weight from the roof to the entablature and evenly portioned it to each of the columns. The Greeks developed methods to move stone that were easier than those used by the Egyptians. They roughly worked the stone at the quarries and then transported it to the building locations using wagons. At the site, the stone was cut with groves and notches for ropes and tongs, and it was attached to a derrick-like device with a system of pulleys for lifting and hoisting. The stone was then shifted into position with crowbars. (Pulleys with ropes are simple machines that multiply force and make work easier, and crowbars are a type of lever and multiply force and make work easier.) The pieces of marble in the temple were not mortared but held together with "dry joints" of iron and bronze dowels and cramps set into lead to prevent corrosion. The columns were made of cylinders or drums of marble, centered one on top of the other, carefully fitted together and held in position by plugs and pins.[101]

Centuries later the Incas of South America built mighty structures at Machu Picchu, Sacsayhuaman and Ollantaytambo. They carefully shaped stone into tight-fitting pieces without the use of iron tools and built structures that held together without mortar or metal pieces. Around doorways and windows, they used the post and lintel device to distribute weight and stabilize the buildings.

Roman architecture was about space and enclosing space within buildings. The Romans developed the arch, a structural device for supporting

weight and spanning an opening. An arch can cross a larger space and is stronger than the post and lintel design. It is made of wedge- shaped blocks that stay in position by pressing against each other. Weight is directed from a center wedge, known as a keystone, to the ones below it. The weight from above is transferred down and out, and the sides of the arch are supported by thick walls and solid construction. To make an arch, a temporary frame of wood, called a centering, is built in the size and shape of the arch. The centering is filled with cut stones or liquid concrete and then removed when arch is finished or the concrete hardens.

Another device for distributing weight is the vault. A vault is a ceiling structure based on the principle of the arch. A barrel vault, a simple type of vault, is a deep arched roof structure made of stone or concrete. The vault directs the weight down and out, and it receives support from the walls.[102]

Binding materials are used to hold blocks of stone and brick together. Mortar is a binding material made of a pasty mixture of slaked lime (calcium hydroxide $Ca(OH)_2$), sand and water. Cement, another binding material, is a mixture of limestone (calcium carbonate $CaCO_3$) and clay that is heated in an oven to form a solid mass and then ground into a powder. Concretes are mixtures of cementing or binding materials, aggregate particles and water. Usually concrete is a mixture of cement, sand, gravel and water and is a dense liquid material that can be shaped and cast into forms. The materials in the concrete become solid or cure by bonding with water and forming crystals. Bonding with water or hydrating causes the chemistry of the materials to change. Curing is a chemical change, and it is not the same as drying. Drying results from the evaporation of water and is a physical change. Concrete will cure underwater, and this property permits its use in tunnel and bridge construction.[103]

Concrete was a favorite building material for the Romans. Their concrete was a mixture of lime mortar, volcanic ash and water, and it allowed architects to create buildings with shapes and interior spaces rather than structures with just sheer mass. The Pantheon in Rome, built around 125 A.D., is a spherical structure with an internal diameter of 142 feet (43.3 m) and a dome that rises 142 feet from the floor. The dome is a shell of concrete with a 30 foot (9.1 m) circular opening at the top, the oculus, that allows sunlight to enter the building. The opening also admits rain, and the floor has a shallow depression and a drain to manage the weather related water. Concrete is a heavy material. To reduce the weight of the dome, the concrete is thinner toward the top and less dense and its interior surface is coffered in a geometric design. Eight massive piers with vaulted niches support the dome and distribute its weight to the ground.[104]

Early buildings depended on massive lower structures to provide support for the weight of the upper sections. With the development of arches, vaults and domes, weight was directed toward piers and walls, and buttresses were used to support the walls. This allowed buildings to become taller and leaner.

Religion was an important part of life in medieval Europe. Towering cathedrals were built in the center of cities and often required over a century to construct. They were made of materials (stone, masonry, metals and glass) that were assembled and moved by human hands. To do this, wooden poles were lashed together, and platforms were connected to form scaffolds for workers. Materials were lifted upward using ropes, pulleys, windlasses and giant wheels that were powered by human labor. Wooden centerings were used to fashion arches and vaults. The ribbed vaulting acted like a skeleton, and space opened up. Walls were supported by external buttresses and became larger. Windows grew in size and admitted more light, and this, in turn, led to the development of stained glass windows.

The building of the Cathedral of Florence, *Santa Maria del Fiore*, was begun in 1296 but was still unfinished in 1420. The construction plan presented a problem. It called for a dome 171 feet (52 m) above the floor with a diameter of over 144 feet (44 m), a space too large for the use of buttresses or the traditional wooden centering frame. Filippo Brunelleschi solved the problem by raising the curve of the dome and designing it as a thin double shell. The curve decreased the outward thrust around its base, and the double shell reduced its weight. The dome was built around a skeleton of ribs on a drum with a lantern on the top. The lantern stabilized the entire structure by pressing on the dome and distributing the weight to the lower parts. The dome took sixteen years to construct and required Brunelleschi to develop new methods and machinery to complete the job.[105]

Buildings are constructed on foundations that give support and provide stability. The Great Pyramid of Giza was built on land carefully prepared and graded with primitive but workable leveling devices. The large gothic cathedrals were erected on stone and mortar that went into the ground several stories. Special care was taken to insure the stones were horizontal, and the support walls were vertical. Present day homes get their support from basements made of cinder blocks or reinforced concrete. All buildings need firm foundations, and they must be built on land that can support them. To provide support on soft ground, steel piles, reinforced concrete or platforms of concrete are used to strengthen and shore up the land.

The Leaning Tower of Pisa is a well-known destination for travelers, and one that brings economy to Pisa because of its unusual inclination. The Tower

was started in 1173 and began shifting from its intended vertical position before it was finished. It was constructed on unstable land, and the tilting was the result of a problem with its foundation. Over the years, the shifting continued, and a number of stabilizations were done. The most recent effort was a ten year project started in the 1990s. Bracing supports were placed around the Tower, soil was carefully removed, and it was straightened about 16 inches (40 cm). The Leaning Tower is at present stable and continues to attract visitors, but it's hard to say what lies ahead for this structure that tempts gravity.[106]

In the nineteenth century, architecture changed. Iron and steel became available, and architects incorporated them into their building plans. They were strong materials, and they permitted architectural designs that were large in scale and ones that enclosed big spaces. Iron and steel frames, rather than thick walls and heavy bases, provided support and resisted gravity. Cement replaced lime in concrete. Concrete by itself is rather brittle, but when it is reinforced with steel bars or mesh its strength increases. Construction techniques improved, and heavy, difficult and time-consuming human and animal labor gradually shifted to power driven tools and machines.

Alexandre Gustave Eiffel developed a system for making strong and light constructions of iron, ones that were stable and never collapsed. He designed buildings, railway bridges, the skeleton for the Statue of Liberty and a tower for the 1889 International Exhibition in Paris.

Eiffel planned this tower very carefully and paid attention to every detail. The foundation was of concrete and stone, and the main structure was a lattice of iron girders held together by rivets. The girders were made and assembled into sections at a factory and moved to the site. They were lifted into place by cranes and joined with rivets heated in portable stoves. When finished, *La Tour Eiffel* was 984 feet (300 m) high and had hydraulic elevators that lifted visitors to the top for a panoramic view of Paris. Eiffel's tower took less than two years to build, and it was the great marvel of its time.[107]

With the aid of computers running complex programs, today's architects are able to design very tall buildings with huge windows. Buildings of this type are important as cities grow and land becomes more valuable, and they are practical because elevators can whisk people to the top floors in a matter of seconds. Tall buildings have superstructures above the ground and substructures below for foundation. Their metal skeletons, made of columns and girders welded together for strength, provide support and distribute weight, and their exterior walls or skins are made of thick glass, sheets of metal or prefabricated materials. Tall buildings also respond to wind and

sway, so their designs must consider both the vertical force of gravity and the horizontal force of the wind. The 1100 feet (335 m) Hancock Center in Chicago has special bracing elements, crisscrossed exterior beams, that resist both gravity and wind.

Movements of the Earth's tectonic plates cause tremors and earthquakes, and buildings in areas subject to tectonic movements must be able to withstand them. The way a building reacts to the motion depends upon its overall size and geometry and how the vibrations are distributed.

Some architectural structures hold up to the stresses while others collapse, making the plans for stable configuration very important. To study the stability of designs, scale models are built and tested in laboratories. The models are placed on platforms that shake and vibrate to simulate natural crustal movements.

Architecture is also concerned with the effect buildings have on the environment and human health. Designs that reduce this impact are known as green or sustainable architecture, and the Leadership in Energy and Environmental Design (LEED) has set standards for this type of architecture. The Burchfield Penney Art Center in Buffalo was the first art museum in New York State to be LEED certified.[108]

Sometimes current architecture echoes the past. A pyramid stands in the central courtyard of the Louvre Museum in Paris. It is 71 feet (21.6 m) tall and made of a network of glass and slender steel rods rather than blocks of stone. The glass and steel pyramid reflects the images of the surrounding buildings and the sky, and it serves as the central entrance to the Museum. An escalator and a staircase take people to a lower level where the interior foyer and visitor's plaza are located. An inverted pyramid and several smaller ones admit light to the space. The pyramids are an architectural reminder of the Great Pyramids of Giza, and they welcome visitors to the Museum and offer access to the various galleries, including the Sully Wing with its Egyptian antiquities. The pyramids and foyer were designed by Ieoh Ming Pei and were part of a renovation marking the two-hundredth anniversary of the Louvre.[109]

The Gateway Arch in St. Louis is a modern version of an arch designed by Eero Saarinen and completed in 1965. It is a catenary arch shaped like the curve of a rope held at both ends and then inverted. It has a three-dimensional triangular form with 54 foot (16.5 m) bases that slim to 17 feet (5 m) at the top and is covered with a surface of stainless steel that glistens in the sun. The sides of the arch were built separately and joined when the center section, "the keystone," was inserted. The interior is made of concrete and metal and has

a lift that takes visitors to the top for a commanding view of St. Louis and Mississippi River. The Arch rises to a majestic height of 630 feet (192 m) and commemorates St. Louis as the gateway for the western expansion of the United States.[110]

Architecture has great diversity. Gordon Bunshaft, of the Skidmore, Owings, and Merrill firm, was a versatile architect who worked in an environment that encouraged his creativity. He championed the use of steel ribs with surfaces of glass to open up space within buildings, and his Lever House in New York City opened a new era for the design of skyscrapers. His designs also included the Lyndon Baynes Johnson Library in Austin, the 1962 Knox building for the Albright-Knox Art Gallery in Buffalo, and the National Commercial Bank in Jeddah, Saudi Arabia.

Zaha Hadid pushed the boundaries of architecture and urban design with her creativity and experiments with new spatial arrangements. Her Rosenthal Center for Contemporary Art in Cincinnati has angular stacks of poured concrete and long stairways that convey the unsettling qualities of contemporary art. While her design for Rome's National Museum of XXI Century Art (the MAXXI) uses aspects from the past and present. It combines massive volumes of concrete that echo antiquity with columns of steel and complex lighting systems that assert modernity.[111]

Jean Nouvel's design for National Museum of Qatar incorporates elements from the nearby desert. Gypsum, a hydrated form of calcium sulfate, is a common mineral found throughout the world. When gypsum forms in desert regions, its crystals are flat and blade-like and arranged like the petals of a rose and contain sand inclusions that add color. Because of this, the gypsum crystals are known as desert roses or sand roses. Nouvel's building has pavilions with interlocking concrete discs that echo the roseate pattern of the crystals and is located within a park landscaped to resemble a desert. The Museum, with its sand colored structures, appears to grow from its environment like a rose in the desert.[112]

An architectural form can become the icon for its location, like the Eiffel Tower of Paris and the Leaning Tower of Pisa. The Opera House on Bennelong Point dominates the surrounding harbor and has become the recognized symbol for Sydney, Australia. The building, designed by Jørn Utzon, is an architectural abstraction with clusters of sectioned shells that suggest the wind-blown sails of harbor vessels. It is made of precast concrete, held together by tensioned steel cables, and is covered with sheets of thin glazed ceramic tiles. Another icon is the Guggenheim Museum in Bilbao,

Spain, designed by Frank O. Gehry. Its distinctive structure has orthogonal shapes in limestone with curves and bends and is covered with fish scale panels of titanium, a lustrous white metallic element.

The Pritzker Architecture Prize is an award given annually, since 1979, to an outstanding living architect for lifetime achievements, "to honor annually a living architect whose built work demonstrates a combination of those qualities of talent, vision, and commitment, which has produced consistent significant contribution to humanity and the built environment through the art of architecture." It is a prestigious honor that is considered the Nobel Prize of architecture and consists of a cash award and a medallion. I. M. Pei, Gordon Bunshaft, Frank O. Gehry, Jørn Utzon, Zaha Hadid, Jean Nouvel and Norman Foster, the founder of Foster + Partners are among the honorees.[113]

Architecture is concerned with the planning and building of functional structures. It is both an art and science, as it involves the art of design and the science of construction. When the nature of architecture is explored, connections between science and art are discovered.

RELATED
PHENOMENA

LIGHT AND COLOR

*"Without the Sun, no shadows. Without the Sun, no colors.
Without the Sun, no life. Without the Sun, nothing."
~ Claude Monet*

LIGHT AND COLOR ARE PHENOMENA related to art. To understand and appreciate light and color, how they work and how essential they are to art, it is necessary to consider the science, especially the physics, behind them.

In the 1600s Isaac Newton studied the light coming from the sun and concluded it was composed of a mixture of colors. When he passed a beam of sunlight through a triangular prism, the light was bent and separated into a spectrum, a continuous band of red, orange, yellow, green, blue, indigo and violet. When he passed the band of colors through a second prism, the colors came together and produced white light. Thus, he concluded, the white light of the sun was a mixture of different colors.[114] (When sunlight passes through moisture laden air, the individual droplets of water act like prisms and disperse sunlight into a rainbow of colors.)

Light is a form of energy, and it is the form perceived by the eye. It is produced by the Sun and other stars through fusion, a reaction that combines the nuclei of smaller atoms into larger atoms and releases energy. Specifically the nuclei of smaller hydrogen atoms fuse into larger helium nuclei, and in

the process, a small amount of mass is converted into energy and released as light and other radiations.

Light is also produced by energizing the electrons of atoms. Electrons move in orbits or energy levels and can absorb energy. When heat, electricity or some other form of energy is absorbed, electrons jump to higher energy levels. When the electrons return to their original energy levels, the energy they absorbed is released as radiations and some are visible as light. This explains the light produced by incandescent bulbs, electric filaments, neon signs, fluorescent bulbs and burning materials.

Light travels through a vacuum at the speed of 186,000 miles (300,000,000 m) per second. This number is known as the speed of light, and it is considered the fastest speed in the universe. Light from the Sun travels about 93 million miles to reach the Earth. It passes through the near vacuum of space and arrives in just over eight minutes. Light also passes through materials. When light goes from one material to another, its speed changes, and it bends. Light traveling from air to water is slowed down and deflected. This bending of light is known as refraction. Materials vary in their refractive properties, and some materials slow light more than others. Water bends or refracts light more than air; glass bends light more than water; leaded glass more than window glass; diamond more than leaded glass. This property, plus the way it is cut, gives diamond its characteristic sparkle. Refraction also explains the distortions that appear when viewing objects immersed in water.[115]

The very nature of light is complex and at times confusing. Sometimes light acts like it is composed of particles, little packets of energy with a pulsating wave-like motions, known as photons. And sometimes light behaves like waves. Color is explained in terms of waves. Waves have length, and their length is measured in wavelengths. (A wavelength is the distance between a point on one wave to the corresponding point on the next wave.) Color depends upon wavelength, and each color has a different wavelength. Thus the difference between one color and another is its wavelength. Red light has the longest wavelength, and violet has the shortest wavelength. The colors are arranged from red to violet, from the longest wavelengths to the shortest. As the wavelengths become shorter, the colors blend from one color to the next and produce a continuous band of colors known as the visible spectrum. When sunlight passes through a prism, the light entering the prism slows down and is refracted, and a spectrum of colors appears. The wavelength of the color determines the degree of slowing down and bending. The shorter wavelengths are slowed down and refracted more than the longer waves, so violet light is bent more than red.

Light waves have electric and magnetic properties and are often referred to as electromagnetic radiations. Radio waves, microwaves, infrared, ultraviolet, x-rays and gamma rays also have electric and magnetic properties and are other types of electromagnetic radiations. All electromagnetic radiations travel at the speed of light, but wavelength and frequency (the number of wavelengths per second) vary with each type of radiation.

A relationship exists between the length of a wave, the frequency of the wave and the speed of light. The relationship is shown in this word equation:

$$\text{wavelength} \times \text{frequency} = \text{speed of light}$$

The length of the wave multiplied by the frequency of the wave is equal to the speed of light.

This relationship is proportional. As wavelength increases, frequency decreases, and as wavelength decreases, frequency increases. Thus the longest waves have the lowest frequencies, and the shortest waves have the highest frequencies. Shorter waves with higher frequencies, like x-rays and gamma rays, have more energy and are able to pass through many materials. If electromagnetic waves are arranged according to their wavelengths and frequencies, they form a continuous band of radiations known as the electromagnetic spectrum.

The Electromagnetic Spectrum

Radio Waves	Microwaves	IR	UV	X-rays	Gamma-rays

red ←---------------→ violet

longer waves ←---------------→ shorter waves

lower frequencies ←---------------→ higher frequencies

lower energy ←---------------→ higher energy

The wavelengths of visible light are very small and are measured in nanometers. Color depends upon wavelength. The red colors have the longest wavelengths, and the violets have the shortest. As the wavelengths become shorter and shorter, the colors gradually change from red to violet.

Infrared radiations have wavelengths slightly longer than the visible red colors and are invisible to the human eye. Sources that emit invisible infrared are warm, sometimes hot, and may have a red color. When infrared is absorbed, it is transformed into heat. Solar radiations contain infrared, and when sunlight passes through glass windows, heat is produced. This effect is an important consideration in the architectural design of buildings with large glass windows and walls.

Ultraviolet radiations have wavelengths slightly shorter than the visible violet colors and are invisible to the human eye. Some sources that emit invisible ultraviolet also produce a dark violet light. The inside of a fluorescent lamp is coated with phosphors. When the lamp is turned on, ultraviolet radiations are produced. The phosphors absorb the ultraviolet, become energized and emit visible light.[116]

Sometimes phosphors are added to paints to create special effects. Anders Knutsson has made luminous paintings by mixing phosphors with traditional pigments, wax and oil and applying them to linen canvases with a palette knife. His canvases have one appearance when viewed under regular museum lighting and another when exposed to ultraviolet (sometimes called "black light") in a darkened gallery. The colors change in intensity and tone and glow with brilliance in the presence of the ultraviolet radiations. To show their full dramatic effect, Knutsson's paintings are viewed under both regular and ultraviolet lighting.[117]

Alfred Jensen was an artist interested in physics, especially the work of Michael Faraday and James Clerk Maxwell. Faraday discovered that motion between a magnet and a conductor produced electricity (electromagnetic induction). Using mathematics, Maxwell explained the relationships that exist between magnetic fields and electricity (electromagnetic theory). He also established connections between magnetic fields and light, and proposed the wave theory of light. (Maxwell's work was the starting point for Albert Einstein's thinking on gravitational fields and his 1905 *Special Theory of Relativity*.) Jensen's colorful painting, *Solar Energy, Optics* of 1975, has three large canvas panels covered with thick applications of oil paint. At first glance, it resembles a bright patchwork quilt or a large sheet cake with rich frosted decorations, but upon close inspection, the visual language of the artist becomes apparent. The side panels contain four diamond filled squares suggesting the magnetic fields

of the Sun, some marked with the plus and minus symbols of electrical charges. The central panel has a square filled with a checkerboard of similar diamond shapes with symbols. Above and below this is a hand written inscription that reads *"Magnetic forces from the Sun's four separate magnetic fields oscillates. In that way an electric field, registers Solar energy."* With this painting, Jensen artistically interpreted the scientific work of Faraday and Maxwell.[118]

When three beams of colored light (red, blue and green) of equal intensity are projected to overlap on a white screen, a patch of white appears at the intersection of the three. Only three colors of light (red, blue and green) are needed to produce the white light, and the three colors are known as the primary colors of light. Where the red, blue and green overlap, the secondary colors of light appear. The secondary color of magenta comes from red and blue, cyan from green and blue, and yellow from green and red. The colors are formed by combining or adding the colors of light, and this is known as additive color mixing or color by addition. Color television pictures are produced by additive mixtures of the three primary colors of light.

Artists use paints that contain pigments. Pigments are substances that absorb some wavelengths of light and reflect others to produce color. The primary colors of paint or pigment are different from those of colored light. The primary colors of paint or pigment are red, blue and *yellow*. When red, blue and yellow paints are mixed together, instead of getting white, a dark muddy color appears. The dark color forms because each of the pigments absorbs different wavelengths of light. (Black paint is made with special black pigments that absorb light, and white paint has white pigments that reflect light.) When two of the primary pigments (red. yellow or blue) are mixed, a secondary color forms. Blue mixed with yellow forms green. The blue pigments absorb the red wavelengths, the yellow pigments absorb the blue wavelengths, and green color is reflected. Red mixed with yellow forms orange, and red mixed with blue forms violet. Pigments absorb light and subtract color, and the color that is not absorbed is reflected. This is known as subtractive color mixing or color by subtraction.

Objects can absorb, reflect or transmit light. The color of an object depends upon the color of the light shining on it and how the object absorbs, reflects or transmits this light. In the presence of white light, an object appears white because it reflects all the wavelengths of light, while another appears black because it absorbs all the wavelengths. In white light, an object appears red because it reflects red light and absorbs the other wavelengths. In blue light, the red object appears black. The blue is absorbed, and there is no red light to reflect, so the object looks black. Incandescent light has a warm

reddish color that comes from a glowing filament, and fluorescent light has a cool violet color from phosphors energized by ultraviolet. When an object is viewed under solar, incandescent and fluorescent lighting, the object can have a slightly different color. Thus colors, like dark blue and black, are sometimes difficult to distinguish under artificial lighting conditions.

Artists arrange colors around a circle, placing red at the top and going around the circle to orange, yellow, green, blue, violet and back to red. Colors opposite each other in the circle are complementary colors. Red is opposite green, yellow is opposite violet, and blue is opposite orange. The pairs are complementary colors. They are colors that provide the strongest possible visual contrast, and they are used by artists to produce interactions between the colors of their paintings.[119]

Nineteenth century artists were interested in color and light. Eugene Delacroix was one of them, and he knew that pure color was rare. He observed shadows and discovered color in shadows, and he studied light, made observations and recorded them in a journal. He wrote: *"It is advisable not to fuse the brushstrokes, as they will fuse naturally at a distance. In this manner, color gains in energy and freshness."* He also wrote: *"Speaking radically, there are neither lights nor shades. There is only a color mass for each object, having different reflections on all sides."*[120]

Delacroix's knowledge of color and its use served as instruction for the Impressionists, a group of French artists interested in light and its effects. They understood color mixing and the use of complementary colors, and they employed bright colors and quick brush strokes to catch the vibrating quality of light. Rather than making sketches for later studio work, many of them painted outdoors in natural light *(en plein air)*. They filled their canvases with light and color and used wisps of paint to capture the reflections of light and the colors of shadows. The paintings they produced were different and were rejected by the established Art Salon, so the artists were forced to set up their own exhibitions. After viewing their first show in 1874, one reporter severely criticized and poked fun at the "impressions" painted by Pierre August Renoir, Camille Pissarro, Paul Cezanne and Claude Monet. Following this critique, the artists became known as Impressionists. In spite of this, the exhibition was well attended, but mainly by people who were looking to laugh at the new art. The Impressionists went on to organize seven additional shows, and their paintings, with dazzling color, were gradually accepted and became popular.[121]

Several nineteenth century scientists were also interested in color. One of them was Michel Eugene Chevreul, a chemist who was hired

to assist industrial designers and workers in a tapestry factory. In this capacity, Chevreul studied the dyes used to color yarns and fading, and he investigated how thread colors in a tapestry were influenced by the colors of the surrounding threads. He conducted experiments with contrasting colors, and from this, he made diagrams to explain the color relationships he found. In 1839 Chevreul published *On the Law of Simultaneous Contrast of Colors*, and in it he described color combinations and interactions and how colors influence each other when placed side by side. Simultaneous contrast involves complementary colors and how they enhance or detract from each other.[122] Decades later Georges Seurat, the artist, became interested in color. He read and became familiar with the earlier studies, including those of Chevreul, whose color diagrams suggested painting applications.

Rather than mixing the colors on a palette (blue and yellow to make green) and applying green to the canvas, Seurat applied separate dots of each color. The separate dots (blue and yellow) were to blend and appear as green. Seurat called this style of painting, divisionism, while others have referred it as pointillism or neoimpressionism to distinguish it from impressionism. The technique was a very precise, methodical and time-consuming way of adding paint to a canvas, and it produced paintings with stiff and formal qualities. It was also one that did not always work as anticipated, but the compositions with their colors were often pleasing to the eye and had popular appeal.[123]

Stephen Sondheim and James Lapine wrote a musical play, *Sunday in the Park with George*, built around Seurat's divisionist painting, *A Sunday Afternoon on the Island of La Grande Jatte*. The play was fiction and based upon little that was biographical, but it did provide insight into Seurat's dedication to art and his method of painting. Seurat thought of color as harmony and approached painting in a manner similar to science. His method was investigative and involved many preliminary drawings, studies and oil sketches of the subjects before the final painting was done. *Sunday in the Park with George* was awarded the 1985 Pulitzer Prize for Drama, an honor rarely given to a musical.[124]

Some artists work directly with light and use it as their medium. Dan Flavin created art with fluorescent light and the lamps and fixtures that produce it. The pieces have a definite industrial appearance, and they are installed in architectural spaces, on walls, floors, ceilings, across corridors and in corners. The lamps emit light colored by the phosphors within the tubes, and the light interacts with the spaces to produce special effects. As the colors blend, they create environments bathed in soft glowing light.[125]

John Armleder uses light from gas filled tubes. Neon is a chemically inert gaseous element, but when sealed within a glass tube and energized by electrons, it emits a characteristic reddish-orange glow. Other gases when energized produce different colors. Krypton glows with a violet color, argon and mercury with a blue color, and sodium with a yellow hue. Additional colors are produced by coating the insides of the gas filled tubes with phosphors. Armleder's installations are wall sized and consist of concentric circles of gas filled tubes. The lighting is controlled by a computer, and the circles flash on and off in a random fashion to produce displays of light. His use of concentric circles is reminiscent of targets and has a commercial look.[126]

Rockne Krebs uses lasers to create visual displays. Lasers produce coherent light, that is, intense light of only one color and wavelength. The light is tightly focused and does not spread out, so the waves line up and behave as a single wave. In light shows that Krebs calls laser sculptures, beams of light are flashed through darkened rooms or across nighttime skies and form vivid interplays of color.[127]

Jenny Holzer's medium is words, and she uses them to express "truisms," her personal statements about life, politics and other things. Sometimes she presents her truisms using displays illuminated with light-emitting diodes or LEDs. (An LED is a semiconducting device that produces light when electricity is applied.) Holzer's lighted truisms were featured as the solo exhibition in the American Pavilion at the prestigious Venice Biennale in 1990 and awarded the Leone d' Oro (Golden Lion) for best pavilion at this event.[128]

Light and color are phenomena related to art. When the science behind light and color and the art related to them are explored, connections between science and art are discovered.

CHAPTER 12
VISION AND ILLUSION

"Art does not reflect what is seen,
rather it makes the hidden visible."
~ Paul Klee

VISION AND ILLUSION ARE OTHER PHENOMENA related to art. To understand and appreciate vision and illusion, how they work and how essential they are to art, it is necessary to consider the science behind them.

Art is a visual experience, and it depends upon the sense of sight. Vision is a phenomenon that involves the presence of light and the experience of sight, and the eye is the sensory organ responsible for the experience. Light enters the eye through the transparent cornea where it is refracted, and then it passes through an opening, the pupil, to the lens. The size of the pupil is regulated by the iris, a muscle with pigmentation. In dim light, the pupil is large and becomes smaller as the light becomes brighter. Light passing through the convex lens is refracted and focused on the light sensitive retina as an upside down or inverted image. Retinal tissue is composed of cones and rods, so named because of their shapes. The cones respond to color, and the rods, more sensitive than cones, detect dimly lit objects and black and white. The cone cells come in three varieties, each receptive to a primary color of light (red, blue or green). When light waves strike the sensitive rod and cone

cells, they are converted into electrochemical nerve impulses and transmitted by the optic nerve to the brain where they are interpreted.

In the presence of bright light, like the headlights of a car, the eyes of dogs, cats and nocturnal animals appear to glow. This is due to a light reflecting layer, the *tapetum lucidum*, located behind the retina of these animals. When light passes through the retina, it is reflected by *tapetum* and magnified by the lens to produce a glowing effect. This also stimulates the animal's retina and improves its night vision.[129]

The camera is an optical device that in many ways resembles the eye. Light passes through a transparent covering, goes through an aperture and is admitted into the camera by opening the shutter. A convex lens focuses the light on light-sensitive film as an inverted image. The film contains emulsions of chemicals that undergo chemical change upon exposure to light.[130] When the film is removed from the camera, it is developed with chemicals to produce a negative. From the negative, a positive print or picture is prepared. A digital camera focuses the image on a light sensitive mechanism, instead of film, that converts the light into a digital code and stores it as a file on a memory card. The digital information can be transferred to a computer, where the images can be manipulated and changed to suit the photographer and stored for printing.

Photography was invented in the 1800s, and it slowly became an acceptable medium for artists. One of the first to advance photography as an art form was Alfred Stieglitz. He developed a direct and candid technique for portraying an American city on film. Stieglitz's city was New York, and he captured the essence of the urban experience at the beginning of the twentieth century. Milton Rogovin developed a direct and candid technique for portraying the people of an American city on film, the same ones over a period of time. Rogovan's city was Buffalo, and he captured the essence of the individuals who lived in city neighborhoods.

Photography is especially popular with contemporary artists. Cindy Sherman uses herself as a model and dresses to take on the identity of others. Rather than self-portraits, her photos are attempts to have viewers see themselves through her work. She asks questions with her photography and leaves her photos untitled to allow freedom of interpretation. Adam Fuss works without a camera and takes pictures by directly exposing film to lighted objects. He calls the large, delicate, sensitive and enigmatic images, photograms.

The camera obscura is a camera-like device for projecting images on a surface. It is a way to transfer images, and it is much easier than freehand drawing. A simple camera obscura is a box with a convex lens at one end and a translucent window at the other. When a well lighted object is placed in front

of the lens, an inverted image forms on the translucent window. If a mirror is placed inside the box to reflect the light, the image is projected upright. From there the image is traced on thin paper. The addition of a system of lenses and an adjustable box sharpens the focus. Another design uses an entire darkened room as the camera. The lens system is in one position and instead of a window with tracing paper, there is a canvas. While considered obsolete, the camera obscura was used by a number of artists in the past. It is believed Jan Vermeer, Jan van Eyck, Hans Holbein, Leonardo da Vinci, Diego Velázquez and Caravaggio (Michelangelo Merisi da Caravaggio) were among the artists who found it useful. The device was an aid used to assist the artist, but it was up to the artist to add color, texture, light and shadow and transform the outline into a work of art.[131] The camera lucida is a similar device. It has lenses and prisms for refracting light and produces images that are enlarged or reduced in size. In the 1800s Frederick Catherwood traveled to the Yucatan and Egypt and made a series of illustrations based upon Mayan and Egyptian art using the camera lucida. Today's artists use modern projection equipment and technology for their transfer processes.

Illusion is a phenomenon that takes place when something appears to be different from its reality, and it occurs as the brain is tricked into perceiving things that are not there. The ancient Greeks were familiar with illusion and incorporated it into the design of their buildings. At first glance the Parthenon appears to be built with straight structural lines, but close inspection reveals something different. The columns have a slight convex curving or swelling from top to bottom, known as entasis, that creates the illusion they are straight. In addition, the columns are not evenly spaced and tilt slightly inward. The architectural variations were intentional, and their presence adds sculptural quality and grace to this ancient building.[132]

Mirrors reflect light, change the way things appear and create illusions. A mirror with a flat reflecting surface is a plane mirror, one with a surface curving outward is convex and one curving inward is concave. The images produced by the three types of mirrors are different, and the differences can be observed with an ordinary flat mirror and a spoon. With a flat or plane mirror, the image is upright and reversed, straight up with the left and right sides switched. The surfaces of a spoon are also mirrors and reflect light, the outside of the spoon is convex, and the inside is concave. The convex side produces a smaller upright image with the sides reversed, and the concave side produces several different images depending on the curvature of the spoon and the closeness of the object to the spoon. Sometimes the image is upright, larger and reversed, and sometimes the image is inverted, smaller and reversed.

Artists use the reflections from mirrors to create illusions. Charles Le Brun designed a room, the Hall of Mirrors, for the Palace of Versailles based on the illusions made by mirrors. Seventeen large windows admit light to the room, and the light is reflected from seventeen plane mirrors on the opposite wall. This gives the long narrow hall the illusion of depth[133]. The *Mirrored Room* by Lucas Samaras is an 8 x 8 x10 foot (244 x 244 x 305 cm) wooden box, covered on the outside and the inside with pieces of plane mirror. The reflections on the outside of the box display images of the surrounding museum space. The ones inside the box are images reflected and reflected again and again off the six mirrored surfaces. The multiple images produce the illusion of depth.[134] Michelangelo Pistoletto has made life-size reproductions based on photographs of people. He painted the likenesses on tissue paper and attached them to flat stainless steel surfaces. When people gazed at them, they saw their images reflected from the shiny surfaces and incorporated into the compositions.[135] Millennium Park in Chicago has a 110 ton (100 metric ton) sculpture, *Cloud Gate*, by Anish Kapoor. It is an outdoor work with a seamless exterior of polished stainless steel. Structurally it resembles a large inverted jellybean, and Chicagoans have nicknamed it "The Bean". Its surfaces are convex and concave, and they reflect light and distort images. As people walk around the sculpture, they see their images against the backdrop of the Chicago skyline, and they see themselves right side up, upside down, reversed, and larger and smaller than reality. The experience forces viewers see themselves in different ways, and perhaps it makes them think about how others view them.[136]

Artists usually paint or draw on flat surfaces, and when they want to create the illusion of depth and space, they rely on a number of artistic techniques to enhance their work. They can use perspective, foreshortening, anamorphosis, composition and light and shadow to organize space and represent the three dimensional forms of reality on two dimensional surfaces.

Aerial or atmospheric perspective is based on the observation that colors appear to change and fade with distance. In areas flooded with light, far away objects are less colorful than nearby ones, and they are out of focus. The artist creates the illusion of depth by altering color and changing sharpness. Roman wall paintings are a good illustration of aerial perspective. The people, plants and objects in the foreground are well colored and sharply defined, while those behind them gradually lose their color and shape with distance. Chinese artists used a similar technique and painted the ridges of mountains in graduated colors and introduced mists and clouds into their compositions.

Linear perspective is based on the observation that objects appear to get smaller and closer together with distance and parallel lines seem to converge as

they recede. The technique was developed during the Italian Renaissance and became a way for artists to use the geometry of lines to organize figures and create the illusion of depth within their work.[137] It was first demonstrated in drawings by Filippo Brunelleschi and written about by Leon Baptista Alberti.

Then Piero della Francesca, who was skilled in both art and geometry, wrote a theoretical treatise on the subject. His art was defined by the mathematics of geometry and by perspective, proportion, light and color. Leonardo da Vinci was also interested in perspective and recorded his observations in notebooks. His *Last Supper* is a well documented use of linear perspective. The architecture of the room and the placement of the figures within the composition are along lines that converge and place attention on the central figure, Jesus.[138]

Foreshortening is a technique used to depict a figure or object close to the viewer. The portions of the figure closest to the viewer are larger than those farther away. Foreshortened objects appear somewhat distorted and angular. A foreshortened arm extended toward the viewer has a larger hand and forearm than upper arm, and this gives the arm a three dimensional shape and makes it look like its coming from the surface of the painting. To create the illusion of depth, foreshortened forms are often included within compositions. *The Supper at Emmaus* by Caravaggio shows four men gathered around a table for a meal. The appendages of several figures are foreshortened: one elbow and two hands appear to project from the painting while another hand recedes.[139] Rembrandt van Rijn's the *Company of Frans Banning Cocq*, also known as the *Night Watch*, shows the dramatic effect possible with foreshortening. The hand of one figure and the spear held by another seem to project from the canvas and penetrate the viewer's space. Michelangelo's ceiling in the the Sistine Chapel shows figures with foreshortened features, ones that created illusion and gave this almost flat ceiling a three dimensional quality.

Another technique, known as anamorphosis, creates an extreme distortion. Objects are hidden within a painting and only become visible when viewed from a sharp angle. The best known example of anamorphosis, that is, the one included in most art history books, is found within the painting, *The French Ambassadors*, by Hans Holbein, the Younger. The composition features two men with their arms resting on a table. Below them and suspended above the floor is a mysterious elliptical form. When the painting is viewed from the right at a very sharp angle, the form appears as a skull. The meaning of the skull is ambiguous, but perhaps it serves as a reminder of human mortality and death, a *memento mori*.[140]

Julian Beever is a contemporary artist who uses anamorphosis. He creates anamorphic drawings in pastels on the streets of European and American cities and is known as "the Pavement Picasso". He works with a camera on a tripod, and he keeps the camera in one spot as he draws and checks every mark he makes. When walkers approach his art, the drawings appear to rise from the sidewalks or sink into them. The illusions are perceived as real, and walkers often turn away to avoid bumping or falling into them. When the anamorphic drawings are viewed from other angles, they look distorted and their illusions are hidden. Beever's pastels take about three days to complete and are subject to the whims of weather. Because they are temporary in nature, they are photographed for the record and appear on his website.[141]

The composition and arrangement of figures within a painting can also create the illusion of depth. In *Madonna and Child with Angels* by Fra Filippo Lippi, the Madonna, the Christ child, one of the angels and the arm of a chair are positioned in front of the framed background. This organization of figures creates an illusion and gives the painting its three dimensional quality.

Light and shadow add form to flat objects, and many artists have used them with great finesse. Leonardo gently modeled his figures and employed light and shadow to direct attention to faces. The shaded atmospheres he created had hazy and smoky qualities. Caravaggio gave form and produced dramatic effects within his paintings with strong light and shadows. The lighting employed by Artemesia Genteleschi intensified the drama of the Biblical and mythological stories she painted. Georges de La Tour, Jusepe de Ribera and Francisco Zubarin used the very sharp contrasts between light and dark to spotlight figures within their paintings.

Masaccio (Tommaso di Ser Giovanni di Mone) was an artist who lived during the early part of the 1400s. He worked with both linear and atmospheric perspective and used light to provide form and unify compositions. Even though he died at the young age of twenty-seven, his work was recognized as important, and it influenced many. Leonardo, Michelangelo and Raphael were among the Renaissance artists who stood before his frescoes, studied his techniques and were inspired by them. Masaccio's fresco, *The Holy Trinity* is a crucifixion scene that illustrates the illusion possible with perspective and light. It shows a barrel vaulted chapel with Christ on the cross surrounded by three figures. The space behind the cross and into the vault appears to gently recede. There are two figures outside the framing of the vault, one on the left and the other on the right. The illusion the painting creates is one of a real chapel filled with mourning people. A viewer standing in front of the fresco

is visually able to enter the chapel and become a participant in the drama. Another Masaccio fresco, *The Tribute Money*, demonstrates several ways of creating illusion within a single painting. It tells a story about Saint Peter with three groupings of figures within the fresco. The central group shows Jesus with Peter and the other disciples. To the left and receded is another figure of Peter, and to the right and slightly forward is third figure of Peter with a man. The building to the right and the figures are represented in space using linear perspective. The building is realistically sculpted with light and shadow. The figures are modeled, but somewhat stiff, and show slight foreshortening. The lighting is soft, and the scene is brought to life with gentle color. The figures are set against a background of trees and mountains that gradually fade into a haze with the color gradations of aerial perspective.[142]

Artists use paint to create illusion. William Hartnett collected items and attached them to surfaces in arrangements that had a shallow depth of field. He used paint to represent the objects in a manner that suggested they were authentic rather than painted objects. The technique is *tromphe l'oeil*, a visual deception that tricks the eye of the viewer into believing the painted objects are real. A century later, Sylvia Plimack Mangold employed perspective and lighting and mastered the *tromphe l' oeil* technique. She has painted floors, measuring sticks and masking tape. Plimack Mangold's faux tape is made from layers of acrylic paint and appears real, so much so that it looks like the actual sticky tape, torn and positioned by hand. Its tactile quality tempts viewers to pick and pull it from her paintings. Chuck Close painted monumental portraits from photographs with careful attention to detail. They are magnified views and were more real than reality. The paintings reveal every pore, whisker, wrinkle, and imperfection and turn the topography of a face into a landscape. Other portraits are recognizable likenesses from a distance, but close up the faces disappear and dissolve into grids filled with ovals and lines and abstractions. The large sweeping gestural paintings of Karin Davie also create illusions. Her fluid loops and lines of rich multicolored pigment twist and fold in and out, up and down, and back and forth. As the colors sweep the canvas they delineate space and create a three dimensional effect that suggests the presence of inner forms.

Artists also use the optical effects of geometric forms to create illusion. Vision and illusion are involved, and the eye and the brain are tricked into seeing things that are not there. Following a 1964 exhibition at the Museum of Modern Art, this art became known as optical art or "op art".

Victor Vasarely used repeated geometric patterns and variations in colors to produce the illusions of shape and motion and referred to his art as

visual research. Jesús Raphael Soto attached thin shaped wires to threads and suspended them against a grid of closely spaced lines. Where the wires and the lines appeared to intersect, visual interference occurred and an effect known as *moiré,* named after a type of silk patterning, was created. Larry Poons has experimented with color and produced paintings with lingering effects. He has painted with complementary colors that stimulated and fatigued the cells of the retina and produced images, "after images" that remained in view. Bridget Riley has created the illusion of motion with wavy lines of black and white and color. Her canvases have a dynamic vibrating quality and are filled with undulations, slightly out of phase with each other, that suggest the electromagnetic waves of light.[143] In 1968, Riley represented Great Britain at the Venice Biennale and was awarded the International Prize for Painting.

Vision and illusion are other phenomena related to art. When the science behind vision and illusion and the art related to them are explored, connections between science and art are discovered.

CONSERVATION

CHAPTER 13
INTO THE LAB

"The important thing in science is not so much to obtain new facts
as to discover new ways of thinking about them."
~ *William H. Bragg*

A MODERN LABORATORY, WHETHER INVOLVED IN scientific pursuits or the conservation of art, is equipped with a multitude of sensitive high-tech instruments and run by a professional staff of well educated people.

When a work of art shows the effects of age and/or environment, it is often taken to an art conservation lab for evaluation, for an actual physical examination. To provide an overall assessment, the exam begins with a visual inspection of the piece to determine its general features. Observation is a key component of all lab work and is especially important in art conservation. The object is observed under a variety of lighting conditions (normal, transmitted and raking light), and its surface characteristics are studied. Normal lighting uncovers cracks, chips, tears, missing parts, discoloration, fading, corrosion, dust, dirt, grease and previous repair work, and it reveals brushstrokes, tool marks and fingerprints of the artists and sometimes the materials of construction. Transmitted light passes through the object and shows tears, cracks and thinly painted areas. This is especially useful in examining works on paper, because it shows structure, density, watermarking and irregularities of the paper. Raking light is light positioned at a low angle, an oblique angle,

so that it reflects off the surface of the object. This lighting exaggerates uneven and subtle variations in the surface and reveals warps, splits, bulges, dents, cupping and flaking. It also aids in the discovery of the artist's technique and previous repair work.

Ultraviolet, infrared, x-ray and computerized tomography are imaging techniques that extend the range of observation and allow internal components and underlying layers to be examined without damage. When used with paintings, they uncover the supports, the ground coats of priming and sizing and the layers of paint and varnish. They also reveal the internal structures and construction elements of sculptures. Since the techniques are noninvasive and nondestructive, they do not harm the art works being observed.

Ultraviolet rays (UV) are electromagnetic radiations with wavelengths slightly shorter than visible violet light. They are invisible to the human eye, but they cause some materials to fluoresce. When UV is directed at a painting, parts of it may fluoresce and show surface changes and the presence of certain pigments and other materials. The UV technique is used to distinguish paint applied by the artist from paint added by others.

Infrared rays (IR) are electromagnetic radiations with wavelengths slightly longer than visible red light. They are invisible to the human eye and are detected with special infrared sensitive film. Infrared technology, IR photography and IR reflectography are able to look through the surface of a painting and uncover the stages of its creation. They reveal the presence of underdrawings and underpaintings that show how the artist developed the work. Drawings done with carbon materials absorb the IR radiations and appear black with this technique.

X-rays are electromagnetic radiations with short wavelengths and high frequencies. They are invisible and affect photographic film, and they are penetrating and can pass through many materials, including the thicker opaque layers of art works. X-ray images reveal the structural conditions of paintings and their supports and show layers, repairs, patches and underpaintings.[144]

Computerized tomography (CT) produces scanned images in thin slices with high resolution and contrast. CT scans of ancient Egyptian mummies, including King Tut's, provide information about the lives and illnesses of the people living along the Nile River.[145] While the scans of medieval illuminated manuscripts are used to examine the paints on the parchment surfaces and their method of application. Other CT scans have studied cuneiform tablets and the intricate carving methods used to make antique Japanese netsukes, the small carved button-like kimono ornaments.[146]

Another technique is autoradiography, and it is used to produce images on film that show the distribution of specific pigments and the layering of paint. Low doses of radiation are directed at the painting, then a series of images, radioautographs, are taken. The images show the distribution of manganese, copper, sodium, arsenic, phosphorus, mercury and cobalt within the pigments and reveal the development of the painting from the underdrawing, layer by layer, to the surface.

A number of paintings from the National Gallery in London, including *Giovanni Arnolfini and His Bride* by Jan van Eyck, have undergone noninvasive examination. An infrared study of this very detailed tempera and oil painting on a wooden panel revealed an underlying preparatory drawing with outlines and shadows with hatched lines. When the position of Arnolfini's hands in the underdrawing were compared with those in the finished painting, it became evident van Eyck made compositional changes while painting. Various glazes used to build up shadows and depth of color also showed up. Rembrandt van Rijn's *Jacob Trip* and *Margaretha de Geer*, oil paintings on canvas, were also studied. Jacob is pictured on a high backed chair, but x-ray examination shows he was originally positioned on a simple round chair. Further inspection with UV uncovered the artist's signature on the side of the canvas. Part of it was missing, and it suggests the painting was cut from its original size to a smaller one. X-rays of Margaretha's sleeves show lace cuffs that were omitted from the final work.[147]

There are many casts of Auguste Rodin's *The Thinker*, a seated figure engrossed in thought. The original was a part of a much larger composition, *The Gates of Hell*, and was grouped with others and positioned over the door. When it was enlarged and cast as a free- standing sculpture, it no longer had support from the other figures and became top heavy. X-rays of the bronze cast, in the collection of the National Gallery in Washington DC, provided an inside view of this statue. They showed a lead counterweight in its base and revealed the presence of iron armatures left from the casting process.[148]

Magnification increases the visual inspection of art objects. A very simple hand lens or magnifying glass often does the trick by extending the range of the unaided eye several times. Elaborate stereomicroscopes magnify between 6 and 40 times, and they have two eyepieces that allow the use of both eyes to provide three dimensional views of the objects being studied. This offers a more detailed examination and enables the viewing of fiber structure, crystals, specks of paint, fungi, spores, the remains of insects and spiders and small artifacts associated with the piece. Other microscopes with higher magnifications add even more detail to the inspections. Some

microscopes have an ultraviolet source, and under this illumination, a number of materials fluoresce and can be identified. Other microscopes are equipped with polarized light, light that is vibrating in a single direction, and are used to observe paint cross-sections and crystalline structures. While scanning electron microscopes provide a close examination of surface topography and cross sections of small samples. And many microscopes are equipped with cameras to record observations for later study.

Materials analysis examines the composition of the materials in paints, binders, oils, varnishes and resins. A *qualitative* analysis identifies the materials present, and *quantitative* analysis determines the amount and proportion of the materials present. For instance, a qualitative analysis of sodium chloride indicates the presence of sodium and chlorine, while a quantitative analysis of sodium chloride shows the proportion, by mass or weight, of 39% sodium and 61% chlorine.

Spectroscopy is a method of materials analysis that uses spectra to identify materials. This is possible because each material has a characteristic spectrum. When a wire dipped in a solution of sodium chloride (NaCl) is held in the flame of a gas burner, a luminous yellow color appears. The yellow color is characteristic of the element sodium and is a property of sodium. When this procedure is repeated with a solution of potassium chloride (KCl), a violet color, characteristic of potassium, shows up. Copper salts produce a blue-green color and strontium salts create a bright red. When light, coming from sodium, potassium, copper, strontium or any other luminous source, passes through a spectroscope, characteristic bands of color or spectra appear. The spectra are used to identify the materials present.

A spectro*scope* is an instrument with a prism or a diffraction grating. A diffraction grating has thousands of fine grooves on its surface, and like a prism, is able to disperse light into a spectrum. (a DVD or CD has grooves like a diffraction grating and can break light into a spectrum.) When light from a luminous source enters a spectroscope, it passes through a narrow slit and comes out as parallel rays. The parallel rays pass to a prism or a diffraction grating that separates them into a pattern of brightly colored lines with specific wavelengths. This is known as a bright line spectrum. The bright line spectrum for each material is unique and is used to identify the material. Sodium produces a characteristic spectrum with two bright yellow lines of specific wavelengths. No other material has the same spectral pattern, so when this one shows up, sodium is identified. Potassium, copper, strontium and other materials have characteristic spectra used for their identification.[149]

A spectroscope is a relatively simple scientific instrument for identifying materials, but when it is combined with other instruments, more precision and detail are added to the analysis. A spectroscope with a meter for measuring wavelengths is spectro*meter,* and one with a photographic or digital device for recording spectra is a spectro*graph.* The photographic record of the spectrum is known as a spectro*gram.* Spectrometers are coupled with infrared, ultraviolet, x-ray fluorescence and other devices. Spectrophotometers and mass spectrometers are more complex and sophisticated instruments used for materials analysis. Spectrophotometers compare the intensities of spectra, and mass spectrometers ionize materials and measure their mass to charge ratios as they pass through electromagnetic fields.

Chromatography is another method of materials analysis, and it is used to separate and identify the materials in a mixture. Paper chromatography is a simple technique for separating the materials in a liquid mixture. When the end of a strip of filter paper is placed in a watery mix of food coloring and allowed to stand for a couple of hours, the colors migrate up the strip at different rates and separate into individual bands of color. Gas chromatography, a more involved technique, separates the materials in a gaseous mixture. A small sample is prepared, vaporized, combined with an inert gas and added to a special column. As the gas carries the materials through the column, the materials move at different rates and separate. The separated materials pass through a detector for identification, and the results are recorded as a series of characteristic peaks that indicate the presence of specific materials within the sample.[150]

Knowing the age of an art work is important. However sometimes it is difficult to determine, especially if the work is old, hundreds to thousands of years old, and has no record. Dendrochronology and carbon 14 dating are two methods for ascertaining the age of older objects.

Dendrochronology is the science of using tree rings to establish a time line. As a tree grows in diameter, concentric rings of fibrous water conducing tubes are added. The tubes formed during the spring, when water is more abundant, are larger than those added later in the year, and the larger tubes are lighter in color than the smaller ones. This difference in coloration produces an annual ring and shows one year's growth. To determine age, the visible rings in a cross-section are counted. (The age of a living tree is established from a small core sampling, one that does not harm the tree.) The annual ring pattern also reveals climate changes that occurred while the tree was alive and growing. Tubes formed during wet years are larger and the rings are farther apart than those formed during dry years. Ring patterns are unique

and are carefully matched with ring patterns from older trees and logs to establish chronology.[151] Tree ring study is an exacting procedure, and it has yielded some interesting results. A study of the wood from a panel painting of Queen Elizabeth I determined the wood came from a tree cut after 1604. Elizabeth died in 1603, so the portrait was painted after the Queen's death. Dendrochronology has produced timelines for a number of areas where pottery, baskets, wall paintings and sculptures are found, and it has established a chronology for the American Southwest that goes back twenty-three hundred years. In 2003 an Anasazi ruin with thirty-five rooms was uncovered in the Tsegi Canyon of northeastern Arizona. The site contained outlines of human hands and pictographs and petroglyphs of bighorn sheep and lizard men, and it had a chiseled snake forty feet long and an artfully designed platform. Using dendrochronology, the location was dated to 1273 - 1285 and confirmed as one of the final places occupied by the Anasazi.

Carbon 14 dating uses an isotope of the element carbon to determine the age of an object. All carbon atoms have 6 protons in their nuclei, and this is what makes them carbon rather than some other element. Most carbon atoms also have 6 neutrons in their nuclei and are known as carbon 12 (6 protons plus 6 neutrons). A less common atom of carbon has 8 neutrons and is referred to as carbon 14 (6 protons plus 8 neutrons). Carbon 12 and carbon 14 are isotopes of the element carbon. Briefly stated, isotopes are atoms of an element with different numbers of neutrons. Most elements have several isotopes. Oxygen has three (oxygen 16, oxygen 17 and oxygen 18), uranium has three (uranium 234, uranium 235 and uranium 238) and carbon has three also (the afore mentioned two plus carbon 13).

Isotopes have properties. Carbon 12 is stable and not radioactive, whereas carbon 14 is radioactive and undergoes changes. A radioactive isotope decays and becomes less radioactive over a period of time. The time it takes for one-half of the nuclei of a radioactive isotope to decay is known as its half-life. Some isotopes have a long half-life (tens, hundreds, thousands, millions of years) while others have a short half-life (seconds, minutes, hours, days). Half-life is a property of the isotope. The half-life for carbon 14 is 5730 years. This means that after 5730 years, one-half of the original amount of radiocarbon in a sample remains radioactive and one-half has decayed and is no longer radioactive. In another 5730 years, one-fourth of the original sample remains radioactive, in still another 5730 years one-eighth remains radioactive and so on, gradually decreasing the amount of the radioactive isotope present.

Living things take in carbon from their environment and form organic compounds made of carbon. Both carbon 12 and carbon 14 occur naturally,

but the vast amount carbon is carbon 12 with only a little carbon 14. All living organisms assimilate both isotopes during their lifetimes and gradually build up radioactivity. When living things die, they no longer take in carbon and gradually loose their radioactivity. Wood and some pigments, fibers and cloth are organic and come from living organisms. The amount of radiocarbon present in a material is a measure of when the organism that produced the material died. Half-life measurement with carbon 14 is useful for dating objects under 50,000 years. Carbon 14 dating helps to establish age, and the date it provides develops a chronology for the organic materials in the art object. An old painting, perhaps an original portrait by Leonardo, was discovered. It was subjected to carbon 14 analysis that determined the wood supporting the canvas dated to the time of Leonardo. However more testing is needed to establish the painting as one by the Renaissance great.

Carbon 14 levels in the environment have varied over the years. To insure the accuracy of the dating, the carbon 14 technique is calibrated with dendrochronology and other methods for determining age.[152]

Art works can be examined scientifically to determine their attribution. The oil painting, *St. Cecilia and an Angel*, in the collection of Washington's National Gallery, was originally attributed to Orazio Gentileschi. Then the materials of the painting were studied to learn if the work had parts that were overpainted by another artist, Giovanni Lanfranco. Small cross-sections of paint were analyzed with a scanning electron microscope / energy dispersive spectrometer. The areas known to be painted by Gentileschi contained a lead-tin yellow pigment, but other areas showed a different one, a lead-tin-antimony yellow pigment used by Lanfranco. The analysis revealed Lanfranco worked on the painting, and now the painting is attributed to both Gentileschi and Lanfranco.[153] Rembrandt was a successful artist with a distinct and innovative style. His paintings were built with layers of paint, and his brushwork was complex and varied. His work was acclaimed and imitated by others. Copies were made, some by his assistants and others by students, and they were done in admiration of the artist's work and not necessarily intended as forgeries. As a consequence, a great number of paintings are credited to Rembrandt. To solve the problem of attribution, the paintings in question are subjected to scientific scrutiny and studied for layering and brushwork. Microscopes examine tiny paint samples for the build-up of paint, and x-rays penetrate the surface to check the layering of paint and brushwork.

Adoration of the Magi, from the Uffizi Gallery in Florence, is a large incomplete work attributed to Leonardo. The painting was subjected to an extensive examination with a wide range of imaging techniques, including

visible light, ultraviolet fluorescence, infrared reflectography and x-radiography. The scientific work uncovered a number of surprising things, including the images of underdrawings, previously hidden from the naked eye. The drawings were done directly on the wooden panel rather than transposed, and they were complex in their composition with groupings of many figures. They showed the genius of Leonardo at work and his interest in motion. The studies also revealed another artist added the brown surface pigment many years later, so *Adoration of the Magi* was not, as previously believed, entirely the work of Leonardo.[154]

Scientific analysis also reveals outright forgeries, and the examination of pigment is especially important in this process. Many of the pigments used by the Old Masters are now available for today's artists and forgers. Lead was a common ingredient in the pigments of old paintings, and if lead is present, the painting may or may not be old. To determine the validity of a suspect painting, it is first checked for lead pigments using an x-ray fluorescence spectrometer, a nondestructive technique. If lead pigments are found, small samples are taken and further examined with a mass spectrometer. If significant amounts of a radioactive isotope, lead 210, are discovered, the pigments are of recent origin, because lead 210 has a half-life of *only* 22 years and is never found in a centuries old painting.

One of the most notorious forgers of the twentieth century was Han van Meegeren. He came to forgery as a way to prove his greatness as an artist, and he succeeded in producing oil paintings that passed as works by Jan Vermeer and other Dutch artists from the past. His story is a classic connecting science and art. In the process of mastering the deceptive craft, van Meegeren spent a number of years learning how to make his paintings look old. Oil paint requires time to dry, sometimes as long as fifty years. He resolved the time constraint by mixing pigments with a synthetic resin rather than oil and baking the canvases in an oven. His deception succeeded, and the paintings were sold, some to Nazis, including one high ranking party official, Hermann Goering. Following World War II, van Meegeren was accused of treason for collaborating with the Nazis and selling Dutch art to them. A trial was held. He confessed to forging paintings and selling the forgeries to the Nazis, but he stated he never sold any original paintings by Vermeer or other Dutch artists. No one believed him, and this led to a two year scientific examination of his artwork. The investigation revealed he used a powdered pigment with lapis lazuli, like Vermeer, but it was mixed with cobalt blue, a nineteenth century pigment not available in Vermeer's time. X-rays disclosed a network of cracks in his paintings that were not consistent with those in original paintings. Further study found the surface cracks were filled with ink to imitate the dirt and grime of age and showed the

presence of ink seepage beneath the paint and into the canvas. One his forgeries was painted over a seventeenth century painting whose surface, all except a small patch of white, was removed with pumice and water. Radiographs were taken, and they showed the original white under the forged areas. To the very end, van Meegeren believed he should and would receive recognition as a great artist. However he was eventually convicted of fraud and sentenced to a year in prison, but he died before being sent to jail.[155]

The instruments and methods of a modern laboratory are essential for scientific research, and they are the ways and means of art conservation. When they are explored, connections between the science of conservation and the art of conservation are discovered.

AS TIME GOES BY

"Art is the signature of civilization."
~ *Beverly Sills*

ALL THINGS CHANGE OVER TIME including art, and some works show the effects of age and environment more than others and require conservation. Art conservation is the study, preservation, restoration and stabilization of works of art and cultural materials, and it involves the examination, analysis and treatment of them. It is delicate and time-consuming work, and it is tailored to fit the individual needs of each object.

How well a piece of art stands up to the test of time is determined by the materials and techniques of its composition and its environment. Works made of glass, ceramic, metal and stone are more durable and stable and hold up better than those of paper, fiber and wood. Some works are produced with well established traditional materials and techniques, while others are built with materials and techniques that are new and experimental and perhaps not as reliable.

Beginning in the 1950s many artists abandoned the use of oil paint and began to use the then new acrylic, alkyd and enamel paints. Some even worked with commercial paints that came in cans straight from hardware stores. The artists liked the properties of the new synthetic paints, specially the way they thinned, the way they handled and the effects they created.

In the intervening years, problems developed, specific problems for the art conservators and the science of conservation. The newer paint surfaces were soft and dirt adhered easily. Some harbored mold, some discolored and others cracked. The use of oil paint was hundreds of years old and understood by the conservators, but this was not the case with the synthetics. Different methods of conservation were needed. To address the ongoing issue of new materials, the Getty Conservation Institute, the Tate in London and the National Gallery in Washington, DC joined forces and formed a research project, Modern Paints. Through the use of technology, this long term project has aimed to understand the science behind the synthetic paints and preserve the art made with them. High-tech instruments collect data related to the new pigments, solvents, binders and other materials, and machines simulate the effects of weather and the fading caused by intense lighting.[156]

Art works respond to their environment. They react to how they are displayed, handled, shipped and stored, and they require special care if they are to survive. The very fragile are often placed behind glass or in vitrines, glass display cases. Environmental factors such as light, humidity, temperature, air pollution, organisms of decay, insects and human handling can affect art. Light, especially light with ultraviolet, can affect paper, fiber and some pigments, and it can start and speed up chemical changes that cause fading and irreversible yellowing. To prevent this, special lighting is often used. Humidity can corrode metal and contribute to the warping, splitting, cracking and shrinkage of wood and painted surfaces, and acid rain and airborne materials can chemically damage outdoor art. When combined with temperature, humidity can encourage the proliferation of molds and fungi that grow into wood, paper and fiber and cause decay, and dust, dirt and smoke can alter the appearance of art. Insects and spiders are not known for their appreciation of art, and when they lay their eggs, they seek places that offer food for their offspring. If the selected spot is a piece of art, it can be eaten away and reduced to a trail of holes and particles. The handling of art is important also, as the objects must be carefully lifted, moved and packaged to avoid damage. Special gloves are worn to protect the works from the residues of the oils, acids, salts and moisture on human hands.

If an art work is in need of repair, it should be taken to a conservation laboratory for evaluation and treatment. The conservators are specialists, educated and trained in the science and art of conservation. They are professionals. They have studied the materials and techniques of art, art history and science, especially chemistry and physics. They know how to examine, analyze and treat pieces of art. Each object is considered individually, and a special treatment plan is developed, as no one treatment fits all. The

conservators aim to maintain the integrity of the object and stabilize it, and they preserve as much as possible of the original for future generations. They also document their examinations, analyses and treatments with written records and photographs.

P. Gabriel Barbisius is a painting with a history that spans centuries. It is a mystery of sorts with elements of the unknown, and it involves the science and art of conservation. The painting shows the half length portrait of a man holding a cross and a spear. It is a dark painting, except for the face and hand of the subject. Below the figure is a lengthy inscription in Latin. The upper right corner has a cross with the letters I, H and S and a small *fleur-de-lis*. The painting measures 37 x 25 x 1 inches (94 x 63.5 x 2.5 cm) and lacks a signature and date.

The story begins in the 1960s on a market day in a European city. A friend of mine spots the painting as it was being unloaded from the back of a truck. She is moved by the tone and mood of the work, reminiscent of many old European paintings, and she asks about it. The vendor tells her it is a portrait of P. Gabriel Barbisius from the seventeenth century. She buys the painting, takes it home and places on display. A few years later, my friend decides to return to the United States and hires a company to package and ship the painting. When the painting arrives, it is damaged. It has a grizzly tear in its upper right corner, and it is no longer suitable for hanging and is put away. Decades pass, and in the interval the painting is moved and stored several times. Then one day, my friend decides to have the painting conserved, and she takes it to the laboratories of the Art Conservation Department at Buffalo State College.

The Latin inscription is translated. It tells of a 1634 battle that destroyed Landshut, a town in Southern Germany, and one that resulted in the death of P. Gabriel Barbisius. Historical research uncovers a 1634 conflict between Protestants and Catholics in Landshut, during the Thirty Years War. The symbol in the upper right corner is interpreted as the monogram adopted by St. Ignatius of Loyola as the emblem for his Society of Jesus, the order of the Jesuits. This symbol plus the cross in his hand suggest the subject of the painting was a Jesuit, and the spear implied his involvement in the battle. This information gives the painting a link with history and perhaps dates the work to the seventeenth century.

P. Gabriel Barbisius is given a thorough examination. The oil painting on canvas is inspected with normal and raking light and determined to be in poor condition. There is a large tear in the canvas, and the ground and paint layers show damage. There is flaking and cleaving of paint throughout the painting and areas of significant paint loss. The varnish layer is discolored,

and the surface is dirty and grimy. The painting has an added lining from an earlier restoration. A portion of the stretcher is detached, and the tacks holding the canvas to the stretcher are rusted. The back of the painting is dusty and harbors insect remains, spider webs and egg cases.

Fiber samples from the support and the lining are examined with polarized light microscopy. This discloses a support made of single ply, plain weave linen canvas and a lining of coarse plain weave jute, similar to burlap, held in place by tape and what appears to be glue paste.

Ultraviolet light shows the presence of many areas of overpainting. Two different ones are visible, the later one on top of the current varnish layer. The hand, areas of the face, the clothing and the background are overpainted. Cross sections are viewed with ultraviolet microscopy, and they reveal the overpaint, the original paint, the sizing and the ground. The sizing layer fluoresces and appears as a separate layer.

Small cross-sections of paint are subjected to pigment analysis to authenticate age. Samples are taken from areas with yellow paint. (Yellow pigments are datable to when they were invented and when they were used by artists.) The pigments are analyzed using scanning electron microscopy / dispersive x-ray spectroscopy. Each layer of the painting is examined in several cross-sections in search of certain metallic elements (antimony, tin, cobalt, cadmium, and chromium) present in yellow pigments. (Their presence would indicate the painting was done at a date later than the seventeenth century.) None are found. The paint layer shows lead with small amounts of iron and calcium, indicating the paint is probably made from lead oxide and is of the type used in the seventeenth century. The middle layer of green paint is similar in composition, with amounts of silicon. The ground layer contains calcium, phosphorus and lead. The pigment particles from the original paint layer and the overpaint are compared. The particles from the original paint layer are coarse and uneven in size. They suggest the pigment was hand processed rather than machine milled and provide evidence the original paint is older than the overpaint.

A specific treatment plan is designed for *P. Gabriel Barbisius*, and it involves ten stages: consolidation, facing, lining removal, tear mending, consolidation, facing removal, varnish removal, overpaint removal, lining and loss compensation.

The conservation process begins with consolidation, facing and lining removal. The most insecure areas are consolidated by applying a solution of glue and covering it with wet strength tissue. The area is gently warmed, and the glue is allowed to dry. Then the tissue is moistened and rolled away. The lining

is in need of removal, so a facing is added. The paint layer is sprayed with a thin temporary varnish. A cornstarch paste is added to the paint layer, covered with tissue and allowed to dry. The lining is removed, and the remaining paste layer is scraped away with a scalpel. The painting is humidified slightly, flattened on a suction table and allowed to dry.

The next stages involve mending the tear, another consolidation and removal of the facing. The tear is repaired under magnification. Using a dental tool, the yarns are aligned and patched together with small amounts of an adhesive and Japanese tissue. The ground and paint layers are rolled with several applications of a consolidating agent mixed with a solvent. The painting is turned face up, and the solvent is allowed to evaporate for several days. Then the painting is placed on a hot table under vacuum pressure to insure the adhesive bond. When this is accomplished, the facing is removed by wetting with another agent, and the tissue is carefully peeled away.

The removal of the discolored varnish and the overpaint with solvents are the next stages. Various solvents are tested, and a mild one is used to dissolve the varnish. With the addition of another solvent, much of the overpaint is also removed. Some parts are delicate and require special treatment with other agents. Some overpaint resists removal and requires the use of stronger solvents. Brushes and cotton swabs are used to apply the solvents and to remove the residue. As the cleaning progresses, a deep red color emerges. (The overpaint had hidden not only the damage to the painting but also the wounds suffered by Barbisius.) Further cleaning reveals additional detail in the original composition.

The next step involves lining the painting with a new support of polyester canvas. A piece of lining fabric with adhesive is placed on the hot table and heated. The painting is aligned and set down on the adhesive. It is covered with silicone treated Mylar and a vacuum membrane and left in contact with the heat while under vacuum pressure for a few minutes. The painting is removed from the hot table and placed on a cool surface under weights for several hours. Then it is attached to a new wooden stretcher with a cross bar for further stabilization. The old stretcher is replaced because it is damaged and not thought to be the original. The final stage is loss compensation. A fill material is brushed into the voids on the paint layer to unify the surface, and it is pigmented to blend with the ground. Several protective layers are airbrushed onto the paint surface and allowed to dry. Then the losses are carefully inpainted with special restoration colors. The conservation of *P. Gabriel Barbisius* is now complete.[157] My friend is given documentation of the procedure, and she takes the painting home to begin its new life.

When an art work undergoes conservation, the entire process is documented from beginning to end. This is important because it is record of the original condition, the treatment given and the condition after treatment, and it provides valuable information for the owner and future conservation work. The documentation includes the Examination Report, the Treatment Report and photographs, those taken before, during and after treatment with normal light, raking light, and ultraviolet induced visible fluorescence.

The conservation of *P. Gabriel Barbisius* involved chemicals, and it required an understanding of the proper use of them. All chemicals deserve respect. People working with them should know their properties and the hazards associated with them. Safety rules exist to prevent fires and accidents and minimize exposure to harmful chemicals. The rules apply to all the places where chemicals are used, including conservation laboratories, science laboratories, art studios, classrooms, industries and private homes. Work areas must have proper ventilation, and food must not be eaten in these places. Chemicals need labels with not only their names, but also their safe use and proper storage. Flammable chemicals require special storage, and fire extinguishers and fire blankets are necessary in areas where they are used. Hazardous, toxic, flammable and/or irritating chemicals necessitate the use of protective goggles, gloves and sometimes respirator masks and the availability of eye washes and shower devices. Finally chemicals demand disposal in ways that are safe and environmentally correct, and hands must be washed after using them.

In the conservation of *P. Gabriel Barbisius,* toluene, xylenes and petroleum benzine were employed as solvents, and all have a hazard alert and are flammable. Toluene and petroleum benzine offer a dangerous risk of fire, while with xylenes the chance is moderate. Toluene is a possible skin irritant and is toxic by ingestion, inhalation and skin absorption. Xylenes is toxic by ingestion and inhalation, and skin contact should be avoided. Petroleum benzine does not carry a toxic warning. Petroleum benzine should not be confused with benzene, a hazardous chemical that was not used in this conservation. Benzene is flammable and a dangerous fire risk, and it is carcinogenic and toxic by ingestion, inhalation and skin absorption.[158]

Conservation involves an understanding of the materials and techniques of art and the instruments, methods and chemicals of science. When they are explored, connections between the art of conservation and the science of conservation are discovered.

CHAPTER 15

TO THE RESCUE

"Our heritage is all that we know of ourselves:
what we preserve of it, our only record."
~ Philip Ward

ART ENRICHES OUR WORLD, and the tangible record of this richness is stored in the paintings, sculpture, architecture and other pieces created by artists. The effects of time, environment, and human interference often take their toll on this heritage, and conservation measures, sometimes heroic, are required.

Modern conservation came to the rescue of Michelangelo's well-known frescoes in the Sistine Chapel. The fourteen year project began with the restoration of the ceiling paintings in the 1980s. The frescoes with their stories from the Old Testament looked dark and grimy and were covered with dust, soot and residue from burning candles. A varnish of animal glue, originally added to brighten the surface, covered the original work. Over time this layer deteriorated, darkened and puckered. Roofing leaks were responsible for deposits of mineral salts, and earlier cleanings left traces of the Greek wine used as a solvent. Utilizing the methods of science, the ceiling was studied and mapped section by section. Computers were involved, and information was gathered and evaluated. From this, the conservators developed a personalized treatment plan and, like Michelangelo, worked on top of scaffolds. They began the cleaning by sponging small sections with distilled and deionized

water. Then using brushes, they applied a cleaning solution known as AB-57 with sodium bicarbonate, ammonium bicarbonate and an antibacterial and antifungal agent mixed with carboxymethyl cellulose and water. This formed a gel that stuck to the ceiling without dripping. The solution was left in place for three minutes, then it and its load of dissolved grime was removed with a sponge and water. Unusually dirty areas were treated at twenty-four hour intervals. As the dirt, remnants of age and previous restorations were cleaned away, the original *buon fresco* layer became visible, and Michelangelo slowly returned to the ceiling. His fingerprints were discovered in the plaster, and evidence of his brushwork and paintbrush bristles were found. As the cleaning progressed, the colors reappeared and sparkled with new life, and the ceiling was restored to its former glory. In spite of this, some people were not pleased with the result and thought the cleaning was too severe.[159]

The *Last Judgment* on the wall behind the altar in the Sistine Chapel had also accumulated years of dirt, soot and candle residue, and it was in need of restoration. Like the ceiling, it was the victim of earlier retouchings that included the darkening of shadows to increase visual effect and the addition of varnish. The cleaning of the wall was done in a manner similar to that of the ceiling, but it was specially modified for the conditions of the wall. First small areas were washed with deionized water, ammonium carbonate and an organic solvent. Then the next day more ammonium carbonate was sponged onto the work area through sheets of absorbent paper. After twelve minutes, the paper was removed, the grime was lifted away and the site was rinsed with water. Slowly the painting emerged and displayed figures set against a background of blue made from two layers of the pigment, lapis lazuli. The color was faded from its original bright blue, and the surface showed abrasions from previous restorations. When Michelangelo planned the fresco, he intended the figures to be nude and painted them without clothing. Some people thought the nude figures were unsuitable for a religious setting, and following Michelangelo's death, another artist added modesty drapes to the figures. During the restoration, most of the drapes were removed, except for a few that were kept for their role in the history of the painting.[160]

The conservation project for the Sistine Chapel also included the installation of a special climate control system designed to regulate the changes in temperature and humidity caused by the thousands of daily visitors. A few years later, new and improved lighting was added.[161]

In 1907, Pablo Picasso completed *Les Demoiselles d'Avignon*, the oil painting that lead the way from realism to abstraction. It remained in the artist's studio until 1924 when it was sold. Sometime after that, the painting

was lined with another canvas. The lining process involved pressure and heat that flattened and probably damaged the paint layers. In 1939, the painting was acquired by the Museum of Modern Art in New York City and given several conservation treatments. It was cleaned in 1950, and lost paint was filled. As a preservation measure, the surface was coated with varnish, but this turned out to interfere with the texture of the painting. In 1963, the stretcher was replaced, and the painting was infused with a wax resin adhesive to strengthen the lining and protect it against temperature and humidity. In 1983, it was given another cleaning, but by 2000 it was looking dull and in need of additional cosmetic treatment. The painting was studied with magnification, infrared and x-rays and found in stable condition. In 2003, the conservators decided to give the work another cleaning and correct the damage of earlier restorations. The dirt and grime were delicately lifted away using cotton swabs moistened with a mild enzymatic solution, commonly known as spit. The varnish was carefully removed with organic solvents, and the earlier retouchings and glue residue from the lining were cleared away. Then the areas of missing paint were inpainted with special soluble restoration paints, a reversible treatment that can be easily removed by future conservators. Following this treatment, the painting was once again bright and clean and returned to the walls of the Museum.[162]

The use of fossil fuels has a profound effect on sculpture and architecture. The fuels contain hydrocarbons and sulfur, and when they are burned, they produce materials that cause damage. The hydrocarbons release water, carbon dioxide and energy, and the sulfur combines with the oxygen in the air and becomes sulfur dioxide. The carbon dioxide joins with water and forms carbonic acid, and the sulfur dioxide unites with water and oxygen and becomes sulfuric acid. Both acids act on the marble and limestone (the calcium carbonate) of statues and buildings and deteriorate them. Some of the world's greatest art is made of marble and limestone and has experienced severe damage of this type. This is especially true of the buildings and statues on the Acropolis in Athens. As a preservation measure, the statues were moved to inside locations and replaced with replicas. Some were placed in cases filled with nitrogen, and others were partially restored with fiberglass.[163] In 2009, the treasures were transferred to the then new Acropolis Museum, a building designed to connect the present with the glory of the past. The contemporary structure, located at the base of the Acropolis, has a glass façade that reflects an image of the mighty Parthenon.

Centuries before the problem of pollution, the Acropolis was in disrepair and was showing the effects of weather, earthquakes and combat. In the early 1800s, it was an Ottoman military fort. Lord Elgin, also known as Thomas

Bruce, the 7th Earl of Elgin, was an ambassador to the Ottoman Empire. He was interested in classical Greek art and was permitted to dismantle some of the relief sculptures from the Parthenon. He carefully selected pieces in the best condition and had them shipped to England where they were were sold to the British government and placed in the collection of the British Museum in London. The Elgin marbles, as they became known, now reside in specially designed rooms within this museum, a long way from their original home in Athens. Ironically the sculptures escaped the ravages of pollution because they were taken to England and placed in a museum. Greece claims the marbles as their cultural property and wants them returned for display in the Acropolis Museum. The British Museum, on the other hand, maintains the marbles are part of mankind's shared culture and should remain with its collection in London. The discussion is ongoing and is likely to persist for many years before it is resolved.[164]

The images on the walls of the Lascaux cave are over seventeen thousand years old and are an important part of early artistic heritage. In 2001 a new climate control system with fans was installed, and it changed the way humidity was regulated and air was circulated within the cave. Shortly thereafter, a white fungus, *Fusarium solani*, began proliferating and threatened to destroy the art. The thread-like mycelia of the fungus spread throughout the cave, and soon everything was covered in white. Perhaps the fans were responsible. They were removed, but the problem persisted. Perhaps the formaldehyde in the foot bath at the entrance was the culprit. The *Fusarium* were resistant to the chemical, but other fungi were affected by it. It was thought the fungi killed by the formaldehyde kept *Fusarium* in check, and this, in turn, upset the delicate system of checks and balances within the cave and allowed the white fungus to spread. An alcohol solution of Vitalub, a disinfectant, was tried, but it also failed. *Pseudomonas fluorescens*, a bacterium in a symbiotic relationship with the mold, was degraded by this treatment. Then quicklime (calcium oxide) was spread on the floor of the cave, bandages soaked with antibiotics were applied to patches of the fungus and slowly the growth of the fungus was contained. Currently the cave is in a stable condition, but its preservation is an ongoing process. Restorers enter the cave on a regular basis and remove the fungus with physical rather than chemical means. As a further measure, access to Lascaux is very limited, and the few entering must don biohazard attire with hoods, booties and face masks.[165]

In the 1970s two bronze statues were found by a snorkeler while swimming off the coast of Riace, Italy. The statues were Greek in origin and perhaps looted from Corinth and lost at sea while en route to their next

destination. The life-sized male figures were raised from the water by divers and taken to the museum at Reggio Calabria. They were badly corroded, heavily encrusted and in need of specialized treatment, so they were sent to Florence. While there, the thick concretions were removed with scalpels and pneumatic hammers, and the surfaces were repaired with microsanders and ultrasonic tools. Gamma ray photographs were taken. They showed support armatures and soldered joints within the statues, and they revealed one of the statues had undergone repair work in antiquity. The figure was made of one alloy, while the corrective work was done with another containing lead.[166] After eight years, the bronzes were returned to Reggio Calabria for display, but soon the inside casting cores, made of vegetable matter, charred wood and animal materials, began to decay and degrade the shells of the statues. In the mid 1990s, the decaying substances were removed from the cores. In a manner similar to a high tech medical procedure, specialized tools and a camera were inserted into the calves of the statues, and carefully manipulated to withdraw the offending materials. In 2009, the museum closed for renovations, and the statues were moved to another location where they underwent more diagnostic work and further conservation. When the figures returned to the renovated Reggio Calabria National Museum in 2013, they were placed on special anti-seismic pedestals in a state-of-the-art climate controlled hall.[167]

The Riace bronzes, as they are known, were made from an alloy used during the fifth century BC and were probably cast between 460 - 420 BC. Over the years, many of the bronze statues from antiquity were recycled, and the metal from them used for other purposes. The Riace bronzes are special because they are two of only a few life-size bronze figures that have survived from the fifth century BC.

Human interference, whether accidental or on purpose, can require intervention by art conservators. A visitor at the Fitzwilliam Museum in Cambridge, England managed to break three antique Qing Dynasty vases valued at $175,000. The late seventeenth to early eighteenth century Chinese vessels were sitting on a windowsill near a stairway, when a gentleman, descending the stairs, tripped on his shoelace and fell into them. The man was not injured, but the vases were shattered. Within six months, the vases were restored and returned for display, but this time within a specially designed cabinet.[168] Another incident, at the Metropolitan Museum of Art, damaged Picasso's 1904 painting, *The Actor*. A woman, on a guided tour with her adult education class, lost her balance and fell into the painting. The accident gashed a six inch tear and required careful repair by the Museum's Conservation Department.[169]

A deliberate interference occurred in St. Peter's Basilica in Rome, when an enraged man used a hammer to attack Michelangelo's *Pieta*. He climbed a guard rail and began pummeling the statue, and he succeeded in chipping the Madonna's face and breaking her arm. Following repair, the statue was returned to St. Peter's and placed behind protective glass. A Roman court declared the perpetrator a socially dangerous person and had him admitted to a mental hospital for two years.[170] Another incident happened at the Detroit Institute of Arts when a twelve year old on a school trip pushed a piece of gum into a Helen Frankenthaler painting valued at over a million dollars. The vandalism required creative work on the part of the conservator, who had removed spitballs, fingerprints and the residue of sneezes from paintings but never gum. First he lifted the gum with tweezers and went over the stain with a damp swab, tissue and solvent. Then he studied the stain under a microscope and tested various solvents. He applied hexane with a cotton swab to remove the stain and pulled the residual gum from the canvas fibers with tweezers. The center of the stained area was lighter than the original, so the color was worked back to the original by gently brushing in pastel. The unidentified offender was properly disciplined, and the incident became subject matter for lessons on proper museum behavior.[171]

The incidental presence of people can also create problems, especially for popular sites like the Great Pyramid of Khufu. Over the years, great numbers of people journeyed to Giza to experience and enter the ancient monument. The humidity within the pyramid gradually increased, and moisture and salt accumulated on the walls. It was estimated that each person entering the pyramid left behind about 0.7 ounces (20 g) of water and salty by-products from their breath and perspiration. At one point, the humidity reached 80%, and in some places the salt deposits were almost an inch thick. In 1998, a decision was made, and Khufu was closed for rest and cleaning. The salt residue was cleared, graffiti was removed and new ventilation and lighting systems were installed. After twelve months, the Great Pyramid reopened, but access to the interior of the ancient monument remains limited.[172]

In early November of 1966, heavy rains fell on the watershed of the Arno River, and nineteen inches of rain accumulated within forty-eight hours. For unknown reasons, the upstream dam gates were opened, and on November 4, the waters of the Arno came roaring down on the city of Florence. The rampant waters picked up debris, overturned cars and took the lives of people and animals. The silt laden waters flooded basements and lifted thick black fuel oil from storage areas. As the currents flowed along the narrow streets and into the surrounding buildings, they picked up sewage and garbage. When the

flood waters receded, they left inches of oily mud on floors. Black oil slicks on walls marked high water points that in some places reached ten feet or more. Florence was a muddy, slimy, reeking mess and many treasures of the Renaissance were in jeopardy. The damage was extensive. Art conservators and student volunteers from many nations appeared on the scene, donned rubber boots, sometimes face masks, and helped with the rescue efforts. They trudged through the ooze and worked tirelessly to salvage the treasures of this city. They evaluated the pieces and started the careful job of saving them. Donations came from far and wide to help with the effort.

A maelstrom of water had surrounded the Baptistery. Five of the ten relief panels from Ghiberti's *Gates of Paradise* were lifted from the doors and caught by the protective fence. The head of one of the figures was severed and later retrieved from the mud and reattached. The precious panels were cleaned and restored and then taken to the Duomo Museum for display, and replicas were made for the doors. Inside the Baptistery, Donatello's *Mary Magdalene* was stranded hip deep in water. The statue required drying and cleaning with solvents, and the process uncovered traces of original paint. The Bargello Museum was inundated as well, and its well-known statues were covered with oily residue. The statues were treated with a poultice of benzene and talcum powder to remove the oil from the pores in the stone and then scrubbed with detergent.

The waters entered the Santa Croce church, where the tombs of Michelangelo Buonorotti and Galileo Galilei were located and left oil slicks on the frescoed walls. The conservators experimented with carbon tetrachloride, benzene and methylene chloride to determine the solvents and the concentrations most effective against the oil and least harmful to the paint. In other buildings it was necessary to remove damaged frescoes from their walls. To do this, layers of cloth were glued to the front of the fresco. Then the cloth with the fresco was gently pulled and lifted from the wall. Following this, the fresco was adhered to another backing, usually a masonite board, and the cloth removed from its front. As the frescoes were moved, their underdrawings were uncovered, and in many cases they were different from the finished paintings. In the aftermath of the flood, thousands of square feet of fresco were taken from Florentine walls.

The painted panels in some churches were soaked with water and presented special conservation problems. They were made of poplar wood, a material that expands when wet and shrinks as it dries. To regulate the rate of drying and prevent the wood from cracking, the panels were taken to a specially set up greenhouse where the humidity was controlled. The paint and gesso layers were also sensitive to moisture and could flake if they dried faster

than the wood. So the panels were covered with rice paper to slow the drying. Antibiotics were also used. They were tested on the pigments, and nystatin in solution was selected. It was sprayed on the rice paper, and it worked as a fungicide and prevented the growth of molds and fungi on the drying panels.[173]

The flood of 1966 had special meaning for me. The year before the deluge, I visited Florence for the first time, and I was captivated by the city and the treasures it held. When I learned about the flood and its path of destruction, I was devastated and decided return to Florence the following summer. *Mary Magdalene* was in restoration, the panels of *The Gates of Paradise* were not in place, tissue covered the frescoes in Santa Croce, and many oil marks were on walls. By 1967 much of the city was cleaned up and many of its churches and buildings were open, including the Bargello. Florence was rising from the damage, and this magnificent city was in the middle of another renaissance. However conservation is expensive and time consuming, and even today there are pieces from 1966 awaiting restoration. The Arno has had a long history of flooding, and a plan for controlling its water with a system of dams, reservoirs and canals was found in one of Leonardo da Vinci's notebooks. The River created problems before 1966, and it will probably repeat its history in the future.

Some conservation projects are a downright challenge. One such project was the conservation of *The Last Supper*, a painting by Leonardo da Vinci, located on a refectory wall in the Santa Maria delle Grazie in Milan. To fully understand the complexity of this one, it is necessary to go back to 1495, when Leonardo received the commission to paint the mural. At the time, most wall paintings were done using the traditional fresco technique of painting on wet plaster. Fresco is a reliable method, where the paint and plaster combine and become one. It is also a technique that requires the painter to work quickly, and Leonardo wished to paint at his own pace rather than within the confines of fresco. He began by having the plastered wall primed and covered with a thin coat of lead white. Then Leonardo carefully and thoughtfully applied his paints to the dry surface and experimented with a variety of them to get the colors he wanted. The painting measured about 15 x 28 feet (4.6 x 8.5 m) and was a masterpiece of composition, color and detail, but soon after its completion, it began to flake and deteriorate. Exactly what caused this to happen is uncertain. Perhaps the formulation of the paint was incorrect. Perhaps the composition of the primer interfered with the painted surface. Perhaps the composition of the wall was such that it held water and gave off corrosive chemicals. Perhaps humidity affected the primed plaster and prevented the paint from adhering properly. Perhaps humidity combined with temperature and encouraged the growth of destructive microorganisms. Perhaps the primed plaster dried too

fast, cracked and took paint with it. Whatever the reason or reasons, this painting had problems.

Over the years, a number of corrective measures were implemented, but they created problems of their own. Glue and wax secured flaking paint, but they held dirt. Solvents removed surface dirt, but they were rough on the painting. The protective curtain held moisture and brushed against the delicate surface. And the many repaintings and retouchings darkened the figures and altered the impact of the painting.

In addition, the painting had suffered a number of direct assaults. In 1652 the doorway under the painting was enlarged, and this cut away a lower portion of the mural with Christ's feet. When Napoleon's troops occupied Milan in 1796, the refectory was used as a stable. Some of the soldiers threw stones at the work and climbed ladders to deface it. During World War II, an Allied Forces bomb exploded near the dining hall and damaged the building. Fortunately the wall was covered with a tarpaulin and sandbagged, so the painting survived.

Following the War, the dining hall was rebuilt. The incrustations of previous restorations were removed, and paint was anchored to the wall with a newly developed shellac that was clear and free of wax. At this point, the painting was secure, but problems remained. The mural was still dark and nothing was being done to control humidity and the effects of the post-war air pollution in Milan.

By the 1970s, numerous technologies were available, and a decision was made to attempt another rescue of the *Last Supper*. Up to this point, much of the restoration work involved retouching and repainting rather than saving and preserving the original work. This time the materials and methods of modern science and modern art conservation were combined for its preservation. First the painting was given a thorough physical examination. It was photographed using stereophotogrammetry, a technique used by cartographers to make topographical maps, and a relief map of the mural was created. Raking light was used to study the surface, and it revealed contours. Ultrasound profiled the thickness of the wall in about 200,000 places and found the wall varied in thickness from 14 to 16 inches (35 to 40 cm), and it located spots where the priming was missing. Hygrometers, infrared cameras and electronic sensors made temperature and humidity profiles and found the wall very sensitive to temperature. The temperature changes between the dining room and the adjacent room produced wall movements, only fractions of a millimeter, but enough to cause the flaking of paint. Humidity was also passing through the wall, and deposits of evaporated materials were accumulating on the surface. Humidity within the room increased with visitors and decreased when they

left. Samples were taken to determine the nature of the plaster, the primer, the pigments and the binders, and the pigments were examined with ultraviolet and x-ray photography. Chromatography was used to distinguish the original paint from the overpaint.

The arduous task of conservation was undertaken by Dr. Pinin Brambilla Barcilon, an art conservator, and her assistants. While visitors watched from below, Dr. Barcilon worked on a scaffold fifteen feet above the floor of the refectory. She concentrated on small sections at a time and examined each square inch of the painting using a stereomicroscope with magnifications up to forty times. She identified original paint and carefully scraped away the disfiguring overpaint with a scalpel and brush. She cleaned areas with specially prepared solvents and filled in missing paint with watercolor that did not interfere with the original colors. The work was slow, day by day and inch by inch, but gradually the original paint and brushwork reappeared. Dr. Barcilon devoted twenty years of her life to the restoration of this mural.[174]

The refectory is open to visitors with reserved tickets, and I have viewed this famous painting in its restored condition. I joined a group of twenty-five and passed from one to the other of the antechambers that control pollution and regulate the air going into the refectory. As I entered the long dark room, I was surrounded by its cool and climate controlled atmosphere. The room was empty except for a few conditioning and monitoring devices, its windows were sealed and the doorway underneath the mural was plastered. The *Last Supper* was on one wall, and visitors were allowed fifteen minutes with it. The painting was gently lighted and had a soft hazy appearance. Not much of the original was left, but what was there was commanding. It was dynamic and peaceful, complete and fragmented, real and unreal. It invited looking and seeing and beckoned me to become involved. Soon my fifteen minutes were up, and it was time for me to leave. As I walked toward the exit, I was deeply absorbed in thought and scarcely noticed the mural on the opposite wall, *Crucifixion* by Donato Montorfano. I quietly left through the two special exiting chambers.

The final meal preceding Christ's death was a popular theme for artists, but Leonardo's painting was different from the others. He placed all of the figures on the same side of the table and arranged them in groups of three. He used linear perspective to direct attention to the central figure, and he added emotion and drama with facial expression and body language. Because of this, scholars recognize Leonardo's *Last Supper* as the first major painting of the High Renaissance—hence the heroic efforts to preserve it.

Science and art come together in conservation to rescue and preserve artistic heritage for future generations. Conservation is a science and an art.

SUBJECT MATTER

CHAPTER 16
THE BODY HUMAN

"The body says what words cannot."
~ Martha Graham

THE HUMAN BODY AND ITS CONDITION have influenced and inspired art for millennia. Prehistoric caves show outlines of the human hand, and sheltered rock walls exhibit early signs of creativity with stick-like figures engaged in hunting, fighting, harvesting and dancing. Other locations yield small female statues with large breasts and abdomens, figurines thought to be about survival and the role of female fertility.

The ancient Egyptians had some knowledge of anatomy gleaned from their practice of mummification and removal of organs from the body. Their statues of servants, carved from wood, were realistic in appearance and had lifelike facial features and body builds. However their statues of royalty, cut from stone, were stiff and formal. People in relief sculptures and paintings were shown with their heads, arms, hips and legs in profile and their eyes and shoulders facing forward, and those of higher rank were larger than those of lesser rank. This distinctive style was the Egyptian way of representing the human form, and it persisted for many dynasties, only interrupted by the reign of King Amenhotep IV, who was later known as King Akhenaten.

For centuries the cult of Amen, with its multiple gods, was professed by the temple priests and the people of Egypt. When Amenhotep IV became pharaoh,

he abolished the beliefs and practices of the polytheistic *Amen* and established the monotheistic worship of *Aten*, the sun god. Amenhotep IV adopted the name, Akhen*aten*, to reflect this change. Aten became the only god to be worshipped, and Akhenaten was the only intermediary between Aten and the people. The name of Amen was removed from inscriptions, and the capital was moved to another location, one near present day Amarna. Attention was shifted from death and afterlife to concern with life on earth, and this shift was reflected in the way the human form was rendered by artists. The figures were more relaxed and lifelike in their appearance, and they had individual characteristics. This manner of representation became known as the Amarna style. Akhenaten was portrayed with an elongated head, long thin face, thick lips, heavy eyelids, long arms, enlarged breasts and a wide and protruding belly. Diagnosticians have suggested Akhenaten's androgynous appearance was hereditary and related to hormones, but DNA studies of the pharaoh's mummy have found no evidence of this. Perhaps the distinctive images of Akhenaten were caricatures of his actual appearance and were the result of artistic embellishment.[175]

The Amarna style is evident in the well-known painted plaster and limestone bust of Nefertiti, Akhenaten's Great Royal Wife. The sculpture shows Nefertiti with delicate facial features and a long neck and wearing a necklace and a simple headdress. Its pose and demeanor are elegant and quite similar to those of a twenty-first century high fashion model, and it was used by stone cutters to create likenesses of her. CT scans of the sculpture have revealed an inner core that not only provides support for the plaster exterior but also a detailed limestone carving.

When the features of the interior carving are compared with the exterior ones, the bump on the nose and the creases around the mouth are missing.[176] Perhaps someone in antiquity decided Nefertiti needed a makeover and gave her an Amarna style facelift.

In 1922, the royal tomb of King Tut was discovered by Howard Carter. The undisturbed tomb had remained hidden for centuries, and it was filled with treasures reflecting the realistic style of the Amarna period. Following DNA analysis, King Tut was determined to be the son of Akhenaten and one of his lesser wives. At age nine, he ascended to the throne of Egypt and died ten years later, possibly from malaria or complications following a broken leg. Following his death, the cult of Amen was reestablished. The images of Aten were removed from inscriptions, King Tutankh*aten* became King Tutankh*amen*, and art reverted to its earlier formula for representing the human form.[177]

The early Greek statues of people were also stiff and formal, but gradually they became more natural and lifelike in their appearance. The body was

represented as a perfection of form and portrayed in various positions to exhibit motion, the shifting of weight and flexibility. The male figure was always nude, while the female form was hidden under folds of drapery. In time the draperies were dropped, and female images were shown nude. The Romans added individual characteristics and humanized their forms. Their statues were portraits of real people with imperfections, and they displayed the wrinkles and the hairstyles or baldness of their subjects.

In 1974, a group of farmers discovered thousands of terra cotta figures entombed in an ancient burial mound, a tumulus, near Xian in China. They were the soldiers of a clay army buried with Qin Shi Huangdi, the first emperor of China, and they were over twenty-two centuries old. They were stiff and formal figures lined up in a procession, but they had personal identities. The faces were modeled separately, and the uniforms, armor and body positions were individualized to give each of the soldiers in Quin's army a distinct appearance.[178]

In the ancient world, human illness and its treatment were a concern, but little was known about human anatomy, the actual structure of the body. Hippocrates of Cos was interested in disease and treating sick people. He relied upon his senses to observe and diagnose illness and taught that diseases have natural rather than supernatural causes. Galen of Pergamon, a Roman physician, believed that knowledge of anatomy was essential, but he limited his study of anatomy to the dissection of animals because Roman law forbade the dissection and autopsy of the human body. In spite of this, Galen's writings were authoritative and considered important for centuries. Later Avicenna of Persia, also known as Ibn Sina, assembled all that was known about medicine and disease and wrote *Canon of Medicine*. It was written in Arabic, translated into many languages, including Latin, and used as medical text in European universities.[179]

A scientific understanding of the human body is based on knowledge of anatomy and physiology, and knowledge of anatomy comes from the dissection of cadavers. Animal dissection was permitted, but the dissection of corpses was considered a desecration of the human body. It was illegal and a crime punishable by death. However it was allowed for autopsy, to determine the cause of death, with the cause of death more important than the anatomy uncovered.

Eventually European universities were given permission to use cadavers for the study of anatomy, and in time the practice of dissection developed into a performance with an audience. The professor was seated on a throne, and the body was dissected by assistants. As the professor lectured, one aide cut and moved the organs about, while another used a pointer to direct attention. The

dissection theaters were poorly lighted and ventilated, and the bodies were not refrigerated or preserved in any way. In spite of the olfactory offenses, public dissections were popular events. They were planned and advertised months in advance, and tickets were sold to curious people.

When Andreas Vesalius became a professor at the University of Padua, performance dissections were a popular diversion for the public. He abolished the practice of using assistants and worked along with his students on the cadavers. Using dissection, he made a complete and accurate study of anatomy and kept a detailed record of his observations. Then he assembled his material into a seven volume work, *De Humani Corporis Fabrica Libri Septum*, and had it published in 1543, when he was only twenty-eight years old. This work, popularly known as *Fabrica*, began the scientific investigation of human anatomy and became a foundation for its study. It contained many illustrations, printed from woodcuts, that were themselves individual works of art with animated skeletons and muscled bodies set against carefully landscaped backgrounds.[180]

Both Leonardo and Michelangelo learned anatomy from cadaver study. With the precision of a scientist and the flair of an artist, Leonardo made observations and recorded them in his notebooks with detailed drawings and descriptions. He planned to publish a text on anatomy with Professor Marcantonio della Torre, but the professor died before the project was completed. Leonardo's notebooks were filled with valuable information on the human body, but following his death they were scattered and lost and not discovered until centuries later. Thus Leonardo's careful and exacting work was not available for study by his contemporaries and never advanced the study of anatomy. Michelangelo became friends with the prior of a monastery with a hospital and a morgue, and he gained permission to visit the morgue and study anatomy using the autopsied bodies. This knowledge enabled Michelangelo to portray his subjects with strong muscles, bold blood vessels and soft flesh.

In 1652, Rembrandt van Rijn was commissioned to paint Dr. Nicolaes Tulp while instructing an anatomy class. *The Anatomy Lesson of Dr. Tulp* portrays the doctor with a cluster of seven students around an ashen white corpse. Dr. Tulp is dressed in black, with white collar and cuffs, and wears a large hat signifying his status, and his students have dark clothing with ruffled white collars. The left arm of the cadaver has a longitudinal incision, and its muscles and tendons are displayed. As the doctor grasps a portion of the flesh with forceps, he addresses his students, some are attentive to his instruction while others are looking directly at viewers.[181]

Thomas Eakins was an artist who studied both the art and science of anatomy. While in art school, he made figurative drawings from plaster casts, and then he attended classes at a medical school and dissected cadavers. He painted from living models, both male and female and was recognized for his realism. In 1875, he painted *The Gross Clinic*, a scene of Dr. Samuel Gross and his assistants performing surgery in the days before the introduction of aseptic techniques. In the painting, the doctor and his assistants are dressed in vested suits with shirts and ties, and the artist is seated in the audience, just to the left of the surgeon. Dr. Gross is shown with a scalpel in his bloodstained hand and standing away from the focus of the surgery. His gaze is thoughtful as he explains the procedure to the medical students seated in the amphitheater. The patient is partially obscured by the four assistants hovering around the operating table. A woman, perhaps the patient's mother, is pictured on the left with arms raised to shield her eyes. When the painting was displayed, some people were disturbed by its realism, by the actual grossness portrayed by Eakins.[182]

With the advent of technology, new ways to study the human body became available. In 1895, Wilhelm Roentgen discovered x-rays while working with vacuum tubes. He found the high energy radiations made phosphors glow, exposed photographic film and penetrated many materials. On one occasion, he took a photograph of his wife's hand, one that showed the individual bones of her hand and the outline of her wedding ring. This was the first human x-ray ever taken, and it opened the door for other imaging technologies.

DNA is a unique and distinguishing feature. Profiles of DNA, sometimes called DNA fingerprints, can be prepared and used for identification. They are especially valuable in forensic science where they are presented as evidence in criminal cases, and they have found use in art.

Iñigo Manglano-Ovalle was commissioned to create a piece of contemporary art and decided to use photographs of DNA profiles. He chose sixteen people and asked them to select two others, from their family or circle of friends. Working with a genetics lab, each of the participants had their DNA profiled and photographed. Then large prints were prepared and arranged in groups of three, as triptychs, to form sixteen triptychs. Manglano-Ovalle entitled the entire work, *The Garden of Delights*, and named each of the triptychs after the three individuals providing the DNA.[183] Like other contemporary art, this work by Manglano-Ovalle is open-ended and invites individual interpretation. The title itself suggests an earlier triptych, *The Garden of Earthly Delights*, circa 1500, by Hieronymus Bosch, another work open to interpretation.

The State University of New York at Buffalo has a large solar installation, *The Solar Strand,* on its North Campus. The site was designed by Walter Hood, a landscape architect, who combined his artistic vision with elements of molecular biology. It consists of an array of 3180 photovoltaic panels, arranged in three long rows or strands that resemble the patterns of a DNA profile. The installation is a linear landscape that depends upon the sun for its energy and provides a carbon free source of electricity for the University.[184]

Proteins are large complex molecules made of smaller amino acid molecules. They are the structural materials and enzymes found within the cells of humans and other living organisms. To understand how proteins work, their molecular shapes must be established. This is usually done with x-ray crystallography, but this information is difficult to interpret. While David and Jane Richardson were studying proteins in their laboratory, Jane devised a way to translate the data from crystallography into drawings that visualize protein structure. The first drawings were done by hand but now they are created with computer graphics. The diagrams indicate how the amino acids within the protein are organized, and they show the chains, rings, helixes and pleated sheets of protein structure. They are bundles of brilliant color filled with ribbons, twists and folds. The ribbon drawings, or Richardson diagrams, were never intended as art, yet they resemble the abstractions of art. Some have been framed and displayed on walls like art, and others have appeared as art on the covers of scientific journals.[185]

Using the research information provided by crystallography and the techniques of studio animation, Drew Berry has created a series of films that visualize molecular biology in action. The colored animations show molecules interacting with each other and present a dynamic view of the cell. Berry's films are artistic and have appeared in multimedia programs at the Museum of Modern Art. In 2010, Berry was awarded a prestigious MacArthur Foundation Fellowship, also known as "The Genius Award," for his outstanding work.[186]

Henry Moore was a sculptor who abstracted the human figure. His signature style was a reclining form, usually a female, and his intention was to suggest the figure rather than represent it. His forms with their open areas have a quality of mystery, and their curved lines and shapes often suggest geological landscapes as well as human figures.

The contemporary artist, John Coplans, took up photography at age sixty. For twenty years he took portraits of himself and documented his body as it aged. His series of large black and white photographs presented the human figure from the perspective of old age. He photographed his naked

body from different angles and included close-ups of his hands, feet and back but never his head and face. He recorded wrinkles, age spots and the vulnerability of the older body. He placed his feet, hands and fingers in positions to create abstract forms suggesting other body parts, animals, plants, rocks and landscapes.

Untitled (Big Man) of 2000 by Ron Mueck is a contemporary sculpture of a man in a crouched position. The figure is corpulent and without clothing; if standing it would be over seven feet tall. Its head is positioned downward and propped with its left hand. Its face is wrinkled and angry, and its blue eyes glare to the right. Its surface looks like skin with blood vessels, blemishes and calluses, but it is a pigmented polyester resin over fiberglass on a wood and chicken wire armature. The figure appears to be a real live person, but it is not.[187]

The plague or Black Death descended on Europe in the mid-1300s. It killed about one- third of the population between 1347 and 1351 and caused epidemics and death in other parts of the world as well. At the time, people had no understanding of disease and the role of bacteria and other microorganisms, and many believed the Black Death was God's punishment for sin. The illness is, in fact, caused by *Yersinia pestis*, a bacterium, and is transmitted by the bite of an infected rat flea, direct contact with infected people or respiratory droplets from them. It is a nasty disease that manifests itself in three ways as bubonic, pneumonic or septicemic plague. People with bubonic plague develop dark painful swollen lymph glands or buboes near the site of the flea bite. Those with pneumonic plague have a bloody cough and breathing difficulties, and those with septicemic plague form blood clots that interfere with circulation. Fortunately, the disease was largely eradicated during the nineteenth century and is rare in today's world. When it does occur, it is treatable with modern medicines.

Following the epidemics of the plague and the death they caused, art responded. Religious art stressed obedience, with redemption for the faithful and punishment for the sinners. St. Roche and St. Sebastian were invoked for protection from the plague, and their images appeared in churches. A fourteenth century fresco, *The Triumph of Death* attributed to Francesci Traini, portrays the omnipresence of death. It pictures a group of well dressed men and women on horseback as they find the caskets of three who have died from the plague. With disbelief, they survey the scene, and one holds his nose in response to the stench coming from the rotting corpses.[188] Almost two hundred years later, Hans Holbein created a series of forty-one woodcuts, *The Dance of Death*, that reflected a preoccupation

with death. They were *memento mori* and intended to remind people of their mortality and death.

Mathias Grünewald was commissioned to create an altarpiece for the St. Anthony Monastery in Isenheim. The Monastery operated a hospice and cared for people suffering from diseases of the skin, leprosy, syphilis and the plague. The central panel portrays Christ on a cross surrounded by mourners, the left one pictures St. Sebastian and the right shows St. Anthony. The image of Christ is covered with sores and carries the message that Christ understands suffering and offers comfort.

Smallpox is another nasty disease capable of taking lives. During epidemics thirty to forty percent of the infected people died, and those who survived were left with complications and ugly scars that marred their appearance. The standard practice to prevent smallpox involved the inoculation of material from a sick person. This procedure had some serious risks, but it also provided immunity to smallpox. Edward Jenner, a physician, observed that dairy farmers, working around cows infected with cowpox, sometimes developed cowpox, a much milder disease, but never contracted smallpox. In 1796 he obtained material from a cowpox sore and inoculated a young boy. A few weeks later, the same child was inoculated with material from a person sick with smallpox, and the child did not become ill. The boy was given subsequent inoculations and never showed infection. This offered proof the boy had developed an immunity to the deadly disease. Jenner went on to study this with other individuals and established that inoculation with cowpox material provided immunity to dreaded smallpox.

Smallpox is caused by the *Variola* virus, and it spreads from person to person by droplet infection or contact with material from the sores (the pox). Cowpox is caused by a similar virus. When vaccinated with the similar cowpox virus, the body responds and makes antibodies that provide immunity for both cowpox and smallpox. The current smallpox vaccine is made with *Vaccina,* another virus capable of stimulating the production of the protective antibodies without causing the disease. In 1967, a global vaccination program was started. It continued until 1980, when the Centers for Disease Control and Prevention declared there was no evidence of smallpox transmission in the world and stopped the wide spread vaccinations. Today the only real threat of smallpox comes from its possible use as a biological weapon.[189]

Jenner had no knowledge of viruses, nor did anyone else at the time. His methodology was based solely on observation, and it saved lives. In the 1870s, two artists commemorated Jenner's great discovery. A statue by Giulio Monteverde, *Edward Jenner Inoculating his Son with Smallpox Vaccine,* shows

the concerned physician and father administering the vaccine to his squirming son. An oil painting by Georges Gaston Melingue, *Edward Jenner Performing the First Vaccination against Smallpox in 1796*, pictures the inoculation of the young boy. The Melingue painting was later produced as a series of prints and is now available in poster form.

In the nineteenth century, Louis Pasteur and Robert Koch studied bacteria. Bacteria are one-celled organisms, smaller than red blood cells, and visible only with magnifications of hundreds of times. Pasteur discovered the spoilage of materials was caused by bacteria and other microorganisms, and he determined fermentation was due to the action of yeast, another single-celled microorganism. This, in turn, led to the development of pasteurization, the process of heating liquids to temperatures that kill the organisms responsible for spoilage. Pasteur also studied a silkworm disease and found it was caused by a bacterium, and he investigated cholera in chickens and anthrax in sheep and discovered other bacteria were responsible. Following this, he developed methods for immunizing animals. Robert Koch established a procedure, Koch's Postulates, for determining the bacterium responsible for a given disease. He discovered *Mycobacterium tuberculosis* caused tuberculosis, and *Bacillus anthracis* produced anthrax. The combined laboratory work and thinking of Pasteur and Koch made a definite connection between certain bacteria and disease and established the Germ Theory of Disease. This was an important discovery, but it was not widely accepted when it was introduced.[190]

A virus is a particle with DNA or RNA and protein. (RNA or ribonucleic acid is similar to DNA, but it is smaller. It is usually a single rather than double strand of molecules, and it contains ribose rather than deoxyribose and uracil rather than thymine.) Viruses are small, even smaller than bacteria, and require electron microscopes with magnifications of thousands of times to be observed. Viruses have a genetic code, but they are not organized like cells and are not considered alive. However when they enter cells, they use the materials of the cell to replicate and make more viruses. In 1935, Wendel Stanley discovered the first virus, the tobacco mosaic virus, an RNA virus, responsible for a disease in plants.

Christy Rupp created an installation, *The Landscape Within*, for the Castellani Art Museum on the campus of Niagara University. She was inspired by the world of the invisible and installed models of bacteria, viruses and molecules on the wall of a large gallery near the entrance of the Museum. The models were based on actual electron micrographs and made of welded steel and paper. She represented the bacteria responsible for diphtheria, tuberculosis, typhoid, Lyme disease, cholera, salmonella and streptococcal

infections, as well as the viruses causing influenza, polio, rabies, herpes, hanta, AIDS, ebola and smallpox. She also included molecules of sulfuric acid, nitric acid, ozone and many harmful organic compounds. Several models of the *Escherichia coli (E. coli)* bacteriophage were placed on the wall and on the floor. (Bacteriophages are viruses that infect bacteria.) The figures had four arthropod-like legs and looked more like science fiction forms than the reality they represented. To invite participation and perhaps stimulate thought, museum visitors were given handouts with labeled sketches of the forms. Rupp's work used disease-causing agents and molecules related to food and environmental problems as a metaphor for the human condition.[191]

The HIV virus (human immunodeficiency virus) causes AIDS (Acquired Immune Deficiency Syndrome). It is a type of RNA virus known as a retrovirus and is able to transcribe its RNA into DNA. AIDS is a serious disease, and it has no cure or vaccine. The development of a vaccine to prevent HIV/AIDS has proven difficult because the HIV virus undergoes mutations and changes. However antiretroviral medicines can slow the disease and provide a near normal life expectancy. Without treatment, the average survival time is eleven years. The World Health Organization (WHO) estimates over 36 million people worldwide are living with HIV/AIDS.[192]

Ross Bleckner's art deals with change, loss and memory, and it has addressed AIDS. It concerns death and the fragility of life and is often viewed as a contemporary *memento mori*. He has painted canvases with floating vases, candelabras and chandeliers in response to the AIDS crisis and his sense of loss. Some paintings are microscopic representations of blood cells, and others suggest the patterns of lesions associated with the disease. His 1998 series, *In Replication*, refers to the replication of the virus and the spread of the disease throughout the body.

In 1987, the AIDS Memorial Quilt was started to remember the men, women and children who have lost their lives to AIDS. It is a huge quilt, with around fifty thousand memorial panels, and an estimated weight of about fifty-four tons. It is a silent memorial and very personal reminder of the loss of life caused by this disease. The individually created panels show a great variety of fabrics and threads and are as diverse as the people they represent. The AIDS Memorial Quilt is the largest piece of community folk art in the world, and sections of it are often placed on public view.[193]

The human body and its condition are subject matter for both science and art. They have inspired and influenced the creation of art for millennia, and they have undergone scientific study for centuries. When this subject matter is explored, connections between science and art are discovered.

CHAPTER 17

BIODIVERSITY

"Each species is a masterpiece,
a creation assembled with extreme care and genius."
~ Edward O. Wilson

L IFE APPEARED ON THE EARTH 3.5 BILLION YEARS AGO. At first, the life forms were simple, but with the passage of time, life diversified. Present day science, specifically biology, has identified over 1.7 million species of living things and estimates another million or more species exist and await discovery. This diversity often influences and inspires the creation of art.

Martin Johnson Heade was an established nineteenth century painter when he made three trips to South America. As he traveled through the tropical rainforests, he captured the elegance of this diversity in his paintings. He painted orchids, passion flowers, hummingbirds and butterflies with rich and sensuous color and placed them within lush green forests. He showed epiphytes growing on branches and loops of liana around dense vegetation. Heade's representations appeared real and invited identification, and they were permeated with an atmosphere of mist and mystery.[194]

The diversity of life on Earth has common origin. New life forms develop from older ones, and life evolves. Evidence for this evolution comes from paleontology, with its fossil records showing sequences of change, and from studies of body structures and embryonic development.

Additional confirmation comes from DNA studies and comparisons and current laboratory and field work. The evolution of living things occurs by natural selection. Natural selection is the process, the natural mechanism, by which living things, compatible with their environment, tend to survive and transmit their genetic characteristics to offspring. Over time natural selection produces species that are adapted to their environments.

During the nineteenth century, both Alfred Wallace and Charles Darwin studied diversity in living things. In 1858 Wallace wrote a short essay on the topic and sent it to Darwin for review. Darwin added to it and submitted it to the Linnaean Society, a prestigious biological group, as a jointly prepared paper. Following this in 1859, Darwin published his manuscript, *On the Origin of the Species by Means of Natural Selection*. In this volume, Darwin presented evidence for the evolution of diversity and introduced his thoughts on the origin of this diversity by a process called natural selection. The book was a sensation and its entire stock sold out the first day it appeared in stores. Some thought Darwin's work was brilliant, while others were very disturbed by the ideas he put forth.[195]

To facilitate the study of diversity, systems for naming living things developed. During the eighteenth century, Carolus Linnaeus devised a workable way to classify living things and assign names. He placed the organisms into groups based on their physical characteristics and gave them distinguishing names. It was a binomial system that gave a two word name to each species, and the names given were in Latin, because Latin was an international language and one known by educated people in the 1700s.

The binomial system with Latin names is used today, and every living thing has a scientific or biological name. For instance, a lion is *Panthera leo*. *Panthera* is the animal's genus name, and *leo* is its species name. A tiger is *Panthera tigris*, a jaguar is *Panthera onca* and a leopard is *Panthera pardus*. Lions, tigers, jaguars and leopards are related and are placed in the same genus, but they are not the same species. The name for a dog is *Canis familiaris*, and the name for a cat is *Felis catus*. The names are italicized because they are Latin words, and the genus name is capitalized while the species name is not. For ease of use, the names are sometimes abbreviated to *C. familiaris* and *F. catus*. The human name of distinction is *Homo sapiens*, and it is derived from the Latin words, *Homo* for man and *sapiens* for wise and literally means "wise man". The binomial system is international and used all over the world. Thus in the zoos of Brooklyn, Berlin, Beijing or wherever, the polar bear is known as *Ursus maritimus*.

Living organisms are quite distinct from nonliving things. They are made of cells with genetic codes, and they are able to maintain stable

internal environments. They respond to their surroundings, grow, develop and reproduce. In addition, all living things require a constant supply of materials and energy to stay alive. Some are autotrophs and use energy from their environment to make the food they need to stay alive, and others are heterotrophs and depend upon autotrophs for their source of food.

Photosynthesis is an autotrophic process that occurs within cells that have chlorophyll and other pigments. The cells take in water and carbon dioxide from their environment, and they capture light energy from the Sun with their chlorophyll and other pigments. The light energy decomposes the water into hydrogen and oxygen. The hydrogen combines with the carbon dioxide and makes food (sugar), and the oxygen is released. Thus the cells that carry on photosynthesis can be considered solar powered chemical factories.

$$\text{water} + \text{carbon dioxide} + \text{light} \xrightarrow{\text{chlorophyll}} \text{food} + \text{oxygen}$$
$$\text{(sugar)}$$

$$6\,H_2O + 6\,CO_2 + \text{light} \xrightarrow{\text{chlorophyll}} C_6H_{12}O_6 + 6\,O_2$$

Living things exhibit great diversity, and the classification of this diversity is a challenge. To do this, biologists use physical characteristics and evolutionary relationships. Living things are organized into large groups called kingdoms, and each kingdom is divided into phyla. Then each phylum is divided into classes, each class into orders, and each order into families. Each family is divided into genera, and finally each genus is divided into individual species. Whew!

Over the years a number of classification systems developed. The one devised by Linnaeus separated living things into either the plant or animal kingdom, and it was adequate for the time. However additional kingdoms became necessary as the diversity of microscopic life was discovered. The current system of classification divides all living things into one of six kingdoms: Eubacteria, Archaebacteria, Fungi, Protista, Plantae or Animalia.

Four of the kingdoms (Eubacteria, Archaebacteria, Fungi and Protista) deal with the great diversity exhibited by the smallest and least conspicuous organisms. The Eubacteria are one celled and lack nuclei. Some are autotrophic, and others are heterotrophic. Some use oxygen, and others do not. Members of this kingdom are free living soil bacteria, normal intestinal

bacteria and disease causing bacteria as well as the simple blue-green algae or cyanobacteria. The Archaebacteria are similar but include bacteria that survive in extreme conditions, such as hot springs and brine pools. The Fungi are small heterotrophic organisms, like molds, yeasts, sac fungi and mushrooms, that feed on dead and decaying organic matter. Their cells have nuclei, and some are single celled, but most are multicellular. The Protista show the greatest diversity of the small organisms. Most are single celled with nuclei, but some are multicellular. Some have chloroplasts with chlorophyll and are autotrophs while others are heterotrophs. This kingdom includes most algae, slime molds, kelp, parasitic protozoans and our "old friends" from biology class, Amoeba, Paramecium and Euglena.[196]

Tam Van Tran is a contemporary artist who uses *Spirulina* and acrylic paint to construct abstract compositions he calls "sculpted paintings." *Spirulina* is a genus of simple blue-green algae or cyanobacteria in the Eubacteria Kingdom, and is the name of a protein-rich food supplement. By mixing *Spirulina*, with its evolutionary history of 3.6 billion years, and a twenty-first century acrylic paint, Tran invites viewers to think about relationships, perhaps ancient v. recent, old v. new, natural v. man-made or anything else the compositions may suggest.[197]

The organisms in the Plant Kingdom (Plantae) are multicellular. They have cells with nuclei, cell walls of cellulose and chloroplasts with chlorophyll. They are autotrophs and carry on photosynthesis and release oxygen. The mosses, liverworts, ferns and horsetails make spores for reproduction, and the gymnosperms and angiosperms produce seeds. The angiosperms have flowers, while the gymnosperms, like conifers and cycads, do not. The angiosperms come in a wide variety of sizes and shapes, and they are the most abundant of the plants today. Some have conspicuous flowers, like roses and tulips, while others have less obvious ones, like corn plants and maple trees.

The organisms in the Animal Kingdom (Animalia) are multicellular also. They are heterotrophs and have cells with nuclei but no cell walls. Some have backbones and are vertebrates, and others lack this support structure and are invertebrates. Sponges, cnidarians (jellyfish), flatworms, roundworms, annelid worms, mollusks, echinoderms and arthropods are invertebrates, and fish, amphibians, reptiles, birds and mammals are classes of vertebrates. Humans are mammals and are further grouped into the primate order and hominid family.

Arthropods are the largest animal phyla, with more than three-quarter of a million different species. They include the arachnids, the crustaceans and the insects and their relatives, the millipedes and centipedes. Among the

arthropods, insects show the greatest diversity and have the largest number of species. Insects have three pairs of legs, and arachnids usually have four pairs. Thus ants, grasshoppers, houseflies, fleas, butterflies and moths are insects, and spiders, scorpions and ticks are arachnids.

Living things and their diversity have influenced and inspired art for centuries. Over five hundred years ago, Albrecht Dürer wrote: "Art is imbedded in nature, and he who can extract it, has it." Dürer succeeded in doing just that when he painted *The Great Piece of Turf,* a watercolor and gouache on paper. It is a study of the plants growing on a portion of sod, one that was collected from the countryside and brought into the artist's studio. With this work, Dürer directed the viewer's attention to the common plants of the field. He painted them with dignity and detail and presented them with scientific accuracy and artistic flair. He turned a natural scene into a work of art, and his precision allowed the plants to be identified as dandelion, great plantain, creeping Charlie, yarrow, meadow grass, cock's foot and heath rush.[198]

The *Unicorn Tapestries* hang on walls of The Cloisters in New York City. They are large cloth works of wool and silk with metallic strands and were made in Northern Europe around 1500. Natural plant dyes (red from the madder plant, yellow from weld and blue from woad) and combinations of them were used to color the cloth threads. The tapestries tell the story of a hunt for the legendary unicorn, an animal whose capture was only possible in the presence of a virgin. With little or no attention to perspective, the figures were woven into scenes filled with plants. Over a hundred different plants were represented in great detail, so much so that biologists were able to identify them.[199]

John James Audubon spent much of his time in the American wilderness of the early nineteenth century. It was the place where he studied birds, identified them, kept records and made many sketches. In the 1800s, it was common practice for artists to kill their specimens before drawing them. The skins were removed and preserved with arsenic, then they were stuffed with a variety of materials and mounted on boards for drawing. The resultant images were stiff and unnatural, and they looked like what they were—pictures of dead birds. Audubon taught himself to draw and devised another way to use the specimens. He arranged his birds in lifelike positions with wires and threads and presented them in context with their environment. He was the first artist to show birds in their natural habitats. Sometimes he dissected the freshly killed birds to study their structure, and sometimes, as a hungry wilderness artist, he feasted on them. He also kept careful records of their

taste and tenderness as some were better fare than others. In time, Audubon decided to assemble a record of North American birds. It was a monumental undertaking that included all North American birds and drawings of all the birds. It involved the transfer of drawings to copper plates for printing on sheets measuring two feet by three feet and the hand coloring of individual prints. When it was finished, Audubon's project, *The Birds of America*, consisted of over four hundred colored prints. It was a definitive record of the diversity of American birds during the early 1800s, and it went on to become one of the all time great works of science and art.[200]

Roger Tory Peterson was a field biologist and a painter who specialized in birds. His paintings pictured birds perched on branches or near vegetation typical of their habitat, and they often included views of both the male and female of the species. Peterson enjoyed working in the wild and studying birds, and he knew the importance of pictures for proper identification. He realized illustrations were necessary if others were going to have the same pleasure. Using simple drawings with arrows to show the differences between species, he developed a system of identification. In 1934, his book, *A Field Guide to the Birds*, was published, and it became an instant success because it opened the world of ornithology for ordinary people. It contained drawings with brief descriptions and scientific names, and it was pocket-sized so it could be taken into the field for use. Following the success of this field guide, he prepared additional ones for the identification of wildflowers, butterflies and mammals. Peterson has the distinction of making natural history accessible to the general public, and his guides, with their special system for identifying species, are still popular with naturalists.[201]

Robert Bateman is known for his paintings of animals in their natural habitats. He has observed them in the wild and taken photos. He has also made sketches of mammals from life and birds from stuffed or frozen specimens. With the aid of his photos and sketches, he has presented detail, given character and retained natural lighting. He has worked with thin acrylic or alkyd paints to create smooth and non-textured surfaces and composed paintings so that either the animal or the landscape is dominant but never both. The animals are presented in their proper settings, sometimes they are visible and other times they are hidden from view as in nature. They have dramatic realism, and they are either poised and silently alert or in dynamic motion. Bateman's art is a diary of the natural world.[202]

Peterson was often asked why he paid so much attention to birds. His response was "Birds are not only beautiful and fascinating but also indicators of what is right and wrong on this planet."[203] Just as the canary in the

mineshaft served as a warning for miners, birds and other animals in the wild serve as a warning to what is happening on this planet. Human activity can threaten biodiversity by hunting species to extinction, introducing toxic chemicals and altering habitat.

Each species is the result of evolutionary changes over millions of years, yet in a very short time a given species can become extinct due to human activity. The Carolina parakeet was one of the birds painted by Audubon and included as a print his *The Birds of America*. It became extinct in 1905 as a result of loss of habitat and hunting. The bird ate almost every kind of grain and fruit, and when it descended on fields it consumed everything available. The bird was viewed as a pest and killed by farmers eager to save their crops, and within a few years this bird was gone. During the late nineteenth century, fashionable millinery demanded lavish feathers. It is estimated the collection of feathers was responsible for the killing over five million ostriches, egrets, herons, birds of paradise, peafowl and seabirds per year. A prominent Bostonian, Harriet Hemenway, was horrified by the slaughter and set out to right this wrong. She gathered a core of women and encouraged them to unite and abandon the fashionable feather. With this action, a part of the modern American environmental movement began. She met with Boston's leaders, and they voted to form the Massachusetts Audubon Society. Others became concerned, and additional organizations were formed to protect birds. In time laws were passed to end the use of feathers from wild birds.[204]

Frank Moore created paintings dealing with the dangers of toxic chemicals in the environment. His *Resistant Fauna* of 1994 is about the use of insecticides on plants and their role in producing species resistant to them. Specifically the painting refers to the use of insecticides to control the boll weevil that thrives on cotton plants. It shows the plant and its weevils against a background of white, perhaps representing a fluff of cotton or a lethal puff of insecticide.[205]

Bateman prepared a series of posters based on the impact humans have on biodiversity and habitat. His poster, *Wildlife Images*, has three panels. The top panel pictures a rocky beach and an endangered bald eagle with a broken wing. The middle one portrays a sea lion resting on rocks with a fishing net caught around its neck. The bottom panel is divided into thirds and shows a rocky shore slathered in oil, a sea bird swimming next to its dead partner and plastic rings from a six pack on a beach. Printed at the bottom is a quote attributed to Chief Seattle, a role model adopted by the environmental movement: "What is man without the beasts? If all the beasts are gone, man

would die from great loneliness of spirit. For whatever happens to the beasts, soon happens to man. All things are connected."[206]

Biodiversity is subject matter for both science and art. Living things and their diversity are studied by science, and they influence and inspire the creation of art. When this subject matter is explored, connections between science and art are discovered.

CHAPTER 18
THE EARTH'S DYNAMIC LANDSCAPE

"No one knows what causes an outer landscape
to become an inner one."
~ Margaret Atwood

ABOUT 4.6 BILLION YEARS AGO, the Earth came into existence. It formed from the condensation of the gases and dust particles within a cloud-like nebula, the same one that gave rise to the Sun and the rest of the solar system. At first the Earth was in a molten state and had elements and compounds mixed throughout, then the liquified rock, known as magma, began to separate. As the separation continued, the dense iron and nickel concentrated in the core and the lighter materials accumulated above them. In time the magma at the surface cooled and formed a rocky crust. Science, specifically geology, studies the Earth and its crustal features, and art is often influenced and inspired by the Earth and its crustal features.

Ansel Adams was a photographer of the natural landscape. His photos were images in black and white, and they were a monumental tribute to the land. They used the light and contrast of the scene to create dramatic effect and presented the mountains, valleys, streams and boulders as icons. Adams recorded scenes from many of the national parks including Grand Canyon, Glacier and Grand Teton and is especially known for his views of Yosemite's Bridal Veil Fall, El Capitan, Half Dome and the Merced River valley. He captured the essence of each place and his work became a standard for the art of photography.[207]

The Earth's crust is made of rock that is composed of minerals, inorganic compounds with crystalline structures. Like all materials, minerals have characteristic physical and chemical properties. Calcite and quartz are common minerals, as are gypsum, feldspar, mica, talc, halite, pyrite and galena. Chemically, calcite is calcium carbonate ($CaCO_3$) and is found in limestone and marble, and quartz is silicon dioxide (SiO_2) and is one of the minerals in granite, sandstone and shale.

Rocks are grouped by their method of formation and are either igneous, sedimentary or metamorphic rocks. Igneous, like granite, basalt, andesite, rhyolite, pumice and obsidian, are produced when magma cools and solidifies, and sedimentary rocks, like limestone, dolostone, shale and sandstone, form from the consolidation of deposited materials and often contain fossils. When igneous and sedimentary rocks are exposed to heat and/or pressure over time, they may undergo transformation and become metamorphic rocks. If this happens, limestone changes into marble, shale into slate, sandstone into quartzite and granite into gneiss.

The Earth's crust is dynamic and is in a constant state of change. As the tectonic plates separate, come together or slide past each other, interactions take place along the boundaries and crustal changes occur. Some of the Earth's tallest mountains and most active volcanoes are found in the regions where the plates are moving. When the plates interact, stress is created, and the rock layers respond. The layers can bend and fold; sometimes the folds are small (only inches or centimeters), and other times they are large. When thick layers of rock are compressed, large scale folding occurs and mountain ranges, like the Appalachians, are formed. The layers can also break and produce a fault, and blocks of stone can move up, drop down or slide past each other. Fault-block mountains, like the Grand Tetons, result when when large pieces of the crust move.

Volcanoes are usually found near actively moving plates. They originate where magma comes to the surface and flows out through a vent. When magma reaches the surface, it is known as lava, and as it accumulates it forms a volcanic mountain. The depression around the vent at the top is a crater, and if it collapses, it becomes a larger caldera. Shield volcanoes have gently sloping sides with layers of lava. They can grow into large volcanoes, but they are not explosive when they erupt. The Hawaiian volcanoes are shield volcanoes and are the result of a tectonic plate moving over a "hot spot," a place where magma comes to the surface. Cinder cone volcanoes, like Paricutín in Mexico, are explosive and release gases into the atmosphere. They have steep sides and are collections of the cinders and fragments thrown from the vent.

Cinder cone volcanoes are smaller than shield volcanoes and are often found on other volcanoes. Composite volcanoes, as the name suggests, are made of alternate layers of lava and cinder fragments and tend to be explosive and dangerous. Mount Rainier and Mount Saint Helens are composite volcanoes.

Mount Vesuvius is a composite volcano that rises to a height of 4300 feet (1310 m) and dominates the Bay of Naples. (It is the result of the African plate grinding against the Eurasian plate and the melting of rock into magma.) During August of 79 AD, Vesuvius erupted with great violence and buried the cities of Pompeii and Herculaneum and claimed the lives of thousands of people. The eruption began with a series of continuous earthquakes followed by an explosion that threw a large column of pumice into the air for eleven hours. Daytime turned into night, and pumice accumulated at the rate of 6 inches (15 cm) per hour in Pompeii. When the column collapsed, a surge of superheated gases, pumice and rocks came down the volcano and consumed Herculaneum and its people, and later a suffocating flow struck Pompeii and asphyxiated its residents. The cities and their inhabitants were trapped under layers of volcanic material and remained there until they were discovered by a well digger in 1709. The entombed cities of Pompeii and Herculaneum contained a repository of first century AD Roman life and its art. There were walls covered with murals showing hunting scenes, mythological stories and theatrical motifs. There were encaustic portraits, stone reliefs and the remains of gardens. There were mosaics, pieces of furniture and gold jewelry, and there were statues carved from marble and others cast in bronze. And there were the bones and impressions of the people and animals that lived and died in these cities. Since 79 AD, the mighty Vesuvius has erupted over eighty times, and it is still considered a very active volcano and remains under constant surveillance.[208]

Weathering and erosion are processes that affect the Earth's crust and sculpt it into dramatic forms. Weathering is the breaking down of the rocks and minerals in the Earth's crust, and erosion is the transport of weathered rock from one place to another.

Physical weathering, also known as mechanical weathering, occurs when rocks and inerals undergo physical changes and are broken into pieces. Changes in temperature cause rocks to expand and contract, and this, in turn, cracks and breaks them apart. Water, as it reaches its freezing point, expands. When water trapped within a crack freezes, it expands, exerts pressure and breaks rock into pieces. Plants growing in rock crevasses, exert pressure and force rock to split. Chemical weathering occurs when oxygen, water, carbon dioxide and other substances interact with rock materials. Oxygen and water combine with many of the materials in rocks and chemically change them.

When water unites with carbon dioxide, it forms carbonic acid that acts on limestone and marble. When sulfur dioxide and nitrogen oxides, pollutants in the air, join with water, they form other acids that attack rock materials.

Gravity, running water, glaciers and wind are the agents of erosion, and they transport weathered rock from one place to another. Gravity causes materials to move down gradients, from higher to lower places, and it affects the erosion caused by running water, glaciers and wind. Running water has the power to move weathered rock. The greater the gradient and the faster the water moves, the greater the size of the particles and the number of particles transported. Moving water, with its particles, cuts channels and carves valleys. When moving water slows down, the particles being carried are deposited as sediment. The Grand Canyon and the Mississippi Delta are due to the action of running water.

Glaciers are dense masses of ice that move under their own weight by gravity. As they move, they scrape and gouge the land. They cut valleys and transport materials, and when they melt, they leave behind a moraine of mixed debris. Continental glaciers cover large portions of land, while valley glaciers are smaller and found on mountains at high elevations. The Antarctic ice sheet is a continental glacier, and the Mendenhall Glacier in Alaska is a valley glacier.

Wind moves particles from one place to another, with higher velocity winds doing a better job than the slower ones. Winds carrying pieces of rock are abrasive, and they pit, chip, carve and smooth the surfaces they strike. When blowing winds subside, the particles in them settle and are deposited.

Mt. Fuji is a very impressive volcano. At 12,388 feet (3,776 m) high, it is the highest point in Japan and has a diameter of 31 miles (50 km) and a crater of 1640 feet (500 m). Even though it has not erupted since 1707 -1708, the volcano has served as a source of inspiration for centuries and is considered holy by some. A series of woodblock prints, *Thirty-Six Views of Mt. Fuji*, were created by Katsushika Hokusai in the 1800s. The prints are in the style of the Ukiyo-e Period, with flat patterns, clear lines, bright colors and no shadows. They show views, some active and others peaceful, of the volcano and its nearby countryside and ocean. *The Great Wave off Kanagawa* pictures a massive ocean wave in the foreground with the majestic Fuji in the background. It suggests relationships, ones that exist between Mt.Fuji and the ocean and ones between volcanic activity and the action of water. Hokusai was considered by many to be the greatest of all the Ukiyo-e artists, and his prints, along with those by other Japanese artists, came to Paris in the nineteenth century. European artists, including Vincent van Gogh, Georges Seurat and Henri de Toulouse-Lautrec, viewed the prints and were influenced by the way the Japanese artists organized space with flat areas of color.[209]

The history of the Earth and its register of life is recorded in the rocks and fossils of the crust. To facilitate the study of this, scientists have developed a geological scale that divides time into sections. The scale enables scientists to correlate geological events, fossil records and environmental changes all over the Earth. It divides geological time into eons, eras, periods and epochs, large sections of time that represent millions of years. Eons are the largest of the units, and they are split into eras, then the eras are separated into periods and the periods into epochs. The scale is a way to organize large amounts of time. Dinosaur buffs are familiar with the Mesozoic Era with its Triassic, Jurassic and Cretaceous Periods, and those interested in anthropology know about the Quaternary Period and the Pleistocene and Holocene or Recent Epochs.

Geological Time Scale

(most recent time)		
		—Holocene or Recent Epoch
	—Quaternary Period	—Pleistocene Epoch
Cenozoic Era	—Neogene Period	
	—Paleogene Period	
	—Cretaceous Period	
Mesozoic Era	—Jurassic Period	
	—Triassic Period	
	—Permian Period	
	—Pennsylvanian Period	
	—Mississippian Period	
Paleozoic Era	—Devonian Period	
	—Silurian Period	
	—Ordovician Period	
	—Cambrian Period	
Phanterozoic Eon		
(Pre-Cambrian Time)		
Proterozoic Eon		
Archean Eon		
Hadean Eon		
(oldest time)		

The scale organizes time from the oldest to the most recent, and it is read from the bottom to the top, from the oldest to the most recent time. The first three eons, Hadean, Archean, and Proterozoic, represent about eighty-eight percent of all the Earth's time. They are the oldest eons, and they have the poorest geological record. For convenience, the three are often grouped together and called Pre-Cambrian Time, getting their name from the Cambrian Period that follows them. The Phanterozoic Eon has three eras: the Paleozoic, Mesozoic and Cenozoic. The Paleozoic Era is divided into the Cambrian, Ordovician, Silurian, Devonian, Mississippian, Pennsylvanian and Permian Periods. The Mesozoic Era is separated into the Triassic, Jurassic and Cretaceous Periods and the Cenozoic Era into three periods, the Paleogene, Neogene and Quaternary. The Quaternary is further separated into the Pleistocene and Holocene or Recent Epochs. So this means the twenty-first century is in the Phanterozoic Eon, Cenozoic Era, Quaternary Period and the Holocene or Recent Epoch.[210] Whoa! Simply stated, the Geological Time Scale is a way to deal with the long periods of time involved in the Earth's history.

During a 2016 meeting of the International Union of Geological Sciences, some scientists stated the effect of human activity had grown so powerful that the Earth had in fact entered a new epoch, the Anthropocene, one defined by humans and their effect on the planet.[211]

Georgia O'Keeffe was an artist who lived in New Mexico. The desert was very much a part of her life and provided a major inspiration for her art. She painted the landscape around her home in Abiquiu with so much majesty and grandeur it became known as "O'Keeffe country."

Her colors were bright and clear and her forms were simplified, yet the places she painted had enough realism that others could locate the sites. Her New Mexico landscape was shaped by sedimentation, volcanic activity, weathering and erosion. *Cliff Beyond Abiquiu—Dry Waterfall* presents a massive rock wall in a variety of sand colors and has a vegetation covered mound at its base. The wall is sedimentary in origin with layers deposited during the Mesozoic Era, and the mound is a talus slope of weathered and eroded rock from the strata above. A series of paintings based on a spot she called "The White Place" show light gray conical structures in the foreground and blue skies in the background. The Pedernal is a ten thousand foot butte near Abiquiu with a flat top of flint and steep sloping sides. O'Keeffe often said: "It's my private mountain... It belongs to me. God told me if I painted it enough, I could have it."[212] And O'Keeffe painted it often and in many different ways, and The Pedernal became *her* mountain, just as Mont Sainte Victoire was Paul Cezanne's mountain.

Frank Lloyd Wright is considered by many to be the most creative architect of the twentieth century. He pioneered the use of organic architecture, the harmonious blend of the natural landscape and man-made, and combined the physical environment with architecture. In the 1920s, he received a commission to design a summer home along Lake Erie for Isabelle Martin, the wife of Darwin Martin, a Buffalo business man. Wright's plan for the site, which became the Graycliff Estate, integrated features of the location and used indigenous materials.

The property had a limestone cliff with a lakeshore beach. The limestone was crystalline in structure and contained the fossils of crinoids, brachiopods, corals and mollusks. It was gray in color with an orange cast from iron compounds, and it was formed from sediments deposited in the shallow seas of the Devonian Period, three-hundred eighty million years ago. During the Pleistocene Epoch, a large continental glacier pushed down from the north and sculpted the land. When the glacier retreated, a moraine with boulders of granite was left behind. Pieces of the limestone were hauled to the building site on carts drawn by oxen and used for sections of the house and its chimney, the rock garden, the estate walls and other buildings. Granite boulders found on the property were incorporated into the entranceway and the fireplace on the first floor.

The very name, Graycliff, denotes the integration of the buildings with their physical environment. The estate sits on cliff above the shores of Lake Erie, a 60 foot (18.3 m) vertical wall of gray shale capped with a foot or so of the gray limestone. The angularity of the cliff is repeated in the L shapes of the house, the other buildings and the surrounding walls. The horizontal planes of the house with their cantilevered terraces echo the stratified layers of rock. As a summer residence, the design celebrates the beginning of summer and includes elements of astronomy. The house is situated so that it serves as a solar calendar. When light enters the house it creates patterns on the floor, and light from the setting Sun of the summer solstice aligns itself along diagonal joints in the flagstone floor. The driveway is also on a diagonal with the setting solstice Sun. The Graycliff Estate is a New York State Landmark and listed on the National Register of Historic Places, and it is undergoing an extensive restoration.[213]

Niagara Falls is one of the great scenic wonders of the world and is visited by millions of people every year. It is also a place with a long geological history and a rich artistic legacy.

The geological history of Niagara Falls is a story in three parts, and it begins like all good stories. Once upon a time…about four hundred-thirty million years ago, give or take a few million years…during the Ordovician and Silurian Periods of the Paleozoic Era, ancient seas covered the Niagara region and much of what is now North America. It was a time of rock formation, and it was a time before the existence of dinosaurs, mammals and primitive human beings. Weathered materials from the mountains east of the Niagara region were transported to the shallow seas, deposited as sediments and consolidated into rock. Layers of shale, sandstone, limestone and dolostone formed, and some contained the fossils of invertebrates that lived in the Paleozoic waters. Then movements of the crust occurred, rock layers were uplifted and the Niagara region emerged from the seas.[214]

Fast-forward…three hundred million years…to the Pleistocene Epoch of the Cenozoic Era. It was a time of glaciation, and many large glaciers formed on the North American continent. It was the time that became known as "the Great Ice Age". Huge masses of ice, in some places 10,000 feet (3,000 m) thick, accumulated in the north and pushed their way south. As the glaciers moved along, they scraped, gouged and changed the landscape. The tremendous weight of the ice depressed the land, but as the ice melted, the glacier retreated and the land gradually rebounded. The melt water ran downhill, followed the topography of the land and formed a number of lakes with drainage connections. Ultimately the water developed a course from Upper Great Lakes to Lake Erie to the Niagara River and then on to Lake Ontario.[215]

The final part of this story began about twelve thousand years ago and continues today. It was and is a time of weathering and erosion. As the water of the Niagara River flowed from Lake Erie to Lake Ontario, it passed over a ridge of rock, the Niagara Escarpment, and formed a turbulent waterfall. Bit by bit, a gorge formed as the Niagara River receded over 7 miles (11 km) from its starting point, near present day Lewiston NY, to its current location within the City of Niagara Falls. Originally the Niagara River had a single waterfall, but now islands divide the River into the American, the Bridal Veil and the Canadian or Horseshoe Falls.[216]

Weathering and erosion are responsible for the formation of the Niagara Gorge and Niagara Falls. To slow the processes involved and maintain the scenic beauty of the Falls, flow control structures direct and distribute the water going over the Falls and anchoring bolts at strategic points hold the rocks together.

The Niagara River is also a source of energy for the generation of electricity, and much of its upstream water is diverted to American and

Canadian hydroelectric facilities. This allows the water to be used by the hydroelectric plants, and it reduces the amount of water going over the Falls. The flow control structures, the anchoring bolts and the water diversion have reduced the recession, but they have not stopped it. The story of Niagara Falls continues, and someday it will conclude. As time marches on, nothing geological is forever.

The artistic legacy of Niagara Falls began in 1678 with Father Louis Hennepin, a priest traveling with a group of French explorers. When Hennepin came upon the thundering waters, he was overwhelmed by what he saw and was the first person to describe the Falls and make them known to the world. With amazement and exaggeration, he wrote about the spectacle he observed and then enlisted Jan van Vienen to prepare an illustration based upon his account. (At the time of Hennepin's visit, the Falls were divided by an island, but the Canadian side had not receded to its present horseshoe shape and was almost straight across.) When *Nouvelle Decouverte* was issued in 1697, it contained the priest's description of the Falls and van Vienen's engraving. This was the first published illustration of the Falls, and it inspired other printmakers to render their versions of the Falls.[217] Many years later, in the twentieth century, Thomas Hart Benton was commissioned to create a painting to celebrate the completion of the Niagara Power Project, and he decided to portray Father Hennepin at Niagara Falls. His 1961 painting is large, 7 by 20 feet (2.1 x 6 m), and represents the Falls in a manner similar to the earlier engraving. The priest is in the center holding a cross and blessing the Falls, members of the French exploration party are on the right and indigenous men are on the left.

During the nineteenth century, landscape painting was very popular, and many artists traveled to Niagara Falls to paint on location. Many of the paintings were panoramic and intended to be awe inspiring. Jasper Cropsey pictured the Falls from the River below with water crashing against rocks and a rainbow emerging from the mist. Alfred Bierstadt showed a misty cloud enveloping the American Falls and the large stone blocks at its base, and John Twachtman painted the Falls with light wispy strokes of pastel colors. *Rapids Above the Falls* by Thomas Moran captured the turbulent nature of the water above the Falls with white-capped undulations.

Frederic Church's *Niagara* was a powerful and spectacular painting of the Falls from the perspective of the viewer. He pictured the Canadian Falls in the foreground and the American Falls in the distance with a delicate rainbow between them. He presented the Canadian waters cascading over the brink and disappearing, in a manner that mesmerized the viewer with its powerful force.[218]

Niagara Falls continues to be popular subject matter for artists, but today's art is different. A shopping center near Niagara Falls commissioned Eric Grohe to paint a mural on an outside wall near an entrance to the mall. Grohe decided to create a sweeping view of the Falls from the Canadian side. He placed an arched form in the foreground to integrate the painting with the architectural elements of the entrance, and he added adults, family groups with children and visitors from other countries. At the very center, he placed a man reading a newspaper. The man was someone who had watched Grohe at work and asked to be included the painting. The mural is visible from a nearby expressway, and its striking realism attracts attention. It beckons people to come into the mall and include shopping as part of their Niagara Falls experience.

Frank Moore's *Niagara*, painted 1994, tells another story. First inspection shows a panoramic view of the Falls with a person in the left foreground holding a large video camera. The *Maid of the Mist* tourist boat is in the water near the Canadian Falls, and a misty spray is above the Falls. Close inspection reveals something else. Industries loom in the distance, and the mist contains the formulas of toxic materials. Protozoans, algae and other free living microorganisms are visible in the water, and the picture frame is made of copper pipe with plumbing valves. The painting attempts perspective, but it is skewed. The Niagara River and its Falls are no longer the pristine and untouched place of Hennepin's time. and the artist is asking viewers to think about the changes that have occurred and what they mean.[219]

Adam Cvijanovic created an installation based on Niagara Falls for the Center for the Arts on the North Campus of the State University of New York at Buffalo. The work occupied the Lightwell Gallery, a two story space with a skylit ceiling. The installation was a floor to ceiling 35 foot (10.6 m) painting of the Falls on three walls of the room. Tyvek, the thin plastic sheeting used in home construction and packaging, was attached to the walls, and an acrylic based paint was applied to it. The colors were light and bright, and the illumination came from above. The illusion created was one of water thundering downward and a gentle mist drifting upward. The illusionary waters enveloped the viewer and brought the experience of the Falls into the gallery space. It was an image of the mighty Niagara waters, and it was filled with power.[220]

Earth's dynamic landscape is subject matter for both science and art. The Earth and its crustal features are studied by science, and they influence and inspire the creation of art. When this subject matter is explored, connections between science and art are discovered.

CHAPTER 19

WEATHER,
WHETHER OR NOT

*"When clouds appear like rocks and towers,
the Earth's refreshed by frequent showers."*
~ *Old Weather Rhyme*

EVERYBODY TALKS ABOUT THE WEATHER, and science tries to do something about it. Science, specifically meteorology, studies weather, climate and the atmosphere and makes predictions based on the data it collects. Weather is concerned with the current state of the atmosphere and its daily changes, while climate deals with the long term condition of the atmosphere. Weather, climate and the atmosphere often influence and inspire the creation of art.

The atmosphere is a blanket of gases surrounding the Earth. It is a mixture of 78-79% nitrogen, 21% oxygen and 1% other gases (water vapor, carbon dioxide and traces of methane, argon, neon, helium, krypton, hydrogen, ozone and xenon). Oxygen is essential for most life forms, carbon dioxide is necessary for photosynthesis and water vapor, methane and carbon dioxide regulate temperature.

The condition of the atmosphere is important for life on Earth, and science constantly monitors it. From the data, scientists know the Earth is getting warmer. They know the Earth's temperature has risen in the past

two hundred years and that the warmest years have occurred in the past two decades. They know polar ice caps and glaciers are melting, deserts are spreading and severe storms are increasing. They know carbon dioxide and other gases enable the atmosphere to retain heat. They know automobile exhaust, fossil fuels and deforestation are sources of carbon dioxide. They also know the amount of carbon dioxide in the atmosphere is increasing and is at an all time high. Hence they believe the rise in global temperature is directly connected to the increase of carbon dioxide (and other gases) in the atmosphere. This phenomenon is known as the "greenhouse effect," and the gases involved are known as "greenhouse gases."

Theo Wujcik created a series based on the theme of global warming. The acrylic and latex paintings on canvas were his personal response to changes occurring within the environment, and his checkerboards of color were a metaphor for indifference. Some hid the underlying message, while others revealed it to play an important role in the drama of the painting. Wujcik asked: "What does it take for the viewer to adjust his/her vision and truly see what's happening because of global warming as well as to take action?" Wujcik's paintings were included in a special exhibition, *Melting Ice/A Hot Topic*, organized by the Natural World Museum and the United Nations Environment Programme in honor of United Nations World Environment Day 2007. The show opened at the Nobel Peace Center in Oslo and featured the paintings, sculptures, photography, installations and multimedia of forty climate change artists from twenty-five countries.[221]

In 2018, the Storm King Art Center presented *Indicators: Artists on Climate Change*. It was a large exhibition that used both the museum building and the 500 acre outdoor site in Cornwall NY. Seventeen contemporary artists, including Maya Lin, prepared installations that focused on the growing and often overlooked issue of climate change.

The Earth's primeval atmosphere was a hot mixture of gases that included nitrogen, water vapor, carbon dioxide, carbon monoxide, methane (CH_4) and ammonia (NH_3) but *no* oxygen. As the temperature dropped, the condition of the atmosphere changed. Water vapor condensed into liquid water. Thunderstorms, volcanic activity and intense solar radiations, including ultraviolet, provided energy. Chemical changes occurred. Molecules formed in the water and combined with other molecules. In time large complex molecules developed, and simple living things appeared. About three billion years ago, organisms able to carry on photosynthesis evolved. They were the ones that used water, carbon dioxide and solar energy to synthesize the food they needed for survival, and they were the ones that released oxygen into the atmosphere.

Millions of years passed, photosynthesis continued and the amount of oxygen in the atmosphere accumulated. The oxygen in today's atmosphere is the result of this photosynthesis.[222]

The atmosphere is layered. One of the layers is made of ozone, a form of oxygen, and it developed as the oxygen in the air accumulated. Ordinary atmospheric oxygen is O_2 (with two atoms of oxygen in its molecule), and ozone is O_3 (with three atoms of oxygen in its molecule). Oxygen and ozone are different materials and have different properties. Oxygen is an odorless gas that supports life, while ozone has a sharp odor and is a respiratory hazard. However this ozone layer is protective and provides a barrier that absorbs most of the Sun's harmful ultraviolet radiations. Scientists detected a thinning or "hole" in this layer, caused by man-made chemicals like the chlorofluorocarbons (CFCs), and became concerned about problems that could arise. Worldwide efforts were made to control the chemicals responsible, and the size of the hole is gradually decreasing.[223]

The sky gets its color from the absorption and scattering of sunlight. When sunlight, composed of colors with different wavelengths, passes through the atmosphere, most of the longer wavelengths are transmitted though it, while most of the shorter wavelengths are absorbed by the molecules in the atmosphere. The absorbed wavelengths are radiated in different directions and scattered around the sky. When the sky is clear, the shorter wavelengths of blue light are absorbed and scattered better than the other wavelengths, so a clear sky has a blue color. When the sky is filled with clouds, it appears gray because the wavelengths of all colors are scattered. At sunrise and sunset, when the sun is lower in the sky, light travels through more of the atmosphere. Most of the wavelengths are scattered, but not the reds and oranges that produce the colorful displays.

Air is affected by temperature, humidity and pressure. Cold air is heavier than warm air, and dry air is heavier than humid air. Air exerts pressure, and heavy air has more pressure than light air. Therefore, cold air exerts more pressure than warm air and dry air more than humid air. Air moves because of differences in pressure, and it moves from areas of higher pressure to those with lower pressure. As air moves it creates winds. Winds blow outward from areas of high pressure and inward to areas of low pressure. In addition, the rotation of the Earth on its axis causes wind to spiral into low pressure areas and to spiral outward from high pressure areas.

Winslow Homer used brushstrokes of paint to show the action of wind. His oil painting, *Breezing Up*, shows three boys and a man aboard the *Gloucester*, a single masted wooden sailboat. The man wears the clothing of

a fisherman, and his catch of fish are in the bottom of the boat. The water is churned into action and has whitecaps, and the sail is billowed by the wind. The boat has rolled toward its port side, and the four are gathered on the starboard as counter weights. The man pulls on the sail lines, and one of the boys controls the tiller. The viewer can surmise the wind picked up and changed a usual fishing trip into an unusual sailing adventure. This oil painting is a scene of energy and movement powered by wind.[224]

When water evaporates, it becomes water vapor, a colorless gas. The amount of water vapor air can hold depends upon the temperature of the air. Warmer air holds more water vapor than colder air. Water evaporates until the air becomes saturated and reaches 100% humidity. When air at a certain temperature is saturated, the air is at its dew point. When saturated air is cooled below its dew point, below this certain temperature, the water vapor in the air condenses around particles and becomes droplets of water or it freezes into crystals of ice. In the atmosphere, water can exist as a gas, a liquid and a solid. If the condensation occurs near the ground, dew or frost forms. If it happens higher in the air, clouds develop, and eventually the water or ice crystals fall from the clouds as precipitation (rain, snow, hail, sleet or freezing rain).

Jan Vermeer's *View of Delft* is a seventeenth century oil painting of a Dutch town. The left foreground has a waterway with boats and a gathering of people on a quay, and the right side has buildings with spires and towers and more buildings in the background. It is a scene that shows rain interrupted by sunlight. The painting appears layered with some areas illuminated and others not. The quay and the buildings in the back are lighted, but the buildings with towers and spires appear damp and have their dark images reflected in the water. The viewer's eye is drawn to the lighted areas, especially the distant buildings which glow with color and glisten with the freshness of a recent rainfall.[225]

Sunrise, by David Hare is a 6 foot (1.8 m) abstract sculpture made of welded bronze and steel attached to a piece of stone. A metallic sphere with pointed projections, positioned at the top, represents the Sun. A large metal crescent and a small circle stand for the Moon, and a jagged collection of metal pieces symbolizes a star. Welded rods come from a horizontal shape to the stone and signify rain falling from a cloud to the ground. This sculpture is a landscape, a three dimensional landscape, and it is about the early morning sun and rain.[226]

In 1802, Luke Howard, a chemist interested in meteorology, devised a system for identifying clouds and giving them Latin names. John Constable,

an artist, studied the sky and filled his landscape paintings with clouds. Around 1822 he produced a series of oil sketches based on his studies of clouds. They were quickly painted works with notations that included the date, time of day and current weather conditions. Using Howard's nomenclature, Constable identified the clouds in his paintings and gave them Latin names. One of his paintings, *Study of Cirrus Clouds*, shows wispy, feathery white clouds against a blue sky.[227]

Clouds continue to have Latin names. Wide clouds with spreading layers are *stratus* clouds, and thick and fluffy ones are *cumulus*. Wispy clouds are *cirrus*, and dark and stormy ones that generate precipitation are *nimbus*. The low forming clouds are *stratus, cumulus, stratocumulus* and *cumulonimbus*. The middle ones are *altostratus, altocumulus* and *nimbostratus*, and *cirrus, cirrostratus* and *cirrocumulus* are the high ones.

Air masses are large bodies of air with fairly uniform temperature and humidity. As they move about, they gather heat and moisture. When they meet, weather fronts develop. Clouds form, weather changes and storms result. When a heavier cold air mass moves under a lighter warm air mass and pushes it upward, a cold front develops. Cold fronts move quickly and produce thunderstorms, heavy rain or snow and a drop in temperature. A warm front forms when a lighter warm air mass moves over heavier cold air. As warm air moves, it displaces the cold air. Widespread light rain occurs along the front, and then the weather becomes clear and warm. When a fast moving cold air mass overtakes a warm front and forces the warm air upward, an occluded front develops. This results in cool temperatures and large amounts of precipitation. If little air movement occurs when a warm air mass and cold one meet, a stationary front forms and this is followed by widespread light precipitation and warm weather.

Most thunderstorms are small and intense storms that produce heavy rain, lightning and thunder. Electrical charges build up within the clouds and are discharged as lightning. When the lightning passes through air, it heats the air. The air expands and contracts, and it vibrates and creates thundering sounds. Thunderstorms can grow into larger storms capable of creating hail, high speed winds and tornadoes. Tornadoes are rotating columns of high speed winds with cores of low pressure that touch the ground.

The Coming Storm by George Inness is a cloud-filled painting. It shows a farmer plowing a field and cows grazing in a pasture. Overhead the sky is dark and ominous, and birds fly for cover. A thunderstorm is imminent, and the farmer and cows are in danger. The dramatic lighting of the painting creates an eerie feeling, and it suggests the silence before a storm arrives.[228]

December Storm, a watercolor by Charles Burchfield, presents a thunderstorm in action. Storms of this type are usually associated with summer weather, but they can occur at other times of the year. This painting shows heavy, dark clouds looming over a group of buildings surrounded by trees. Sharp beams of sunlight pierce the clouds, branches bend in the wind and large raindrops fall. Burchfield's use of color and gesture describe the energy of the event and unveil the fury of this storm.[229]

Hurricanes are large rotating tropical storms with sustained winds of at least 74 miles (120 km) per hour. They are the most powerful storms on Earth and can have devastating effects. They begin as groups of thunderstorms over warm tropical water and join to form low pressure areas. As the winds spiral inward, more thunderstorms form, and the tropical storm grows stronger. When the winds reach 74 miles per hour or higher and a distinct eye has formed, the tropical storm officially becomes a hurricane. In 2005 Hurricane Katrina struck the New Orleans area and caused death and extensive damage. It was one of the strongest hurricanes on record to make landfall in the United States.

An oil painting, *George Went Swimming at Barnes Hole, but It Got Too Cold,* by Joan Mitchell, is an abstract painting with multicolored brushstrokes on a white background. The name in the title refers to the artist's dog, and the colors and gestures allude to her beloved pet *and* a hurricane that struck the East Hamptons in 1954. Mitchell's energetic brushwork and choice of colors recall the death of George and the fury unleashed by the blowing wind and the surging waters of the storm.[230]

Nancy Graves often worked with data gathered by scientists. She created *Hurricane Camille,* an india ink and acrylic painting, using technical images relayed from a weather satellite. The piece appears to represent a weather station monitor with the 1969 hurricane on its screen, but close inspection discloses a variegated swirl of color set against a grid. It is an artistic interpretation of a scientific image, and it is more expressive than realistic.[231]

Venice is located on islands surrounded by the waters of an Adriatic lagoon. It is a city famous for its canals, and a city that has fought flood waters for hundreds of years. Many factors are responsible, including heavy rains, strong winds and high tides. St. Mark's Piazza, a popular site for visitors, occupies the city's lowest elevation and is subject to frequent flooding. During times of high water, planks and boardwalks are put in place to facilitate walking about the Piazza. On November 4, 1966, the same day the Arno River went on its rampage and damaged Florence, St. Mark's Square was inundated and remained under water for fifteen hours. Fortunately there was no loss of life, but furniture, debris and dead rodents were strewn about the

area. In 2003, an ambitious flood control project was started in an effort to eliminate the flooding in St.Mark's Square and elsewhere.

The sea level in Venice has varied over the centuries, but actual measurement did not begin until 1872. To gain an understanding of earlier water levels, scientists have turned to the work of Canaletto (Giovanni Antonio Canal), an eighteenth century Venetian artist. His paintings showed the city and its buildings and were probably done with assistance from the camera obscura. Their detail allowed the scientists to locate specific buildings with high water marks. Photographs of the buildings were taken and superimposed over the paintings. Computer graphics corrected for distortion and perspective, and comparisons were made. The study revealed the sea level during Canaletto's time was about 20 inches (50 cm) lower than it is today.[232]

Weather and climate are affected by many factors including volcanic activity. In 1783, Benjamin Franklin wrote an essay that attributed an unseasonably cool summer to ash coming from an eruption of Mt. Laki, a volcano in Iceland. Franklin was the first person to make a connection between volcanic activity and weather.

Throughout the year of 1816, regions of the northern hemisphere experienced severe events. Sunlight was reduced, temperatures dropped and unusual weather occurred. Crops were damaged and lost, and people starved to death. It became known as "the year without a summer." In 1920, William Humphreys, a scientist studying climate change, read Franklin's essay and eventually determined the events of 1816 were caused by ash from Mt. Tambora, a thirteen thousand foot stratovolcano. The devastating eruption took place during April of 1815 on the Indonesian island of Sumbawa. It was a fierce explosion, erupting with more violence than the mighty 1883 blast from Krakatoa, and killed more than fifty thousand people. The volcanic activity lasted for days and spewed millions of tons of material into the atmosphere. As the ash circulated about the Earth, it caused dramatic effects and was responsible for the severe weather and climate changes of 1816.

Volcanic ash and dust, in sufficient quantities, are known to change the color of the sky, In 1817, Joseph Mallord William Turner painted, *The Decline of the Carthaginian Empire*, a scene of classical buildings set against an incandescent sky. Turner's skies before 1816 and those immediately after 1817 were blue with white clouds. The bright coloration was a sharp departure from the artist's style at the time, and ash from Mt. Tambora is presumed responsible for the rich display in this painting.[233] (Turner's well known paintings with colorful skies were created years after this volcanic event.)

Nineteenth century London was a very industrial city, and pollution was a problem. James Tissot lived in London and painted the people and places of this city. Several of his oil paintings pictured scenes of the Thames River and its dock areas. The vessels were shown in thick murky water with columns of black smoke belching from their stacks. While some were concerned about the pollution presented, others thought the paintings were too severe and directed undue attention to the City's dirty environment.

At the turn of the twentieth century, Claude Monet traveled to London on three occasions and while there completed a series of paintings that featured the buildings and skies of London. He painted the sky as he observed it, with realistic representations of the colors he saw. The artist was known to paint quickly and perhaps completed each work within a matter of hours. The Monet paintings are a serial account of the smog-filled city, and their colors offer clues about transmitted and scattered light. His paintings, drawings and letters have become the subject of scientific inquiry, and the dates, times of day and his vantage points have received study. This research may help scientists uncover the chemical composition of the London smog circa 1900.[234]

Weather and climate are subject matter for both science and art. They are studied by science, and they influence and inspire the creation of art. When this subject matter is explored, connections between science and art are discovered.

CHAPTER 20

THE SKY ABOVE

"All truths are easy to understand once they are discovered;
the point is to discover them."
~ *Galileo Galilei*

ASTRONOMY IS THE VERY OLDEST of the sciences. It began
thousands of years ago when people turned their eyes skyward
and noticed changes in the positions of the Sun and the stars.
Gradually they learned that what they saw foretold the cycling
of the seasons, and they used this information as a guide for the planting
and harvesting of their crops. Aspects of astronomy have also influenced and
inspired artistic endeavors for thousands of years.

Stonehenge is a ring of large gray stones on the Salisbury Plain in
England. Much about this megalithic structure remains a mystery, but what
is known shows patterns of stones lined up with the position of the Sun at
the summer and winter solstices. The summer solstice is the longest day of
the year. It has the most sunlit hours and takes place around June 21 when
the Sun is at its highest point in the sky. The winter solstice is the opposite,
the shortest day with the least amount of sunlight and occurs when the Sun
is lowest in the sky around December 21.

In 1987 Jim Reinders created *Carhenge*, a contemporary version
of Stonehenge, just outside of Alliance NE. It is a circle of thirty-eight
discarded cars that are spray-painted a stone gray color and aligned in a

manner similar to Stonehenge. Appropriately the site was dedicated on the summer solstice.[235]

Mesoamericans living on the Yucatan Peninsula studied the sky and were familiar with the changes that occurred. *El Caracol*, the snail-shaped structure at *Chichén Itzá*, was an observatory. From the top, the sky and horizon were clearly visible, and sightings were made and celestial positions were calculated. The large pyramid at Chichén Itzá, *El Castillo*, was designed to represent the seasons of the year. It has four sides, one for each season, with 91 steps and a top platform for a total of 365 to match the number of days in a year. On the first day of spring and the first day of fall, the vernal and autumnal equinoxes, an unusual optical event occurs on the pyramid. Sunlight appears to move like a snake and undulate down one of the stone railings to the serpent head at its base. This event is biannual and draws people to Chichén Itzá to witness the phenomenon.[236]

In 2003, Daniel Libeskind won the competition and became the master planner for rebuilding the World Trade Center site in New York City. His plan incorporated the solar lighting of September 11 and called for a wedge of light to appear in one of the plazas between 8:46 AM and 10:28 AM. It was designed to commemorate the events of September 11, 2001, the time between the crash of the first hijacked plane into the South Tower and the fall of the North Tower.[237] (Over the years, the design for the site changed, and the Wedge of Light Plaza was not included in the final plan.)

The Great Pyramid of Giza is built along the cardinal points of a compass, with the north- south and the east-west sides aligned with a deviation of less than a fraction of a degree. It is believed this was accomplished by using measurements taken from a celestial object, a polar or north star. When the pyramids were built, about 4600 years ago, the Earth's axis was pointed at Thuban rather than Polaris, the current north star. The shift in polar stars happened because the Earth wobbles, like a top, as it rotates on its axis. The wobbling motion is known as precession, and the Earth requires 26,000 years to complete one wobble. Since the building of the pyramids, enough precession has occurred to alter the orientation of the axis and change the Earth's polar star from Thuban to Polaris.[238]

Knowledge about the solar system and the universe developed gradually, and ideas changed slowly. Early astronomers studied the movement of celestial bodies, and their Earth-based observations led to certain conclusions. They came to view the Earth as the center of the universe with the Sun, the planets and the stars in orbits about the Earth. The Greeks adopted this idea and combined it with their views on the importance of man in the universe.

Aristotle championed this thinking and taught it to his students. Later Aristarchus of Samos made observations and concluded the Earth and the other planets revolved around the Sun. but his thinking contradicted Aristotle and was not widely accepted. Around 140 A.D. Ptolemy wrote a treatise, *Almagest,* that presented the Earth as the center of the universe. In time the Roman Catholic Church combined the Greek thinking about the importance of man and Ptolemy's writings into a Christian vision of the world that made the Earth the center of everything and man its master. This geocentric view was ingrained into western thinking, and it remained there for centuries.[239]

In the early 1500s Raphael Sanzio received a commission to decorate the walls of a papal apartment at the Vatican. He designed a series of paintings based on the themes of theology, law, poetry and philosophy in western civilization. The fresco dedicated to philosophy, *The School of Athens,* celebrated Greek thinking, that is, truth acquired by reason. It is a large painting, and it presents prominent Greeks within an architectural space dominated by arches and piers. Aristotle and Plato are the central figures, and the viewer's eyes are drawn to them by the lines of perspective. The others are freely placed in groups and engaged in dialogue. Socrates, Pythagorus, Epicurus, Alexander the Great, Diogenes and Euclid are among the many included in this work. In the far right portion of the fresco are four identified as Zoroaster (a 6th Century BC prophet), Protogenes (a 4th Century BC painter), Ptolemy (a 2nd Century AD astronomer) and the artist himself. Zoroaster, the bearded figure, balances a celestial globe on his fingers, and Ptolemy, with his back to the viewer, holds a terrestrial globe in his hands. Protogenes is listening, while Raphael stares directly at the viewer with an uncertain expression and is perhaps questioning the ideas that dominated thought for so many centuries.[240]

Nicolaus Copernicus was an astronomer and mathematician who was familiar with the work of other astronomers. Without the aid of a telescope, he studied the sky and recorded what he saw. His observations and mathematical calculations led him to formulate a theory placing the Sun at the center of the solar system with the Earth and other planets revolving around it. As an elected canon of the Roman Catholic Church with ecclesiastical duties, he realized this was contrary to the prevailing thought. Not only did this thinking shift the position of the Earth, it challenged the role of man in the universe. In 1514 he prepared a manuscript, *On the Revolution of the Heavenly Spheres,* that described his heliocentric theory. He circulated the document within a select circle, but he delayed its publication until 1543, the year he died.

Johannes Kepler used observations made by Tycho Brahe to discover the science behind the movement of planets. He determined the planets

revolve around the Sun in elliptical rather than circular orbits, and he found planets travel faster when orbiting near the Sun and slower when far away. From there, he formulated a series of laws to describe planetary motion.

In time people invented instruments for observation and devised techniques for measurement. Galileo Galilei was the first to use a telescope for astronomical purposes. He discovered the rings of Saturn and the moons of Jupiter, and he confirmed the heliocentric theory, In 1632 he wrote *Dialogue on the Two Chief World Systems* and reviewed the geocentric and heliocentric theories. In it, he stated the Earth rotates on an axis and revolves about the Sun, a view in conflict with the teachings of the Roman Catholic Church. Subsequently *Dialogue* was barred and placed on the *Index*, a list of books prohibited by the Church. Galileo was investigated by the Inquisition for heresy and placed under house arrest. A trial was held, and he was forced to recant his statements and acknowledge the Earth as stationary and the center of the universe. Despite this, it was said he tapped the Earth with his foot and muttered: "And yet, it does move!" In the centuries following Galileo's death, the Church gradually reassessed the astronomer's ideas, and reconciliation occurred.[241]

The events of Galileo's time live on in the oft-produced plays of Berthold Brecht. In 1937 Brecht wrote *The Life of Galileo* and presented the astronomer as a heroic figure for science. Following World War II and the dropping of the atomic bombs, the play was revised, and Galileo was depicted as someone who betrayed science in favor of power. The latter version of this play was produced in the United States under the title, *Galileo*.[242]

Isaac Newton possessed one of the greatest scientific minds of all time. In addition to his studies of light and color, he developed laws describing motion and gravitation. Newton's laws were a unified system of principles that explained events on Earth and in the solar system, and they built upon the earlier work of Kepler and Galileo. Newton realized the same force that pulls an object toward the Earth keeps the Moon in its orbit. The force of gravity makes every pair of bodies attract each other, and the size of the force depends upon the mass of the bodies and the distance between them. Thus there is a gravitational attraction between the Earth and the moon and between an apple and the Earth. (It is interesting to note that Newton was staying in the country, to avoid an outbreak of the plague in London, when he formulated his ideas on gravitation. He was clearly aware of falling objects, including apples, but it is debatable whether he was actually hit on the head by an apple.) In 1687 Newton published *Principia Mathematica*, one of the most significant science books ever written, to explain his laws of motion and gravitation.[243]

The French Ambassadors by Hans Holbein is a painting of two men on a mission to protect French interests and to prevent the breakaway of England from the Roman Catholic Church. It was painted at a time when scientific discoveries were challenging the teachings of the Church. In addition to the mysterious elliptical skull discussed in Chapter 12, a number of scientific instruments are included within this painting, and their presence may allude to the philosophical difficulties created by the recently discovered science. They are sixteenth century devices, and the ones used for establishing time and making astronomical observations. There is a horary quadrant for observing the position of stars and a torquetum for determining the positions of the planets and stars. There are also several types of sundials, a polyhedral, a pillar or shepherd's dial, a universal equinoctial, a terrestrial globe and a celestial globe.[244]

The Earth rotates on an imaginary axis, from west to east, and makes one rotation on its axis every twenty-four hours. Only half of the Earth is lighted at any given time, and this results in day and night and sunrise and sunset. This also gives the Sun its apparent motion of rising in the east, traversing the sky and setting in the west. Strange as this may seem, crustal movements may shift the mass of the Earth, and this, in turn, may affect the rate of rotation. In March 2011, a massive earthquake occurred in Japan, and it moved the coastline of eastern Japan 13 feet closer to North America. This shifted the Earth's mass, moved the axis 6.5 inches and shortened the day by 1.6 microseconds. (This same earthquake was responsible for the Fukushima Daiichi nuclear disaster that caused reactor meltdowns, equipment failures and the release of radioactive materials into the environment.)[245]

Twilight in the Wilderness by Frederic Church is a landscape painting of a sunset over a lake in mountain country. It is about the time when day ends and night begins, and it portrays the last minutes of daylight with a brilliant and glowing sky. Church painted it to create awe and wonder and to engender a feeling for the greatness of nature and the unimportance of man.[246]

James McNeill Whistler painted a number of works around the theme of nighttime. They were his nocturne paintings and were concerned with the colors and the void of night. He painted scenes of the Thames River, an amusement park and an empty street. Whistler liked the night and often worked in his studio from nightfall until dawn. His paintings were dark and dim with faintly recognizable figures and created a mood. In 1877, he showed several of his nocturne paintings in an exhibition, including one entitled *Nocturne in Black and Gold: The Falling Rocket*. It was his version of a fireworks display and presented a cascade of colored specks set against a dark and somewhat smoky background. The painting was abstract and expressive

in nature, and it was different from the other more traditional works in the show. It was a painting ahead of its time. John Ruskin, an art critic, reviewed the show and richly criticized the artist for flinging "a pot of paint in the public's face." Whistler sued Ruskin for libel, and the case went to trial. Whistler was awarded damages of one farthing (one-fourth of a British penny) and "without costs". Whistler won the trial, but the expenses of the trial were shared equally.[247]

Edward Hopper was interested in light and shadow and the daily changes that occur with them. The shadows he painted were dark and well-defined, and the effects they produced added to the lonely quality of his paintings. *Early Sunday Morning* shows a deserted downtown street with a flat row of storefronts and upper tenements. The buildings are illuminated by the light of the early morning, and the shadows are long and horizontal. *Morning Sun* is an interior scene with a clothed woman seated on a bed and staring out an open window. Sunlight enters through the window and forms an angular reflection on the wall. The woman is bathed in light and modeled by shadow, and her body casts a dark outline on the sheets. *High Noon* presents a stark two-story white house with a woman standing in the doorway. The front of the house is sunlit but has shadows around its edges, roof and windows.

The Earth revolves about the Sun in an elliptical orbit, and it completes one revolution every year, every three hundred and sixty-five days. The axis of the Earth is tilted at an angle of 23.4° to its orbit. Because of this, the northern hemisphere receives more direct rays of sunlight during the summer and less direct rays of sunlight in the winter. The tilt of the Earth's axis and the revolution of the Earth around the Sun produce the annual change of seasons.

In the fifteenth century, the Limbourg Brothers (Pol, Herman, and Jehanequin) received a commission from the Duc de Berry to create an illuminated manuscript, *Les Tres Riches Heures*. It is a book of hours, a devotional book with a series of prayers to be said at eight different times of the day, and a calendar of months with pictures of the peasantry and nobility. The paintings are miniatures, and each one has an astrological hemisphere at the top with a calendar and zodiac. For February, the scene is snow covered and shows an open building with three peasants warming themselves in front of a fireplace. Nearby animals are huddled in an enclosure, and birds are pecking through snow in search of grain. A man and a donkey, laden with goods, are trudging through the heavy snow toward a distant village, while another man is working in the field. The month of May shows well dressed people of noble rank riding horses in a procession led by people carrying banners and playing horns. The August view

combines the activities of the nobility and the peasantry. Elegantly dressed people on horseback, with falcons and dogs, go forth on a hunt, while some peasants labor in the fields and others skinny-dip in a nearby stream.[248]

Pieter Bruegel, the Elder, painted a series of panels based on the seasons. He painted the joy and drudgery of peasant life against a backdrop of seasonal changes. *The Dark Day* shows a sixteenth century peasant village in March. At the time, Europeans considered March the beginning of their year, and this painting presents a scene of awakening and coming to life after a long winter. Most of the snow is gone, and tree limbs are on the ground. People are busy. One man surveys a hole in a thatched roof, and others bundle branches and prune trees. *The Hay Harvest* illustrates the activity of peasants engaged in a June harvesting. The foreground shows baskets of fresh fruits and vegetables, some are on a horse drawn sledge and others are balanced on workers' heads. A seated man sharpens a blade, while a group of women with rakes walk by. In the distance, men work in the fields and cut, rake and pile hay into carts, *The Harvesters* shows the August gathering of golden wheat on a hot and sunny day. Some field workers cut, bind and move wheat to a wagon, while others enjoy a midday meal under a shade tree. One man sleeps, while a young man, with jugs of drink for the workers, emerges from a path through the wheat field.[249]

Pigments in the leaves of a plant absorb light for photosynthesis, and they reflect light and give the leaves their color. Leaves contain not only green (chlorophyll) pigments but also yellow (xanthophyll) and orange (carotene) pigments. They appear green because the chlorophyll pigments are there in greater abundance and mask the presence of the others. During autumn, the hours of sunlight decrease, temperatures drop and the leaves of some trees respond with a seasonal display of colors. Chlorophyll production gradually decreases and eventually stops, the green color disappears, and the yellow and orange pigments become visible. As this is happening, the leaves of maple, oak and other trees produce anthocyanin, a red pigment that contributes additional color to the array.[250]

The annual display of color often appears in paintings. Tom Thomson portrayed the vast Canadian landscape and its wilderness and drew inspiration from the seasonal changes. *The Pool* is a painting with a rich palette of fall colors, showing a pond surrounded by brilliant autumn foliage. Grace Hartigan painted *New England, October* following a trip to Maine where she was moved by the effect of rain on fall coloration. It is an abstract painting with thick layers of expressive color. As she painted, she noted the contrast of the yellows and browns of the trees against the white of the colonial houses, and she distilled the scene until she captured the essence of a wet fall day in New England.[251]

The effects of seasonal lighting were important to the Impressionists. As a group, they were interested in light and color, and they often painted scenes showing the colors of different seasons. Many of them were intrigued by the effects of light on snow, *effet de neige*. Camille Pissarro alone created over one-hundred scenes displaying snow and the lighting of winter.[252]

The solar system is a collection of celestial bodies revolving around the Sun, a medium sized star in the Milky Way Galaxy. The planets, Mercury and Venus, are closer to the Sun than the Earth and have smaller orbits around the Sun. While the planets, Mars, Jupiter, Saturn, Uranus and Neptune, are farther from the Sun than the Earth and have larger orbits. Most of the planets, except Mercury and Venus, have moons circulating about them. Asteroids, rocky objects measuring a few feet to hundreds of miles in diameter, are found in the space between Mars and Jupiter. Farther out, beyond Neptune, are the Kuiper Belt and the Oort Cloud with comets, other objects—and Pluto.

Pluto was discovered in 1930 by Clyde Tombaugh. It appeared as a tiny speck of reflected light on photographs taken with the aid of a telescope. At first, Pluto was identified as a planet, the ninth in the solar system. Additional study found it had moons, like most of the planets, but it was different from the other eight. It was smaller, its rotational axis had an unusual angle, its orbit was eccentric and tilted and its density indicated a composition of half ice and half rock. This precipitated a discussion about planets and their scientific definition. In 2000, Neil DeGrasse Tyson, an astrophysicist and Director of New York's Hayden Planetarium, announced that Hayden would reclassify Pluto as a ball of ice in the Kuiper Belt. Then in 2006, the International Astronomical Union defined the term planet and determined Pluto was not, as previously thought, one of the Solar system's planets. It was a dwarf planet in the Kuiper Belt and added it to the growing list of other dwarf planets that included Ceres, formerly thought to be an asteroid, Haumea, Makemake and Eris. On January 7 of 2007, the spacecraft, *New Horizons*, was launched on a 3 billion mile (4.8 billion km) journey through space. Nine years later, on July 14, 2015, it flew past Pluto and sent back images of its surface features and moons.[253]

Comets are made of ice, rock, dust and frozen carbon dioxide and, as a consequence, they are often thought of as "dirty snowballs". As a comet approaches the Sun, solar radiations cause it to glow and develop a tail. The tail grows in length and always points away from the Sun. Of the thousands of comets that revolve about the Sun, the best-known is Halley's comet. It appears every seventy-six years and has a record dating back to antiquity. It was last seen in 1985-86 and is not due for a return until 2061.

The Bayeux tapestry, actually an embroidery 220 feet (6.7 m) long, dates back to 1067 - 1080. It tells the story of the Norman invasion of Britain by William, the Conquerer, and it has script written in Latin for the literate and illustrations for the illiterate. Panel 67 shows soldiers looking upward and pointing to an object in the sky, a *stella*. Halley's comet appeared in 1066, and the *stella* on the Bayeux tapestry is interpreted as a representation of the comet.[254]

Giotto covered the walls of the Arena Chapel in Padua with frescos depicting the life of Christ, the passion of Christ and the life of Mary. One of the frescoes, *The Adoration of the Magi*, is about the arrival of the Wise Men with their gifts for the Christ child, and it shows a blazing object over the stable. Halley's comet made a passage by the Earth in 1301, and Giotto's fresco was painted between 1304 - 1306. It is thought Giotto's Star of Bethlehem was inspired by Halley's comet.[255]

In 1961 President John F. Kennedy addressed congress with an initiative in mind: "I believe that this nation should commit itself to achieving the goal, before this decade is out, of landing a man on the Moon and returning him safely to the Earth."[256] The Moon is the Earth's closest neighbor in space, about 240,000 miles (385,000 km) away, and it revolves around the Earth once every twenty-eight days. On July 20, 1969, Kennedy's goal became a reality when the Apollo 11 mission successfully landed Neil Armstrong and Buzz Aldrin on the surface of the Moon. The National Aeronautics and Space Administration (NASA) invited Robert Rauschenberg, the artist, to attend the launching at the Kennedy Space Center. This event and the success of the Apollo 11 mission. inspired Rauschenberg to create *Stoned Moon*, a series of thirty-three prints with a variety of images related to the Man on the Moon Project.[257]

In the 1970s Nancy Graves produced a series of drawings and acrylic paintings based on the lunar surface. The paintings have a grainy appearance and show scan lines similar to those used for transmitting photos. Later she traveled to the Jet Propulsion Laboratory in California and viewed actual data gathered by the Mariner 9 satellite that circled Mars, and this, in turn, inspired her to do a series on Mars.[258]

While astronomy is the oldest of the sciences, modern astrophysics is the frontier. Observations that began thousands of years ago with the naked eye continue today with sophisticated technology. Complex instruments are placed in orbit to probe the hidden reaches of the universe and transmit the information they find back to the Earth for study. In 1990 the Hubble Space Telescope, named after the astronomer, Edwin Hubble, was launched. It has

imagers to take pictures, spectrographs to analyze light and transmitters to send data. In addition, it is the only space telescope designed to be repaired and upgraded while in orbit and has been serviced number of times, the most recent being in 2009. The Hubble is an important space tool that has provided much data about the nature of the universe and the rate at which it is expanding. It has also transmitted many images from the far reaches of space, images of the unknown that in many ways resemble the abstractions of art.

The sky above is subject matter for both science and art. It is studied by science, and it influences and inspires the creation of art. When this subject matter is explored, connections between science and art are discovered.

In Conclusion

"The noblest pleasure is the joy of understanding."
~ Leonardo da Vinci

A T THE BEGINNING OF *Exploring Science and Art: Discovering Connections*, I invited you to join me on an incredible venture of discovery. The worlds of science and art were entered. Science was studied with an artistic eye, and art was probed with a scientific lens. As the chapters evolved, relationships were developed, connections were made and an integrated and often overlooked view was introduced.

And now, in conclusion, I propose **Ten Connections** between science and art. They are original statements based on the material presented in this book.

One: *The basic nature of science and the basic nature of art are similar.* When the basic nature of science and the basic nature of art are compared, both are activities of the mind and ways of thinking that shape and enrich the world. Both are creative and original in their approach, both produce things that are new and never existed before and both study things, ask questions and experiment. And both have specific vocabularies and build on preceding developments.

Two: *Contemporary science and contemporary art share common ground.* When today's science and art are compared, both offer special challenge because of their inherent complexity. Both are based on the science and art that preceded them, but what they present is often very different from the earlier science and art. Both propose ideas and advance perspectives that are new, sometimes

confusing and outside the realm of ordinary experience. As a result, both may be difficult to understand and have unsettling qualities.

Three: *Art involves the use of materials and techniques related to science.* Art uses materials and techniques in its creative activities, and science studies materials to determine their properties and techniques for working with them.

Four: *Architecture is an art and a science.* Architecture is concerned with the planning and building of functional structures. It involves the art of design and the science of construction, and its very nature combines science and art.

Five: *Art depends upon phenomena studied by science.* Art is visual. It depends upon the phenomena of light and vision and sometimes it involves color and illusion. Science studies light, vision, color and illusion and explains how they function.

Six: *The conservation of art depends on the instruments, methods and chemicals of science.* Science provides the instruments, methods and chemicals, the ways and means, to conserve works of art.

Seven: *Conservation is an art and a science.* The conservation of art involves a knowledge of art and its materials and techniques and a knowledge of science and its instruments, methods and chemicals.

Eight: *Science can influence and inspire the creation of art.* Science has a great diversity of subject matter and issues, and this diversity can influence and inspire the creation of art.

Nine: *Science has a central role in art.* Science studies the materials and techniques of art and the phenomena associated with art. It provides the materials, methods and instruments for art conservation, and it has subject matter that can influence and inspire the creation of art.

Ten and perhaps the most important connection of all: *Every work of art is connected to science.* Art is visual, and every work of art depends on light and vision and sometimes color and illusion as well. The phenomena of light, vision, color and illusion are investigated by science. Every work depends upon the materials and techniques of its construction, and science studies materials and techniques, including those of art. Some works show the effects of age and require conservation procedures that rely on the chemicals, instruments and methods of science. And some works are influenced and inspired by the subject matter and issues of science.

Venturing on, there is more to explore and discover. The first concerns a Jackson Pollock painting and authentication. Pollock dripped and poured paint, ordinary house paint, onto canvases with carefully planned gestures and created paintings with dynamic fields of energy. He is considered, by many art historians, to be the most important American artist of the Twentieth Century. In today's art market, his paintings are worth millions, but first they must be identified as original and not copies or forgeries. Some of Pollock's paintings are signed and have provenance, records of their origin and ownership, and others have neither. Without signatures and/or provenance, problems exist, big problems that perhaps science can solve. In the late 1990s, a group of physicists studied Pollock's drip paintings and subjected them to scientific analysis. They examined seventeen of his paintings and determined they contained fractals. (Fractals are complex geometric figures with repeating patterns.) The scientists demonstrated that fractal analysis could be used to recognize and date Pollock's paintings, and they published their findings in a scientific journal. A few years later, another researcher came across the article and began a separate investigation. She created artificial patterns with a computer program and subjected them to fractal analysis. Her work recognized the computer generated patterns as Pollock paintings and refuted the use of fractals for authentication. Subsequently an art authority became involved and stated that fractal analysis was not a reliable way to recognize a Pollock drip painting.[259] So can science be used to identify an original Pollock painting? The question remains and awaits an answer.

Another authentication case involves an abstract painting from a thrift shop. The art work was purchased for five dollars and gifted, as a joke, to someone who didn't appreciate the humor. The painting was returned and placed in a yard sale, where it was spotted by an art teacher who thought it was an original Pollock. In response, the owner replied: "Who the $#%& is Jackson Pollock?" Following this, she set out to determine the artist responsible for her newly acquired painting, and her indelicate question became the title of a documentary film relating her efforts to authenticate the piece. The work in question was unsigned and had no provenance, so she took the painting to several art connoisseurs for appraisal. Their experience and knowledge of Pollock's work led them to conclude it was an imitation. With persistence, she consulted a forensic specialist, who examined the paining and found a fingerprint on the back of the canvas. Using scientific instruments, he compared the fingerprint with one from Pollock's studio. The specialist thought the two prints were consistent, and this led him to conclude the painting was an original. Fingerprint analysis is authoritative and considered

final as evidence. However there is no such thing as a perfect fingerprint match, only features in the prints that appear consistent. The art authorities decided the painting was not the product of Pollock's hands, whereas the forensic specialist decided the print was the product of Pollock's fingers. Both were based on the experience of the people involved, and both were judgment calls.[260] The authentication of art work is tricky business. Is this five dollar abstraction an original Pollock? That's a good question and a matter of opinion.

Many people like to own original art, and it is now possible for them to have a piece of designer art made from their genetic material. Specially equipped companies can turn a DNA sample into a printed work of art, a portrait based on the person's very own DNA. The art work is offered in a variety of sizes and colors, with size and color being personal choices and perhaps selected to match or complement the person's household decor. Here's how it works. The company provides a DNA kit. Then a swab of cheek cells is taken, prepared according to directions and returned to the company. The DNA is processed by a laboratory, and a DNA profile is prepared. A photo is taken of the profile, and colors are added. The photo is then transferred to canvas by a high quality printing process and framed.[261] Is the canvas print of DNA an original? It most certainly is, because the DNA of an individual is unique and one of a kind. Is it art? That's a another question.

Chimeras were imaginary creatures that appeared in the arts. The ancient Chinese carved them from stone and used them as guardians for their tombs. Homer referred to them in the *Iliad*, and the Etruscans created statues and wall paintings of them. The story of Bellerophon, the heroic Corinthian, and his slaughter of a chimera was recorded in the art of antiquity. The chimeras of old were made from the parts of several animals, commonly the head of a lion, the body of a goat and the tail of a serpent. They were mythical and never existed, but now, with the help of modern science, they exist. Today's chimera is an organism with tissue from a genetically different organism. Routinely human kidneys and hearts are transplanted, and sometimes pig and cow heart valves are used as replacements and inserted into damaged human hearts. Medically people who have received kidneys and hearts from other individuals are modern day chimeras, as are the human recipients of animal heart valves.[262]

The American Society of Microbiology (ASM) holds an annual agar art contest for microbiologists. The agar in a petri dish becomes the canvas for the art, and bacteria serve as the paint. To get the desired colors and other effects, the agar and bacteria are carefully selected. The agar may have

a special formulation, and the bacteria may be pathogens capable of causing disease. Because dangerous bacteria may be involved, only members of the ASM are allowed to enter this contest, and safety measures for storage and disposal of the bacterial cultures are carefully followed. The results are very creative, and some are based on actual works of art. In 2015, Melanie Sullivan was inspired by Vincent van Gogh's painting, *Starry Night*, and grew bacteria on the agar of five different petri dishes to represent this work.[263] A design inspired by Sullivan's agar art appears on the cover of this book. Who says science can't be artistic?

Chiasma is a scientific term derived from the Greek letter *chi* or *X* and means crossing or exchange. During the formation of sperm and egg cells, genetic material is exchanged. The site where the genetic material comes together, crosses over and is exchanged is known as a chiasma. An optical chiasma is located at the base of the cerebrum, and it is the place where the optic nerves come together and some fibers from each eye cross over to opposite sides of the brain. The Finnish word for chiasma is *kiasma*. Kiasma is also the name of the contemporary art museum in Helsinki, and it is a cultural center and meeting site for the exchange of ideas, information, opinions and experiences.[264]

Chiasma and Kiasma are about coming together and exchange. Science and art came together in this book and had exchanges. Many areas were explored, relationships were developed and connections were made. There are more, and I encourage you to make discoveries on your own. Use the *ten connections* as starting points, and please remember, the more you look, the more you will see.

Exploring Science and Art: Discovering Connections offers a fresh perspective. It provides a view that adds depth and a degree sophistication to the understanding and appreciation of science and art. I hope you welcomed this approach and found this book an interesting, insightful and enjoyable read. And now, with that thought in mind, this incredible venture of discovery concludes. *Au revoir!*

Mary Kirsch Boehm

ACKNOWLEDGMENTS

NOW THAT *Exploring Science and Art: Discovering Connections* is a *fait accompli*, a number of people deserve special recognition. First of all, I thank my husband for his constant support and patience. He was my mentor and the first to review my writing and offer suggestions. His comments and recommendations were greatly appreciated. And I thank my parents for their guidance and encouragement during my formative years.

I also acknowledge the help and support of my friends and colleagues. I especially thank Nancy Spector for carefully reading and critiquing my manuscript; Jennifer Bayles for editorial assistance; Maureen Millane for her special comments and suggestions; Jessica DiPalma for sharing her experience with writing and publishing; Rosemarie Cardoso for the use of her conservation documents.

And finally, I thank all involved with the publication of this book, especially Marti Gorman of City of Light Publishing. For without them, *Exploring Science and Art: Discovering Connections* would still be a manuscript waiting to be published.

NOTES

AN INTRODUCTION

1 Paul Trachtman, "Night Visions," *Smithsonian* (January 2009), 68-73.

2 *A New Installation by Jim Hodges* (www.albrightknox.org/art/exhibitions/new-installation-jim-hodges).

ABOUT SCIENCE AND ART

I. GETTING STARTED

3 *Picasso at the Lapin Agile*, brochure (Buffalo: Studio Arena, 10 September - 8 October 2000), 5, 7, 18-19.

4 Frederic Golden, "Albert Einstein: Person of the Century," *Time* (31 December 1999), 58, 62-85.

5 Robert Hughes, "The Show of Shows," *Time* (26 May 1980), 70-76.

6 *I, Leonardo: A Journey of the Mind*, education materials (CBS-TV program: 26 April 1983).

7 Michel D. Lemonick, "Edwin Hubble," *Time* (29 March 1999), 124-131.

8 Ivan Amato, "Wallace Hume Carothers: The Father of Nylon," *Time* (29 March 1999), 84.

9 Michael D. Lemonick, "A Twist of Fate," *Time* (17 February 2003), 49-58.

10 *Chuck Close: Self-Portraits 1967-2005*, exhibition (Buffalo: Albright-Knox Art Gallery, 22 July—22 October 2006).

11 Horst de la Croix and Richard G. Tansey, *Gardner's Art Through the Ages*, (New York: Harcourt Brace Jovanovich, Inc., 1980), 784-785.

12 Peter Murray and Linda, *Dictionary of Art and Artists* (New York: Frederick A. Praeger, Publishers, 1965), 137.

II. THE NATURE OF SCIENCE

13 Harvey Brace Lemon, *From Galileo to the Nuclear Age* (Chicago: The University of Chicago Press, 1949), 13-17.

14 Mordecai L. Gabriel and Seymour Fogel, ed., *Great Experiments in Biology* (Englewood Cliffs: Prentice-Hall, 1955), 64-71.

15 *The Nobel Prize Internet Archive* (www.nobelprizes.com).

16 Thomas D. Brock and Katherine M. Block, *Basic Microbiology* (Englewood Cliffs: Prentice-Hall, 1978), 27-28.

17 Robert Lamb, *What does Einstein's Famous Equation Really Mean?* (science.howstuffworks.com/science-vs-myth/everyday-myths/einstein-formula.htm).

III. THE NATURE OF ART

18 H. W. Janson, *History of Art* (Englewood Cliffs: Prentice-Hall, 1966), 509.

19 Steven A. Nash et al., *Painting and Sculpture from Antiquity to 1942*

(New York: Rizzoli International Publications, 1979), 174-175.

20 "Pfaff Installation Transforms Gallery Space," *Albright-Knox Calendar* September / October 1982.

21 Linda Levine, "Photographer John Pfahl Updates the Sublime Landscape," *Buffalo Spree* (November/ December 1999), 10-11.

22 Peter Schjeldahl, "In the Museums," *The New Yorker* (15 October 2018), 10.

23 Jane Norman and Theodore Norman, *Traveler's Guide to Europe's Art* (New York: Appleton-Century, 1965), 382.

24 *Contemporary Art 1942-72: Collection of the Albright-Knox Art Gallery* (New York: Praeger Publishers, 1993), 39.

25 Horst de la Croix and Richard G. Tansey, *Gardner's Art Through the Ages* (New York: Harcourt Brace Jovanovich, Inc., 1980), 821.

26 Steven A. Nash et al., *Painting and Sculpture from Antiquity to 1942* (New York: Rizzoli International Publications, Inc., 197), 344-345.

27 *The quilts that made America quake: How Faith Ringgold fought the power with fabric* (www.theguardian.com/ artanddesign/2019/jun/04/faith-ringgold-new-york-artist-serpentine-gallery-london).

28 *Vietnam Veterans Memorial*, (en. wikipedia.org/wiki/Vietnam Veterans Memorial).

29 Yasminia Reza, *Art* (Buffalo, Studio Arena Theatre, 27 October 2001).

30 *Rudolf DeCrignis* (http:// rudolfdecrignis.com)

31 Horst de la Croix and Richard G. Tansey, *Gardner's Art Through the Ages* (New York: Harcourt Brace Jovanovich, Inc., 1980), 760-762.

32 Horst de la Croix and Richard G. Tansey, *Gardner's Art Through the Ages* (New York: Harcourt Brace Jovanovich, Inc., 1980), 858-860.

33 Richard Lacayo, "Cultural Revolution: Ai Weiwei revives what China forgets."

Time (29 October 2012), 66-69.

34 Susan Krane with Robert Evren and Helen Ray, *Albright-Knox Art Galler, The Painting and Sculpture Collection: Acquisitions since 1972* (New York: Hudson Hills Press, 1987), 42.

IV. CONTEMPORARY SCIENCE / CONTEMPORARY ART

35 Jim Holt, "Unstrung." *The New Yorker* (2 October 2005), 86-91.

36 Neil deGrasse Tyson, "In the Beginning," *Natural History* (September 2003), 18-22.

37 Neil deGrasse Tyson, "Gravity in Reverse," *Natural History* (December 2003), 16-22.

38 *Earth's Dynamic Crust*, National Geographic Society map (Washington, DC: August 1985).

39 Shankar Vedantam, "Earth Ruptures in an Instant, Creating Huge, Devastating Upheavals of Water," *The Buffalo News* (28 December 2004).

40 *Somatic cell nuclear transfer* (www. britannica.com/science/somatic-cell-nuclear-transfer).

41 *Dolly (The Sheep)* (https:// en.wikipedia.org/wiki/Dolly (sheep).

42 *Researchers clone the first primates from monkey tissue cells* (https:// www.washingtonpost.com/news/ speaking-of-science/wp/2018/01/24/ researchers-clone-the-first-primates-from-monkey-tissue-cells).

43 John Cloud, "Why Genes Aren't Destiny," *Time* (18 January 2010) 49 - 53.

44 *Julie Mehretu: Drawings into Paintings*, exhibition (Buffalo: Albright-Knox Art Gallery, Buffalo 24 January - 28 March 2004).

45 *Materials, Metaphors, Narratives: Work by Six Contemporary Artists*, exhibition (Buffalo: Albright-Knox Art Gallery, 4 October 2003—4 January 2004).

46 Calvin Tomkins, "His Body, Himself," *The New Yorker* (27 January 2003) 50-9.

47 *Materials, Metaphors, Narratives: Work by Six Contemporary Artists*, exhibition (Buffalo: Albright-Knox Art Gallery, 4 October 2003—4 January 2004).

48 *Anselm Kiefer: Beyond Landscape*, exhibition (Buffalo: Albright-Knox Art Gallery, 17 November 2013—5 October 2014.

49 Richard Rogers and Oscar Hammerstein, *The King and I*, 1951.

MATERIALS AND TECHNIQUES

V. THE SCIENCE OF MATERIALS

50 Martin Puryear, *Untitled, 1997 exhibition* (Buffalo: Albright-Knox Art Gallery).

51 Kenneth Snelson, *Portrait of an Atom* (Kenneth Snelson: 1981), 1-23.

52 Hindenburg Disaster (en.wikipedia. org/wiki/Hindenburg_disaster).

53 *Antoine Laurent Lavoisier and Marie Anne Lavoisier, 1788* (www.metmuseum. org/art/collection/search/436106)

VI. PAINT AND PAINTING

54 Ray Smith, *The Artist's Handbook* (New York: Alfred A. Knopf, 1996), 11-13.

55 Ray Smith, *The Artist's Handbook* (New York: Alfred A. Knopf, 1996), 138-140.

56 Ray Smith, *The Artist's Handbook* (New York: Alfred A. Knopf, 1996), 166.

57 Ray Smith, *The Artist's Handbook* (New York: Alfred A. Knopf, 1996), 228.

58 Ray Smith, *The Artist's Handbook* (New York: Alfred A. Knopf, 1996), 234-236.

59 Ray Smith, *The Artist's Handbook* (New York: Alfred A. Knopf, 1996), 170-174.

60 Ray Smith, *The Artist's Handbook* (New York: Alfred A. Knopf, 1996), 180-182.

61 *What happens when oil paint dries?* (www.liveabout.com/what-happens-when-oil-paint-dries-2578564)

62 Ray Smith, *The Artist's Handbook* (New York: Alfred A. Knopf, 1996), 208.

VII. SCULPTURE

63 Elizabeth Kolbert, "Forever Amber," *The New Yorker* (14 April 2003), 36-45.

64 Horst de la Croix and Richard G. Tansey, *Gardner's Art Through the Ages* (New York: Harcourt Brace Jovanovich, Inc., 1980), 542.

65 Horst de la Croix and Richard G. Tansey, *Gardner's Art Through the Ages* (New York: Harcourt Brace Jovanovich, Inc., 1980), 488-489.

66 *Degas in Bronze* (Rochester: Memorial Art Gallery, Fall 2002), 5-7.

67 *Rodin: Sculpture from the Iris and B. Gerald Cantor Collection* (Beverly Hills: The Iris and B. Gerald Cantor Foundation).

68 *Rodin: Sculpture from the Iris and B. Gerald Cantor Collection* (Beverly Hills: The Iris and B. Gerald Cantor Foundation), 2-3.

69 Horst de la Croix and Richard G. Tansey, *Gardner's Art Through the Ages* (New York: Harcourt Brace Jovanovich, Inc., 1980), 486-487.

VIII. DRAWING AND PRINTMAKING

70 Ray Smith, The *Artist's Handbook* (New York: Alfred A. Knopf, 1996), 69-70, 79.

71 Ray Smith, The *Artist's Handbook* (New York: Alfred A. Knopf, 1996), 84, 90, 95.

72 Ray Smith, The *Artist's Handbook* (New York: Alfred A. Knopf, 1996), 100, 106, 118.

73 Horst de la Croix and Richard G. Tansey, *Gardner's Art Through the Ages* (New York: Harcourt Brace Jovanovich, Inc., 1980), 528.

74 Richard Lacayo, "Line Dances. Sol Lewitt took conceptual art from dry to dazzling. Now his drawings have a long-term home" *Time* (1 December 2008), 81.

75 *Wall Drawing # 1268: Scribbles*
 https://www.albrightknox.org/
 artworks/200724a-c-wall-drawing-
 1268-scribbles-staircase-akag

76 *Robert Mangold: Beyond the Line/
 Paintings and Project 2000-2008*,
 exhibition (Buffalo: Albright-Knox
 Art Gallery, 23 October 2008—31
 January 2009).

77 *Ingrid Calame: Step on a Crack*,
 exhibition (Buffalo: Albright-Knox
 Art Gallery, Buffalo 25 September
 2009—28 February 2010).

78 Ray Smith, The *Artist's Handbook*
 (New York: Alfred A. Knopf, 1996),
 259-260, 264-265.

79 Ernest O. Hauser, "The Floating
 World of Japanese Prints." *The Reader's
 Digest* (1976), 138-142.

80 Ray Smith, *The Artist's Handbook*
 (New York: Alfred A. Knopf, 1996),
 266-274.

81 Ray Smith, *The Artist's Handbook*
 (New York: Alfred A. Knopf, 1996),
 275-281.

82 Ray Smith, *The Artist's Handbook*
 (New York: Alfred A. Knopf, 1996),
 282-287.

IX. GLASS AND CERAMICS

83 William S. Ellis, "Glass: Capturing the
 Dance of Light." *National Geographic*
 (December 1993), 37-69.

84 Ray Smith, *The Artist's Handbook*
 (New York: Alfred A. Knopf, 1996),
 246-249.

85 *The glass blowing project*
 (dmgschoolproject.org/the-glass-
 blowing-process).

86 David Zax, "The Nature of Glass."
 Smithsonian (April 2007) 84-87.

87 Richard Huntington, "Touch of
 Glass," *The Buffalo News* (August 9,
 2005)

88 Bruce Bernstein, *From This Earth: Pottery
 of the Southwest* (Santa Fe: Museum of
 Indian Arts and Culture, 1993).

89 *The different types of pottery techniques*
 (londondesigncollective.com/art/the-
 different-types-of-pottery-techniques).

90 *Basic Guide to Some Historic Artifacts*,
 instructional materials (Kenmore-
 Town of Tonawanda: Teacher Center,
 16 December 1992).

91 Horst de la Croix, and Richard G.
 Tansey, *Gardner's Art through the
 Ages* (New York: Harcourt Brace
 Jovanovich, Inc., 1980), 55.

92 Horst de la Croix and Richard G.
 Tansey, *Gardner's Art Through the
 Ages* (New York: Harcourt Brace
 Jovanovich, Inc., 1980), 112.

93 *Islamic Ceramics* (Washington DC:
 Smithsonian Institution, Freer Gallery
 of Art).

94 Bruce Bernstein, *From This Earth:
 Pottery of the Southwest* (Santa Fe:
 Museum of Indian Arts and Culture,
 1993).

95 Horst de la Croix and Richard G.
 Tansey, *Gardner's Art Through the
 Ages* (New York: Harcourt Brace
 Jovanovich, Inc., 1980), 510-511.

96 Mark Sommer, "Terra Cotta
 Treasures." *The Buffalo News* (28
 January 2007), G 1-2.

97 Ralph Mayer, *Dictionary of Art Terms
 and Techniques* (New York: Thomas Y.
 Crowell Company 1975), 252-253.

X. ARCHITECTURE

98 Horst de la Croix and Richard G.
 Tansey, *Gardner's Art Through the
 Ages* (New York: Harcourt Brace
 Jovanovich, Inc., 1980), 41-43.

99 Horst de la Croix and Richard G.
 Tansey, *Gardner's Art Through the
 Ages* (New York: Harcourt Brace
 Jovanovich, Inc., 1980), 68.

100 Horst de la Croix and Richard G.
 Tansey, *Gardner's Art Through the
 Ages* (New York: Harcourt Brace
 Jovanovich, Inc., 1980), 68-70.

101 Gisela Richter, *A Handbook of Greek
 Art: A Survey of the Visual Arts of*

Ancient Greece (New York: E.P. Dutton, 1980), 20-26.

102 Horst de la Croix and Richard G. Tansey, *Gardner's Art Through the Age* (New York: Harcourt Brace Jovanovich, Inc., 1980), 192-193.

103 *Explained: Cement vs. Concrete- their differences, and opportunities for sustainability* (https://news. mit.edu/2020/explained-cement- vs-concrete-understanding- differences-and-sustainability- opportunities-0403).

104 Horst de la Croix and Richard G. Tansey, *Gardner's Art Through the Ages* (New York: Harcourt Brace Jovanovich, Inc., 1980), 190-192.

105 Horst de la Croix and Richard G. Tansey, *Gardner's Art Through the Ages* (New York: Harcourt Brace Jovanovich, Inc., 1980) 489-490.

106 *Napkin Math: Will the Leaning Tower of Pisa ever Fall?* (https://www. nationalgeographic.com/culture/ article/napkin-math-will-the-leaning- tower-of-pisa-ever-fall).

107 *Origins and Construction of the Eiffel Tower* (www.toureiffel.paris/en/the- monument/history).

108 *A First for New York* (https//www. burchfieldpenney.org/visit/the building/green-building).

109 *Louvre Pyramid* (https://en.wikipedia. org/wiki/Louvre_Pyramid).

110 *Gateway Arch Still a Modern Engineering Marvel* (https://www.nps.gov/jeff/ planyourvisit/gateway-arch-still-a- modern-engineering-marvel.htm).

111 John Seabrook, "The Abstractionist," *The New Yorker* (21 & 28 December 2009), 113-124.

112 *Qatar National Museum by Jean Nouvel: The Desert Rose* (https://www.re- thinkingthefuture.com/case-studies/ a2458-qatar-national-museum-by- jean-nouvel-the-desert-rose/).

113 *Pritzker Architecture Prize World Wide* (www.pritzkerprize.com).

RELATED PHENOMENA

XI. LIGHT AND COLOR

114 William O. Brooks, George R. Tracey, and Harry E. Tropp, *Modern Physical Science* (New York: Holt, Rinehart and Winston, 1962), 496-497.

115 William O. Brooks, George R. Tracey, and Harry E. Tropp, *Modern Physical Science* (New York: Holt, Rinehart and Winston, 1962), 484-487.

116 William O. Brooks, George R. Tracey, and Harry E. Tropp, *Modern Physical Science* (New York: Holt, Rinehart and Winston, 1962), 498-499.

117 *Anders Knutsson: Luminous Paintings*, exhibition (Buffalo: Albright-Knox Art Gallery, 23 July—5 September 1983).

118 Susan Krane with Robert Evren and Helen Ray, *Albright-Knox Art Gallery, The Painting and Sculpture Collection: Acquisitions since 1972* (New York: Hudson Hills Press, 1987) 176-178.

119 William O. Brooks, George R. Tracey, and Harry E. Tropp, *Modern Physical Science* (New York: Holt, Rinehart and Winston, 1962), 500-503.

120 Horst de la Croix and Richard G. Tansey, *Gardner's Art Through the Ages* (New York: Harcourt Brace Jovanovich, Inc., 1980), 741.

121 Horst de la Croix and Richard G. Tansey, *Gardner's Art Through the Ages* (New York: Harcourt Brace Jovanovich, Inc., 1980), 775-782.

122 *Michel Eugene Chevreul* (https://www. britannica".com/search?query="Michel- Eugene+Chevreul").

123 Horst de la Croix and Richard G. Tansey, *Gardner's Art Through the Ages* (New York: Harcourt Brace Jovanovich, Inc., 1980), 782.

124 Stephen Sondheim and James Lapine, *Sunday in the Park with George*, performance (Amherst: Musical Fare Theatre, 22 March 2009).

125 Susan Krane with Robert Evren and Helen Ray, *Albright-Knox Art Gallery,*

The Painting and Sculpture Collection: Acquisitions since 1972 (New York: Hudson Hills Press, 1987), 132-133.

126 *Extreme Abstraction*, exhibition (Buffalo: Albright-Knox Art Gallery, 15 July,2005—2 October 2005).

127 Rockne Krebs (rocknekrebsart.com).

128 *Jenny Holzer: The Venice Installation*, exhibition Buffalo: Albright-Knox Art Gallery, 13 July 1991—1 September 1991).

XII. VISION AND ILLUSION

129 *The Mammalian Eye: Vision and Sight in Mammals* (https://www.earthlife.net/mammals/vision-2html).

130 Charles E., Dull, H. Clark Metcalfe, and John E. Williams, *Modern Physics* (New York: Henry Holt and Company, 1960), 349-350.

131 Horst de la Croix and Richard G. Tansey, *Gardner's Art through the Ages* (New York: Harcourt Brace Jovanovich, Inc., 1980), 668.

132 Horst de la Croix and Richard G. Tansey, *Gardner's Art through the Ages* (New York: Harcourt Brace Jovanovich, Inc., 1980), 130-131.

133 Horst de la Croix and Richard G. Tansey, *Gardner's Art through the Ages* (New York: Harcourt Brace Jovanovich, Inc., 1980), 681.

134 *Contemporary Art 1942-72: Collection of the Albright-Knox Art Gallery* (New York: Praeger Publishers, 1993), 322-323.

135 *Contemporary Art 1942-72: Collection of the Albright-Knox Art Gallery* (New York: Praeger Publishers, 1993), 286-287.

136 *The Bean (Cloud Gate) in Chicago* (https://www.choosechicago.com/articles/tours-and-attractions/the-bean-chicago).

137 Ralph Mayer, *A Dictionary of Art Terms and Techniques*. New York: Thomas Y. Crowell Company, 1975), 218.

138 Horst de la Croix,and Richard G. Tansey, *Gardner's Art Through the*

Ages (New York: Harcourt Brace Jovanovich, Inc., 1980), 8.

139 Robert Cumming, *Annotated Art* (New York: DK Publishing,1995), 44-45.

140 Robert Cumming, *Annotated Art* (New York: DK Publishing, 1995), 38-39.

141 *Julian Beever and Pavement Drawings* (julianbeever.net).

142 Horst de la Croix and Richard G. Tansey, *Gardner's Art Through the Ages* (New York: Harcourt Brace Jovanovich, Inc., 1980), 494-497.

143 *Op Art Revisited: Selections from the Albright-Knox Art Gallery*, exhibition (Buffalo: Albright-Knox Art Gallery, 18 July—25 January 2009).

CONSERVATION

XIII. INTO THE LAB

144 Buffalo State College: Art Conservation Department (artconservation.buffalostate.edu).

145 Ted Chamberlain, "King Tut gets a CT-scan in Egypt's Mummy Project," *The Buffalo News* (23 January 2005).

146 Hannah Fiske, "CT Imaging of Antique Art and Books." *Radiology Today* (4 March 2002), 22- 25.

147 Jacob Trip and Marbaretha de Geer, "The Arnolfini Marriage" *The Collection of the National Gallery, London* (CD-ROM, Brighton: Microsoft, 1993).

148 L. Glinsman and D. Barbour, "Science and Art Converge at the National Gallery of Art." *JOM* (49 (1), 1997), 14-17.

149 Henry Dorin, *Unified Chemistry* (New York: Cebco Standard Publishing, 1973), 320-322.

150 Henry Dorin, *Unified Chemistry* (New York: Cebco Standard Publishing, 1973), 322-328.

151 *Dendrochronology*" (https://en.wikipedia.org/wiki/Dendrochronology).

152 *Why Is Radiocarbon Dating Important*

to *Archaeology?* (www.parks. ca.gov/?page_id=24000).

153 Lois R. Ember, "Chemistry and Art." CENEAR (30 July 2001), 51-59.

154 *Da Vinci Detective* (https://ucsdnews. ucsd.edu/archive/thisweek/2006/ may/05_22_davinci.asp).

155 Hans Koningsberger, *The World of Vermeer* (New York: Time Incorporated, 1967) 174-185.

XIV. AS TIME GOES BY

156 Randy Kennedy, "Paints Mysteries Challenge Protectors of Modern Art," *The New York Times* (14 February 2007).

157 159 Pamela Skiles, *The History and Treatment of a 17th Century Portrait*, senior specialization project, Art Conservation Department (Buffalo State College, 30 July 2002).

158 *Flinn Chemical Catalog Reference Manual 1991* (United States of America: Flinn Scientific, Inc., 1991).

XV. TO THE RESCUE

159 David Jeffery, "A Renaissance for Michelangelo," *National Geographic* (December 1989), 688-713.

160 Meg Nottingham Walsh, "Out of the Darkness: Michelangelo's Last Judgment," *National Geographic* (May 1994), 102-123.

161 *Sistine chapel dazzles after technological makeover* (https://news.yahoo.com/ sistine-chapel-dazzles-technological-makeover-053301688.html).

162 Paul Trachtman, "Cleaning Picasso," *Smithsonian* (October 2004), 90-94.

163 Kenneth M. Pierce, "Saving the Crumbling Parthenon," *Time* (3 October 1983), 70-71.

164 Richard Lacayo, "Who owns history?" *Time* (3 March 2008), 62-65.

165 James Graff, "The Battle to Save the Cave," *Time* (19 June 2006), 44-48.

166 Joseph Alsop, "Warriors from a Watery Grave," *National Geographic*

(June 1983), 821-829.

167 *Greek Bronzes Raise Hope of Revival at Reggio Calabria National Archeological Museum* (https://artdaily.cc/ news/67407/Greek-bronzes-raise-hope-of-revival-at-Reggio-Calabria-National-Archeological-Museum-#. YLZ1ay2ZPVU).

168 *Vase Breaker Banned from Museum* (www.cbsnews.com/news/vase-breaker-banned-from-museum).

169 Carol Vogel, "Woman Collides with a Picasso," *The New York Times* (24 January 2010).

170 *Michelangelo's Pieta* (http:// content.time.com/time/specials/ packages/article/0,28804,1956922 _1956921_1956897,00.html).

171 173 Mark Stryker, "Boy's Gum Is Plucked from Valuable Art," *Detroit Free Press* (11 March 2006).

172 *The Restoration of the Great Pyramid of Khufu* (http://guardians.net/hawass/ restoregp.htm).

173 Joseph Judge, "Florence Rises from the Flood," *National Geographic* (July 1967), 1-43.

174 *Conservation of "The Last Supper"* (www.bibliotecapleyades.net/davi/ project/restoration.htm).

SUBJECT MATTER

XVI. THE BODY HUMAN

175 Horst de la Croix and Richard G. Tansey, *Gardner's Art Through the Ages* (New York: Harcourt Brace Jovanovich, Inc., 1980), 66-87.

176 Patrick McGroarty, "CT Scan Reveals Hidden Face under Nefertiti Bust," *Yahoo News* online (31 March 2009).

177 Paul Schemm, "A Frail King Tut Died from Malaria, Broken Leg," *Associated Press* (16 February 2010).

178 Arthur Lubrow, "On the March," *Smithsonian* (July 2009), 35-42.

179 *The Most Influential People in the*

History of Medicine (https://www.msn.com/en-in/news/photos/the-most-influential-people-in-the-history-of-medicine/ss-BB14VCD6#image=2).

180 "*Andreas Vesalius* (www.britannica.com/search?query=Andreas+Vesalius).

181 Robert Wallace, *The World of Rembrandt* (New York: Time-Life Books,1968), 63-64, 75.

182 Horst de la Croix and Richard G. Tansey, *Gardner's Art Through the Ages* (New York: Harcourt Brace Jovanovich, Inc., 1980), 764.

183 Iñigo Manglano-Ovalle. *Doug, Joe and Genevieve from the Garden of Delights*, 1998 (Buffalo: Albright-Knox Art Gallery).

184 Arthur Page, "Solar Power as Public Art," *UB Today* (Fall 2010), 21-23.

185 *Science's Mother of Ribbon Diagrams' Celebrates 50 years at Duke* (stories.duke.edu/sciences-mother-of-ribbon-diagrams-celebrates-50-years-at-duke).

186 *Drew Berry* (https://www.macfound.org/fellows/class-of-2010/drew-berry).

187 *Bodily Space: New Obsession in Figurative Sculpture*, exhibition (Buffalo: Albright-Knox Art Gallery, 20 April—7 September 2004).

188 H. W. Janson, *History of Art* (Englewood Cliffs: Prentice-Hall, Inc., 1966), 273-274.

189 *Smallpox vaccine* (en.wikipedia.org/wiki/Smallpox_vaccine).

190 Thomas D. Brock and Katherine M. Brock, *Basic Microbiology* (Englewood Cliffs: Prentice Hall, Inc. 1976), 5-13.

191 *Christy Rupp: the Landscape Within*, exhibition (Niagara University: Castellani Art Museum, 26 June—29 August 1999).

192 T.V. Rajan, "Fighting HIV with HIV." *Natural History* (February 2004), 38-44.

193 "The NAMES Project: AIDS Memorial Quilt" exhibition (Buffalo: Canisius College, 31 March—2 April 1995).

XVII. BIODIVERSITY

194 Bennet Schiff, "Martin Johnson Heade: An American Original," *Smithsonian* (January 2000), 62-71.

195 Kenneth R. Miller and Joseph Levine, *Biology* (Upper Saddle River: Prentice Hall, 2003), 375, 378-379.

196 Kenneth R. Miller and Joseph Levine, *Biology* (Upper Saddle River: Prentice Hall, 2003), 448-449, 454.

197 *Tam Van Tran* (vase.art.arizona.edu/tam-van-tran).

198 Joseph Kastner, "Extracting Art from Nature," *Natural History* (September 1989), 76-80.

199 Bonnie Young, *A Walk through the Cloisters* (New York: Viking Press, 1979), 64-75.

200 Richard Rhodes, "Audubon: America's Rare Bird," *Smithsonian* (December 2004), 73-80.

201 Nicholas Hammond, *Twentieth Century Wildlife Artists* (Woodstock: The Overlook Press, 1986), 155-163.

202 Nicholas Hammond, *Twentieth Century Wildlife Artists* (Woodstock: The Overlook Press, 1986), 39-42.

203 Paul Gray, "The Birdman of America," *Time* (12 August 1996), 67.

204 Joseph Kastner, "Long before furs, it was feathers that stirred reformist ire," *Smithsonian* (July 1994), 97-104.

205 *Frank Moore: Green Thumb in Dark Eden*" exhibition (Buffalo: Albright-Knox Art Gallery, 1 February—20 April 2003).

206 *Robert Bateman: Limited Editions* (Venice FL: Mill Pond Press, March 1992), 14

XVIII. THE EARTH'S DYNAMIC LANDSCAPE

207 Robert Hughes, "Master of the Yosemite," *Time* (3 September 1989), 36-44.

208 Rick Gore, "The Dead Do Tell Tales at Vesuvius," *National Geographic* (May 1984), 556-613.

209 *Mount Fuji* (www.britannica.com/place/Mount-Fuji).

210 Samuel N. Namowitz and Nancy E. Spaulding, *Earth Science* (Lexington: D.C. Heath and Company,1985), 404-405.

211 Justin Worland, "The Anthropocene should bring awe—and act as a warning," *Time* (12-19 September 2016), 10.

212 Barbara Buhler Lynes, Leslie Poling-Kempes, and Frederick W. Turner, *Georgia O'Keeffe and New Mexico: A Sense of Place* (Princeton: Princeton University Press, 2004), 42-45, 79-83.

213 *Penn Dixie and Graycliff Rocks!* field trip (Derby: Graycliff, 27 August 2005).

214 *Escarpment Origins - Ancient Seas and Fossils* (www.giantsrib.ca/escarpment-origins-ancient-seas-and-fossils/).

215 *Pleistocene Epoch: Facts About the Last Ice AgePleistocene Epoch: Facts About the Last Ice Age* (https://www.livescience.com/40311-pleistocene-epoch.html).

216 *History of Niagara Falls* (www.niagarafallsusa.com/planning-tools/about-niagara-falls/history).

217 *The Early History of Europeans in the Niagara Area* (https://bandbniagara.com/early-history-europeans-niagara-area/)

218 "Niagara's power as seen by painters through the ages." *Smithsonian* (1985), 126-131.

219 Moore, Frank. *Niagara, 1994-5* (Buffalo: Albright-Knox Art Gallery).

220 *Adam Cvijanovic*, installation (Amherst: Center for the Arts, University at Buffalo, 23 March-29 July 2006).

XIX. WEATHER, WHETHER OR NOT

221 Kevin Costello, "Tampa Museum of Art display sheds a little light on ecoissues," *Herald Tribune* online (17 September 2006).

222 *The Origin of Oxygen in Earth's Atmosphere* (www.scientificamerican.com/article/origin-of-oxygen-in-atmosphere).

223 *Hole on earth's ozone layer* (https://

www.yahoo.com/news/nasa-hole-earth-apos-ozone-165309117.html).

224 James Thomas Flexner, *The World of Winslow Homer* (New York: Time Incorporated), 88-89.

225 Hans Konigsberger, *The World of Vermeer* (New York: Time Incorporated, 1964), 54-55.

226 *Contemporary Art 1942-72: Collection of the Albright-Knox Art Gallery* (New York: Praeger Publishers, 1993), 92-93.

227 *Luke Howard: Namer of the clouds* (creation.com/luke-howard-namer-of-the-clouds).

228 *Contemporary Art 1942-72: Collection of the Albright-Knox Art Gallery* (New York: Praeger Publishers, 1993), 298-299.

229 *December Storm* (www.burchfieldpenney.org/collection/object:1966-005-000-december-storm).

230 *Contemporary Art 1942-72: Collection of the Albright-Knox Art Gallery* (New York: Praeger Publishers, 1993), 72-73.

231 Linda L. Cathcart, *Nancy Graves: A Survey 1969/1980* (New York: Albright-Knox Art Gallery, 1980), 42.

232 Joseph A. Harriss, "Turning the Tide." *Smithsonian* (September 2002) 76-88.

233 *The Eruption of Mount Tambora* (whethertheweatherbefine.wordpress.com/2015/04/10/the-eruption-of-mount-tamboro).

234 Roger Highfield, "Monet's view of London casts light on Victorian pollution," *London Telegraph* online edition (8 September 2006).

XX. THE SKY ABOVE

235 Chris Welch, "Plain and Fancy." *The Buffalo News* (26 January 2003).

236 Gualberto Zapata Alonzo, *An Overview of the Mayan World* (Merida: Gualberto Zapata Alonzo, 1993), 159-164.

237 *A Study in Light as the World Trade Center Site Is Reborn* (graphics.wsj.com/glider/911light-63f91d79-bebe-4dfa-8244-0a7eb79c9722).

238 Donald Goldsmith, "Turn, Turn, Turn," *Natural History* (December 2006/ January 2007), 20-26.

239 Edward McNall Burns, *Western Civilizations: Their History and Their Culture* (New York: W. W. Norton and Company, 1949), 155-156.

240 Robert Cumming, *Annotated Art: The World's Greatest Paintings Explored and Explained* (New York: DK Publishing, Inc.,1995), 32-33.

241 Robert Wallace and the Editors of Time-Life Books, *The World of Bernini* (New York: Time-Life Books, 1970), 34-38.

242 *Life of Galileo* (en.wikipedia.org/wiki/Life_of_Galileo).

243 *Did an apple really fall on Isaac Newton's head?* (https://www.history.com/news/did-an-apple-really-fall-on-isaac-newtons-head).

244 Robert Cumming, *Annotated Art: The World's Greatest Paintings Explored and Explained* (New York: DK Publishing, Inc.,1995), 38-39.

245 *Japan's Earthquake Shifted Balance of the Planet* (https://news.yahoo.com/news/blogs/lookout/japan-earthquake-shifted-balance-planet-20110314-065608-417.html).

246 *Twilight in the Wilderness* (http://www.frederic-edwin-church.com/twilight-in-the-wilderness).

247 Tom Prideaux, *The World of Whistler* (New York: Time-Life Books, 1970),132-139.

248 Horst de la Croix and Richard G. Tansey, *Gardner's Art Through the Ages* (New York: Harcourt Brace Jovanovich, Inc., 1980), 584-585.

249 Timothy Foote, *The World of Bruegel* (New York; Time-Life Books, 1968), 172-183.

250 Carl E. Palm Jr., "Why Leaves Change Color" brochure (Environmental Information Series, SUNY College of Environmental Science and Forestry,1993).

251 *Contemporary Art 1942-72: Collection of the Albright-Knox Art Gallery* (New York: Praeger Publishers, 1993), 62-63.

252 *Impressionists in Winter: Effets de Neige*, brochure (Brooklyn: Brooklyn Museum of Art, 28 May—29 August 1999).

253 Michael D. Lemonick, "The Path to Pluto," *Time* (20 July 2015), 52-55.

254 *Bayeux Tapestry* (en.wikipedia.org/wiki/Bayeux_Tapestry).

255 *Adoration of the Magi* (www.wikiart.org/en/giotto/adoration-of-the-magi-1306).

256 *Address to joint session of Congress, May 25, 1961* (https://www.jfklibrary.org/learn/about-jfk/historic-speeches/address-to-joint-session-of-congress-may-25-1961).

257 *Robert Rauschenberg and the Men on the Moon* (https://hyperallergic.com/509120/robert-rauschenberg-and-the-men-on-the-moon)

258 Linda L. Cathcart, *Nancy Graves: A Survey 1969/1980* (New York: Albright-Knox Art Gallery, 1980), 22-25.

IN CONCLUSION

259 *Physicists Refute Analysis of Jackson Pollock's Paintings* (https://www.sciencedaily.com/releases/2006/12/061204123447.htm).

260 *Who the #$%& Is Jackson Pollock?* film (Buffalo: Market Arcade Theatre, 11 February 2007).

261 Rob Walker, "Genetic Prints," *The New York Times Magazine* (24 December 2006), 22.

262 *Animal Human Hybrids Spark Controversy* (https://www.orthodoxnet.com/news/2005/Animal-Human_Hybrids_Controversy_2005-01-25.php).

263 *Scientists Create van Gogh's 'Starry Night,' Other Artwork Using Bacteria as Paint* (https://www.yahoo.com/gma/scientists-create-van-goghs-starry-night-other-artwork-171827530--abc-news-lifestyle.html).

264 *Kiasma*, brochure (Helsinki: Kiasma Museum of Contemporary Art).

INDEX

A

Absorption of light, 91–92
Abstract art, 4–5, 21, 23, 166, 175, 181
Abstract Expressionism, 23
Accidental damage to art, 124
Acids, 43–44
Acropolis, Athens, Greece, 122–123
Acropolis Museum, 122–123
Acrylic paints, 50–51, 114–115, 146
The Actor (Picasso), 124
Adams, Ansel, 151
Adhesion, molecules, 42
Adler, Dankmar, 72
Adoration of the Magi (Leonardo), 111–112
The Adoration of the Magi (Giotto), 177
Adsorption, 65
Aerial perspective, 98
Agar art, 182-183
Age of artwork, analysis of, 109–112
AIDS (Acquired Immune Deficiency
 Syndrome), 142
AIDS Memorial Quilt, 142
Air. *See* Wind and air
Air masses and storms, 165–166
Ai Weiwei, 24
Akhenaten. *See* Amenhotep IV
Albers, Joseph, 24
Alberti, Leon Baptista, 99
Albright-Knox Art Gallery, Buffalo, 20, 61, 82
Alkalis, 43–44
Alloys as material for sculpture, 53
Almagest (Ptolemy), 171
Amarna style, Egypt, 57, 134
Amber, for sculpture, 53–54
Amber Room, Catherine Palace, 53–54

Amen (polytheism), 134
Amenhotep IV (Akhenaten), Egyptian
 king, 133–134
American Society of Microbiology (ASM),
 182–183
American Southwestern art
 dendochronology and, 110
 Georgia O'Keeffe, 156
 pottery, 71–72
Anamorphosis, 99–100
Anasazi culture, 71, 110
Anatomy, human, 135–137
The Anatomy Lesson of Dr. Tulp
 (Rembrandt), 136
Ancoma pottery, 72
Andersen, Hans Christian, 22
Animal Kingdom (Animalia), 146
Antibiotics
 in conservation, 123, 127
 discovery of, 13–14, 22, 46
Antler, as material for sculpture, 54
Antoine Lavoisier and His Wife (David), 43
Anuszkiewicz, Richard, 65
Applied science, 15–16
Archaebacteria kingdom, 145–146
Arches, in architecture, 77–78, 81–82
Architecture, 74–83
 diversity in, 82
 solar radiations and, 90
 terra cotta tilework, 72
Aristarchus of Samos, 171
Aristotle, 10–11, 171
Armleder, John, 94
Arno River flood, Italy, 125–127
Art. *See also specific topics throughout this index*
 audience for, 19

challenges from, 23
as communication, 19
computers and, 20
contemporary, 26–33
controversy, 22–23
defined, 18–19
diversity of form, 19
as experience, 22
experimentation by, 24
familiarity of, 23
foundations of, 26
glass and, 67
materials and, 37–44
nature of, 18–25
as product of time and place, 21
questions asked by, 24
video art, 20–21
vocabulary of, 24
Art (play, Reza), 22
Art conservation. *See* Conservation
Arthropods, 146–147
Art installations, 20
Assembling, sculpture technique, 55
Assyrian sculpture, ancient, 57
Astronomy, 169–178
Astrophysics, 177–178
Aten (sun god), 134
Atmosphere, Earth's, 161–163
Atmospheric perspective, 98
Atomic fission, 16
Atomic research, 13, 27
Atoms, 40–41, 44, 88
Attribution, scientific analysis and, 111–112, 181–182
Atwood, Margaret, 151
Audience, for art, 19
Audubon, John James, 147–149
Authentication, scientific analysis and, 111–112, 181–182
Autoradiography, 107
Autotrophs, 145
Autumn, as subject in art, 175
Autumnal equinox, 170
Avicenna of Persia (Ibn Sina), 135
Axis, Earth's, 173, 174

B

Babylon
ceramics, 70
ziggurats, 75

Bacteria. *See also* Antibiotics
as art, 182–183
classification of, 145–146
depicted in art, 141–142
effect on artworks, 121, 123
effect on humans, 139, 141–142
Banting, Frederick, 11–13
Baptistery, Florence, 57, 125–126
Barcilon, Pinin Brambilla, 129
Bargello Museum, 126
Barney, Matthew, 31–32
Barrel vaults, in architecture, 78
Bases (alkalis), 43–44
Bas relief sculpture, 57
Bateman, Robert, 148–150
Bayeux tapestry, 177
Becquerel, Henri, 16
Beever, Julian, 100
Bellerophon, 182
Benton, Thomas Hart, 159
Ben Tré, Howard, 68
Benzene, 119
Berry, Drew, 138
Besemer, Linda, 51
Best, Charles, 11–13
Bierstadt, Alfred, 159
"Big Bang," 27–28
Big Man (Untitled) (Mueck), 139
Binding materials in architecture, 78
Binding media in paints, 45
Binomial system (Latin names), 144
Biodiversity, 143–150
Biology. *See* Life sciences
Birds, 147–149
The Birds of America (Audubon), 148, 149
The Birth of Venus (Botticelli), 50
Black death ("the plague"), 139–140
Black lead pencils, 59
Blanc-de-Chine, 70
Bleckner, Ross, 142
Blue light, sky and its colors, 163
Borosilicate glass, 67
Bosch, Hieronymus, 137
Botticelli, Sandro, 50
Bourgeois, Louise, 19, 54
Bragg, William H., 105
Brahe, Tycho, 171–172
Braque, Georges, 4–5
Brass, for sculpture, 53
Brecht, Berthold, 172
Breezing Up (Homer), 163–164

Brick work, 75
Bright line spectrum, 108
British Museum, London, 122–123
Bronze, as material for sculpture, 53, 55–56, 57, 123–124
Bruce, Thomas (Lord Elgin), 122–123
Bruegel, Pieter, 175
Brunelleschi, Filippo, 79, 99
Buffalo State College Art Conservation Department, 116
Bunshaft, Gordon, 82, 83
Buonarroti, Michelangelo. *See* Michelangelo
Buon fresco, 48
Burchfield, Charles, 47, 166
Burchfield Penney Art Center, Buffalo, 81
Byzantine mosaics, 72

C

Cadaver dissection and study, 135–137
Calame, Ingrid, 62
Calendars, 174–175
Camera lucida, 97
Camera obscura, 96–97
Cameras. *See also* Photography and photographers
 comparison to eyes, 96
 microscopes with, 108
Canal, Giovanni Antonio (Canaletto), 167
Canaletto (Giovanni Antonio Canal), 167
Canon of Medicine (Avicenna), 135
Canvas, for painting support, 46
El Caracol, 170
Caravaggio (Michelangelo Merisi da Caravaggio), 97, 99, 100
Carbon, 44
Carbon 14 dating, 110–111
Caretaking for art, 114–119
Carhenge (Reinders), 169–170
Caro, Anthony, 55, 57
Carothers, Wallace Hume, 6
Carrara marble, as material for sculpture, 54–55
Carson, Rachel, 3
Carter, Howard, 134
Carving, sculpture technique, 54–55
Cassatt, Mary, 64
Castellani Art Museum, Niagara University, 141–142
El Castillo, 170
Casting, sculpture technique, 55–56

Cathedral of Florence, 79
Cathedrals, 79
Catherine Palace, Leningrad, 53
Catherwood, Frederick, 97
Catholic Church, astronomy and, 171–173
Cave drawings, 60–61, 123
Cement, 78, 80
Ceramics, 68–73
Cezanne, Paul, 8, 92
Chagall, Marc, 67–68
Chain, Ernst, 14
Chalk, for drawing, 60
Challenges, from art, 23
Chance, science and, 13
Charcoal, for drawing, 60
Chartres Cathedral, France, 57
Chemical changes, 38–39
Chemical properties, 37–38
Chemical reactions, 42–43
Chemicals
 in printmaking, 63
 used in conservation, 118
Chemical weathering, 153–154
Chevreul, Michel Eugene, 92–93
Chiasma, 183
Chief Seattle, 149–150
Chihuly, Dale, 68
Chimeras, 182
Chinese art, 24
 burial mound figures, 135
 chimeras, 182
 human body as subject matter, 135
 perspective in, 98
Chinese porcelain, 70, 124
Chlorine, 41–42
Christ, depictions of, 5, 99, 127–129, 140, 177
Christina's World (Wyeth), 50
Chromatography, scientific analysis, 109
Church, Frederic, 159, 173
Cicero, Marcus Tullius, 59
Cinder cone volcanoes, 152
Cire perdue. See Lost wax casting
Classification of living things, 144–146
Clay
 in bricks, 75
 in ceramics, 68–70. *See also* Ceramics
 Chinese burial mound figures, 135
 in graphite pencils, 59
 for sculpture, 53, 55, 56
Cleaning in conservation process, 120–121. *See also* Conservation

Cliff Beyond Abiquiu-Dry Waterfall
(O'Keeffe), 156
Climate change, 161–162
Climate control systems, conservation and,
121, 123–125, 126–127
The Cloisters, New York City, 147
Cloning, 29–30
Close, Chuck, 8, 101
Cloth. *See also* Silk
canvas, for painting support, 46
linen, 46, 90, 117
in printmaking, 65
for sculpture, 54
Cloud Gate (Kapoor), 98
Clouds, classification of, 164–165
Cohesion, molecules, 42
Coiling, ceramics, 69, 71
Collas machine, 56–57
Collip, John, 12–13
Colloids, 40
Color. *See also* Pigments; *specific materials
and mediums*
definition of, 24
light, relationship with, 87–94
nineteenth and twentieth centuries, use
in art, 26, 92–93
primary and secondary colors, 91
pure color, 92
seasons' different effects, 175–176
of sky, 163, 167–168
Colored pencils, 60
Color wheel (circle), 92
Columns, in architecture, 77, 97
Combination, chemical reaction, 42–43
Comets, 176–177
The Coming Storm (Inness), 165
Communication, art as, 19
*Company of Frans Banning Cocq (Night
Watch)* (Rembrandt), 99
Complexity
contemporary art, 30
contemporary science, 26
Composite volcanoes, 152–153
Compounds, materials, 39–42, 43–44
Computerized tomography (CT) scans,
106, 134
Computers, art and, 20
Concave and convex mirrors, 97
Concrete, 78, 80–82
Connections between science and art, 179–183
Conservation, 103–129

definition, 114
Les Demoiselles d'Avignon case study,
121–122
effects of age and environment, 114–119
The Last Supper case study, 127–129
P. Gabriel Barbisius case study, 116–119
repair, 115–116
rescue and repair, 120–129
scientific analysis, 105–113, 116–117
Sistine Chapel case study, 120–121
Constable, John, 164–165
Conté crayons, 60
Contemporary architecture, 80–81
Contemporary art, 26–33
Contemporary artists, photography and, 96
Contemporary science, 26–33
Controversy and art, 22–23
Copernicus, Nicolaus, 171
Coplans, John, 138–139
Copper, 38–40
in printmaking, 63
for sculpture, 53
Cowpox, 140
Crayons, for drawing, 60
Creation, art and, 17
Cremaster Cycle series (Barney), 31–32
Crichton, Michael, 53
Crick, Francis, 6–7
Cropsey, Jasper, 159
Crucifixion (Montorfano), 129
Crust, Earth's, 151–152
Crystal, 67
Crystallography, X-ray, 138
CT. *See* Computerized tomography scans
Cubism, 4–5
Cuneiform tablets, 106
Cupid as a Link Boy (Reynolds), 19
Curie, Marie, 16, 37
Curie, Pierre, 16
Cvijanovic, Adam, 160
Cyanobacteria, 146

D

Dali, Salvador, 23
Dalton, John, 13
Damage to artwork, 114–119
The Dance of Death (Holbein), 139–140
The Dark Day (Bruegel), 175
Darwin, Charles, 144
Dating of artwork, analysis of, 109–112

Daumier, Honore, 65
David (Michelangelo), 54–55, 57
David, Jacques Louis, 43
Davie, Karin, 101
da Vinci, Leonardo. *See* Leonardo da Vinci
Death
 cadaver dissection and study, 135–137
 epidemics and, 139–140
 memento mori, 99, 139–140, 142
 mummies and mummification, 106, 133
December Storm (Burchfield), 166
The Decline of the Carthaginian Empire (Turner), 167
Decomposition, chemical reaction, 42–43
DeCrignis, Rudolf, 22
Degas, Edgar, 17, 55, 60
Le Déjeuner sur l'herbe (Manet), 22–23
Delacroix, Eugene, 24, 65, 92
de La Tour, Georges, 100
Delaunay, Robert, 21
Democritus, 41
Les Demoiselles d'Avignon (Picasso), 3, 4, 121–122
Dendrochronology, scientific analysis, 109–110
Depth, illusion of, 100
de Ribera, Jusepe, 100
Detroit Institute of Arts, 125
Dew point, 164
Diabetes mellitus, research, 11–13
Dialogue on the Two Chief World Systems (Galileo), 172
Disasters and salvage, 120–129
Dissection of cadavers, 135–136
Distortions, 99
Diversity
 in architecture, 82
 in art forms, 19–20
Divisionism (pointillism), 93
DNA (deoxyribonucleic acid), 6–7, 30, 134, 137–138, 141
 art from genetic samples, 182
 evolution, evidence of, 144
Donatello, sculptor, 55, 57, 126
Drawing, 59–62
 proteins and X-ray crystallography, 138
Drying oils, painting and, 49–50
Duchamp, Marcel, 23
DuPont chemical company, 6
Dürer, Albrecht, 62, 147

E

Eakins, Thomas, 137
Early Sunday Morning (Hopper), 174
Earth
 axis, 173, 174
 development of, 151–160
 planetary orbits, 171–172, 174
 in solar system, 171–173. *See also* Sun and solar system
Earthenware ceramics, 70
Earthquakes, 29, 173
Earth sciences, 17, 28–29, 151–160
Edward Jenner Inoculating his Son with Smallpox Vaccine (Monteverde), 140–141
Edward Jenner Performing the First Vaccination against Smallpox in 1796 (Melingue), 141
Effet de neige, 176
Egg tempera painting, 50
Egypt, ancient. *See also* Tutankhamen
 Amarna style, 57, 134
 human body as subject matter, 133–134
 mummies, 106, 133
 pyramids, 75–77, 79, 81
 sculptors, 54, 57
Eiffel, Alexandre Gustave, 80
Eiffel Tower, 19, 80
Einstein, Albert, 3–4, 16–17, 90
Electromagnetic radiations, 89. *See also* Infrared radiations; Ultraviolet radiations
Electromagnetic spectrum, 89–90
Electrons, 40–41
Elements, 39–42
 and glass, 66–67
 metals for sculpture, 53
Elgin marbles, 122–123
Elizabeth I, Queen of England, portrait of, 110
The Emperor's New Clothes (Andersen), 22
Emulsions, 40, 50
Enamels and enamel paints
 durability, 114–115
 stained-glass and, 67
Encaustic paiting, 48
Energy. *See* Matter and energy
English system of measurement, 14
Engraving in printmaking, 63–64
Eons and epochs, 155–156

Epidemics, 139–140
Epochs and eons, 155–156
Equinoxes, vernal and autumnal, 170
Eras, geological, 155–156
Erosion, 153–154, 158–159
Etching
 glass, 67
 printmaking, 63–64
Ethics, cloning and, 30
Eubacteria kingdom, 145–146
European cave drawings, 60–61
Evolution, 143–144
Examination and scientific analysis, 105–
 113, 116–117, 128–129
Experience, art as, 22
Experimentation, 10, 11
 by art, 24
 materials science, 41
Exponents. *See* Scientific notation
Eyes and eyesight, 95–96

F

Fabric. *See* Cloth
Fabrica. *See* De Humani Corporis Fabrica
 Libri Septum
Familiarity, of art, 23
Faraday, Michael, 90, 91
A Field Guide to the Birds (Peterson),
 148–149
Fingerprint analysis, 181–182
Firing, ceramics, 69–70
Fission, atomic, 16
Fitzwilliam Museum, Cambridge, England,
 124
Flavin, Dan, 93
Fleming, Alexander, 13–14
Floods, 125–127
Florence, Italy, 125–127. *See also* Baptistery,
 Florence
Florey, Howard, 14
Fluorescent light, 88, 90, 92, 93
Force, defined, 74
Foreshortening technique, 99
Forgeries, scientific analysis, 112–113, 181–182
Fossil fuels, damage to artwork, 122
Foster, Norman, 83
Foundations, for construction, 79
Foundations of art, 26
Fractals, scientific analysis, 181
France, Anatole, vii

Frankenthaler, Helen, 50–51, 125
Franklin, Benjamin, 167
Franklin, Rosalind, 7
Frederick William I, Prussian king, 53
Freestanding sculpture, 57
The French Ambassadors (Holbein), 99, 173
French Revolution, 43
Fresco paintings, 48–49
 restoration of, 126, 127–128
Friction, defined, 75
Fundamental nature of matter and energy, 27
Fungi, damage to art, 123
Fungi kingdom, 145–146
Fusarium solani (fungus), 123
Fuss, Adam, 96

G

Galen of Pergamon, 135
Galileo (play, Brecht), 172
Galileo Galilei, 10–11
 tomb of, 126
 use of telescopes, 172
The Garden of Delights (Manglano-Ovalle),
 137
The Garden of Earthly Delights (Bosch), 137
The Gates of Hell (Rodin), 56, 107
The Gates of Paradise (Ghiberti), 57–58, 126
Gateway Arch, St. Louis, 81–82
Gauguin, Paul, 63
Gehry, Frank O., 82–83
General Theory of Relativity (Einstein), 4
Genetics, 182, 183. *See also* DNA
 (deoxyribonucleic acid)
"The Genius Award" (MacArthur
 Foundation Fellowship), 138
Genteleschi, Artemesia, 100
Gentileschi, Orazio, 111
Geocentric view of universe, 171
Geological Time Scale, 155–156
Geology, 151–160
Geometric forms, illusion from, 101–102
*George Went Swimming at Barnes Hole, but
 It Got Too Cold* (Mitchell), 166
Germ Theory of Disease, 141
Gesso
 conservation of, 126
 defined, 22, 46
 use of, 49, 54, 55
Ghiberti, Lorenzo, 57–58, 126
Giacometti, Alberto, 55, 57

Giotto di Bondone, 19, 48, 177
Giovanni Arnolfini and His Bride (van Eyck), 107
Giza, Egypt, 76–77, 79, 81, 125
Glaciers, erosion from, 154
Glass
 in architecture, 74, 80. *See also* Stained-glass
 art, 66–68
 glassblowing, 68
 mosaics, 72
 solar radiations and, 90
 stained-glass, 67–68, 79
Glassblowing, 68
Glaze and glazing, 70
Global warming, 161–162
Goering, Hermann, 112
Gouache painting, 47–48
Goya, Francisco, 21, 64
Graham, Martha, 133
Granite
 pyramids, 76
 for sculpture, 45
Graphite pencils, 59, 61
Graves, Nancy, 166, 177
Gravity and gravitational force, 15, 75, 172
 erosion and weathering, 154
Graycliff Estate (Lake Erie), 157
The Great Piece of Turf (Dürer), 147
Great Pyramid of Giza, 19, 79, 81, 170
Great Pyramid of Khufu (Great Pyramid of Cheops), 19, 76–77, 125
The Great Wave off Kanagawa (Hokusai), 154
Greece, ancient
 astronomy, 170–171
 human body as subject matter, 134–135
 marble, 77
 philosophy, 171
 pottery, 70–71
 sculpture, 123–124
Greek architecture. *See also* Acropolis, Athens, Greece; Parthenon
 columns, 77, 97
 Elgin marbles, 122–123
 illusion in, 97
 temples, 77
The Greeting (Viola), 20–21
Grid techniques, 8, 54, 61, 101, 102, 166
Grohe, Eric, 160
Gross, Samuel, 137
The Gross Clinic (Eakins), 137

Grünewald, Mathias, 140
Guernica (Picasso), 21
Guggenheim Museum, Spain, 82–83
Gypsum
 and design, 82
 and Plaster of Paris, 53

H

Hadid, Zaha, 82, 83
Half-life measurements, 111
Halley's comet, 176–177
Hall of Mirrors, Palace of Versailles, 98
Hammerstein, Oscar, 32–33
Hancock Center, Chicago, 81
Hans Holbein, 63
Hare, David, 164
Hartigan, Grace, 175
Hartnett, William, 101
The Harvesters (Bruegel), 175
Hayden Planetarium, New York, 176
The Hay Harvest (Bruegel), 175
Heade, Martin Johnson, 143
Hemenway, Harriet, 149
Hennepin, Louis, 159
Herculaneum, Italy, 153
Heredity, human, 30
Heterotrophs, 145, 146
High Noon (Hopper), 174
High relief sculpture, 57
Hindenburg explosion, 42
Hippocrates of Cos, 135
Hiroshigi, Utagawa, 63
HIV virus (human immunodeficiency virus), 142
Hodges, Jim, viii–ix
Hogarth, William, 64
Hokusai, Katsushika, 63, 154
Holbein, Hans, 97, 99, 139–140, 173
The Holy Trinity (Masaccio), 100
Holzer, Jenny, 94
Homage to a Square (Albers), 24
Homer, 182
Homer, Winslow, 47, 163–164
Hood, Walter, 138
Hopi pottery, 71–72
Hopper, Edward, 174
Howard, Luke, 164–165
Hubble, Edwin, 6, 177–178
Hubble Space Telescope, 177–178
Human body, as subject matter, 133–142

Human Genome Project, 30
De Humani Corporis Fabrica Libri Septum
(Vesalius), 136
Human interference, damage to art, 124–125
Humidity
effects of, 115, 125, 128–129
water vapor, 163–164
Humphrey, William, 167
Hurricane Camille (Graves), 166
Hurricanes, 166
Hydrogen, 42, 87
Hypotheses, 11

J

Ibn Sina (Avicenna of Persia), 135
Igneous rocks, 152
Iliad (Homer), 182
Illness, human, 135, 139–142
Illuminated manuscripts, medieval, 106
Illusion
defined, 97
geometric forms, 101–102
paint and, 101–102
perspective, 98–101
vision and, 95–102
Imaging. *See* Computerized tomography
(CT) scans; Infrared radiations;
Photography and photographers;
Ultraviolet radiations; X-rays
Imhotep, Egyptian architect, 75
Impressionism and Impressionists, 92, 176
Incas, South Amercia, 77
Index (Index Librorum Prohibitorum), 172
Indicators: Artists on Climate Change
(exhibition), 162
Infrared (IR) radiations, 90, 106
Ingres, Jean Dominique, 24
Ink
drawing, 60
printmaking, 64, 65
used in forgeries, 112–113
Inness, George, 165
Inorganic compounds, 44
In Replication (Bleckner), 142
Inspection, as part of conservation, 105–108
Installation art, 20, 61
climate change issues, 162
neon lights, 94
Instruments, scientific use of, 14
Insulin, research, 11–13

Intaglio printmaking, 63–64
Interaction of Color (Albers), 24
International Astronomical Unioin, 176
International System of Units (SI), 14
International Union of Geological
Sciences, 156
Iron, 39–40
in architecture, 80
Ishtar Gate, Babylon, 70
Islamic ceramic, ninth century, 71
Isotopes, 111–112
Italy. *See also* Rome, ancient
Arno River flood, 125–127
Mount Vesuvius, 153
Venice, 166–167
Ivory, as material for sculpture, 54

J

Jacob Trip (Rembrandt), 107
Jade, as material for sculpture, 54
Japan
earthquakes, 173
volcano, 154
Japanese art
netsukes, 106
printmaking, 63, 154
Jenner, Edward, 140–141
Jensen, Alfred, 90–91
Johns, Jasper, 48
Jurassic Park (Crichton), 53

K

Kaolin clay, 69, 70
Kapoor, Anish, 98
Kennedy, John F., 177
Kepler, Johannes, 171–172
Khufu, Egyptian pharaoh, 76–77
Kiasma, Helsinki (museum), 183
Kiefer, Anselm, 32
Kilns and ovens
ceramics, 69–70
glass, 67
The King and I (play), 32–33
Kingdoms, classification of living things,
145–146
Kings
Amenhotep IV (Akhenaten), Egyptian,
133–134
Frederick William I, Prussian, 53

Tutankhamen (Tutankhaten), Egyptian, 106, 134
Zoser, Egyptian, 75
Kirchner, Ernst, 63
Klee, Paul, 95
Knutsson, Anders, 90
Koch, Robert, 141
Kollwitz, Kathe, 63
Krebs, Rockne, 94

L

Laboratories, scientific analysis of art, 105–113, 181–182
Landscape, 151–160
The Landscape Within (Rupp), 141–142
Lanfranco, Giovanni, 111
Lascaux cave drawings, 123
Laser light, 94
Last Judgment (Michelangelo), 121
The Last Supper (Leonardo da Vinci), 5, 99, 127–129
Latin names (binomial system), 144
Lavoisier, Antoine, 43
Lavoisier, Marie Anne, 43
Lead
 scientific analysis of paintings, 112
 stained-glass and, 67
Leadership in Energy and Environmental Design (LEED), 81
Leaning Tower of Pisa, 79–80
Le Brun, Charles, 98
LEDs (light-emitting diodes), 94
Lenses. *See* Cameras; Photography and photographers
Leonardo da Vinci, 5–6, 23, 61, 179
 Arno River control plans, 127
 attribution of works by, 111–112
 cadaver and anatomy study, 136
 camera obscura, 97
 The Last Supper, 5, 99, 127–129
 perspective, use of, 99, 100
 use of shadows, 100
Lever House, New York City, 82
Levers, defined, 75
LeWitt, Sol, 61
Libeskind, Daniel, 170
The Life of Galileo (play, Brecht), 172
Life sciences, 17, 29–30
 biodiversity, 143–150
 classification of living things, 144–146

human body, as subject matter, 133–142
Light and lighting. *See also* Computerized tomography scans; Infrared radiations; Ultraviolet radiations; X-rays
 color and, 87–94, 163
 in conservation, 105–107, 115, 121
 as medium, 93
 observation, in art conservation, 105–107
 photosynthesis, 145
 raking light, 105–106
 seasons' different effects, 175–176
 shadows and, 100
 vision and illusion, 95–96
 waves. *See* Waves and wavelength, light and color
Lightfastness, of paint, 46
Lightwell Gallery, SUNY Buffalo, 160
Limbourg Brothers, 174–175
Limestone
 ancient Egyptian works, 75–76, 134
 in architecture, 83, 157
 in cement, 78
 in lithography, 64–65
 pollution damage to, 122–123
 for sculpture, 45
Lin, Maya, 21, 162
Line
 definition of, 24
 in drawing, 59, 61–62
Linear perspective, 98–99
Linen, 46, 90, 117
Linnaean Society, 144
Linnaeus, Carolus, 144
Lippi, Fra Filippo, 100
Liquid states, materials, 38, 66
Lithography, 64–65
Little Dancer, Aged Fourteen (Degas), 55, 57
London pollution (England), 168
look and see (Hodges), viii–ix
Lost wax casting, 55–56
Louvre Museum, Paris, 81
Low relief sculpture, 57
Luca della Robbia, 72
The Luncheon on the Grass (Manet), 22–23

M

MacArthur Foundation Fellowship ("The Genius Award"), 138

Machines, defined, 74–75
Machu Picchu, ancient structures at, 77
MacLeod, John, 12–13
Madonna and Child as subject for art, 72, 100, 125
Madonna and Child with Angels (Lippi), 100
Magnification, for inspection, 107–108
Maid of the Mist (tourist boat), 160
Manet, Edouard, 22–23
Manglano-Ovalle, Iñigo, 137
Mangold, Robert, 61–62
Mangold, Sylvia Plimack, 51, 101
Mantegna, Andrea, 64
Marble
 in architecture, 77
 as material for sculpture, 54–55
 pollution damage to, 122–123
Marcantonio della Torre, professor, 136
Margaretha de Geer (Rembrandt), 107
Mars (planet), 177
Martin, Darwin, 157
Martin, Isabelle, 157
Martin, Steve, example using, 3
Mary Magdalene (Donatello), 55, 57, 126
Masaccio, 49
Masaccio (Tommaso di Ser Giovanni di Mone), 100–101
Massachusetts Audubon Society, 149
Massachusetts Museum of Contemporary Art (MASS MoCA), 61
Materials. *See also specific materials and mediums*
 agar in petri dish as, 182–183
 analysis, in conservation, 108–110
 for art, 37–44
 defined, 37
 paint and painting, 45–51
 science of, 37–44
 for sculpture, 52–54
Matisse, Henri, 24, 25
Matter and energy. *See also* Light and lighting
 fundamental nature of matter and energy, 27
 scientific study of, 16, 17
Maxwell, James Clerk, 90, 91
Measurement, scientific, 14, 15
Mehretu, Julie, 31
Melingue, Georges Gaston, 141
Melting Ice/A Hot Topic (exhibition), 162
Memento mori, 99, 139–140, 142
Mesoamerican structures, 57, 170

Mesopotamian ziggurats, 75
Metal. *See also* Iron; Steel
 in architecture, 80, 81
 as material for sculpture, 53, 55–56
 in printmaking, 63–64
Metalpoint, for drawing, 60
Metamorphic rocks, 152. *See also* Marble
Meteorology, 161–168
Metric system, 14
Metropolitan Museum of Art, New York City, 124
Mezzotint, 63
Michelangelo Buonarroti, 52, 54–55
 cadaver and anatomy study, 136
 David, 54–55, 57
 perspective, use of, 100
 Pieta, 125
 Sistine Chapel ceiling, 18, 49, 99, 120–121
 tomb of, 126
Michelangelo Merisi da Caravaggio. *See* Caravaggio
Microbiolgists' art contest, 182–183
Microscopes, 14, 107–108
die Milchstrasse (Kiefer), 32
The Milky Way (Kiefer), 32
Milky Way Galaxy, 6, 28
Millennium Park, Chicago, 98
Mirrored Room (Samaras), 98
Mirrors, 97–98
Mitchell, Joan, 166
Mixtures, materials, 39
Modeling, sculpture technique, 55–56
Modern Paints research project, 115
Moiré (visual effect), 102
Moisture. *See* Floods; Humidity
Molds and molding, sculpture technique, 55–56
Molecular biology, 138
Molecules, 42, 44
Mona Lisa (Leonardo da Vinci), 5, 23
Monet, Claude, 8, 87, 92, 168
Monochromatic works of art, 22
Monteverde, Giulio, 140–141
Montorfano, Donato, 129
Moon, Earth's
 in art, 177
 gravitational force on, 15
Moore, Frank, 149, 160
Moore, Henry, 57, 138
Moran, Thomas, 159

Morning Sun (Hopper), 174
Morris, Robert, 54
Mortar, in building, 78
Mosaics, 72
Motherwell, Robert, 21
Mount Vesuvius, 153
Mt. Fuji, Japan (volcano), 154
Mt. Laki, Finland (volcano), 167
Mt. Tambora, Indonesia (volcano), 167
Mueck, Ron, 139
Mummies and mummification, 106, 133
Munch, Edvard, 19, 64
Museum of Modern Art in New York City,
 5, 101, 122, 138

𝔑

National Aeronautics and Space
 Administration (NASA), 177
National Endowment for the Arts, 41
National Gallery of Art, Washington, 111
National Mall, Washington, DC, 21
National Museum of Qatar, 82
National Museum of XXI Century Art
 (MAXXI), Rome, 82
Natural pigments, in paint, 45–46
Natural selection, 144
Nature of art, 18–25
Nature of science, 10–17
Nefertiti (ancient Egypt), 134
Nehru, Jawaharlal, 10
Neon and neon lights, 94
Netsukes, Japanese, 106
Neutrons, 40–41
Nevelson, Louise, 55
New England, October (Hartigan), 175
New Horizons (spacecraft), 176
Newton, Isaac, 87, 172
Niagara (Church), 159
Niagara (Moore), 160
Niagara Falls, 157–160
Niagara Gorge, 158
Niagara Power Project, 159
Niagara River, 158–159, 160
Nighttime and twilight, as subject matter,
 vii, 173–174
*Night Watch (Company of Frans Banning
 Cocq)* (Rembrandt), 99
Nineteenth century
 interest in color, 26, 92–93
 landscape painting, 159

Nobel Prize in Chemistry, 16
Nobel Prize in Physics, 16–17
Nobel Prize in Physiology/Medicine, 12, 14
Nobel Prizes, 12
*Nocturne in Black and Gold: The Falling
 Rocket* (Whistler), 173–174
Nolde, Emil, 63
Noninvasive examination, in conservation, 107
Notation, scientific, 15
Nouvel, Jean, 82, 83
Nouvelle Decouverte, 1697, 159
Nuclear reactions, 16

𝔒

Observation, in art conservation, 105
Offset printing, 65
Oil paints and painting, 50–51, 115
Oil pastels, for drawing, 60
O'Keeffe, Georgia, 156
Oldenburg, Claes, 54
Old Masters paintings, scientific analysis, 112
Ollantaytambo, ancient structures at, 77
*On the Law of Simultaneous Contrast of
 Colors* (Chevreul), 93
*On the Origin of the Species by Means of
 Natural Selection* (Darwin), 144
On the Revolution of the Heavenly Spheres
 (Copernicus), 171
Op art, 101–102
Opera House, Sydney, 82
Orbits, planetary, 171–172, 174
Organic compounds, 44
Organ transplants, 182
Orrefors crystal, 68
Ovens. *See* Kilns and ovens
Oxidation-reduction reactions, 71
Oxygen, 42, 161–163
Ozone layer, 163

𝔓

P. Gabriel Barbisius (painting), conservation
 case study, 116–119
Paint and painting, 45–51. *See also*
 Pigments; *specific types of paints and
 painting*
 illusion and, 101–102
 phosphors as additives, 90
 stained-glass and, 67
Palace of Versailles, France, 98

Paleontology, 143–144
Pantheon, Rome, 78
Paper, for painting support, 46, 47
Paris World Exposition of 1900, 56
Parthenon, 19, 97, 122–123
Pastels, for drawing, 60, 61–62, 100
Pasteur, Louis, 141
Pasteurization, 141
"Pavement Picasso," 100
Pedernal (butte), 156
Pei, Ieoh Ming, 81, 83
Pencils, for drawing, 59–60
Penicillin, discovery of, 13–14
Penicillium, 13–14
Pergamon Museum, Berlin, 70
Personal experience, art as, 22
Perspective, technique of, 98–101
Peterson, Roger Tory, 148–149
Peter the Great, Russian Czar, 53
Pfaff, Judith, 20, 61
Pfahl, John, 20
Phosphors, 90, 93, 94
Photograms, 96
Photography and photographers, 20, 96–97
 human form, 138–139
 landscapes, 151
Photons, 88
Photosynthesis, 145, 175
Physical changes, materials, 38
Physical properties, materials, 37–38
Physical sciences, 17
Picasso, Pablo, 18
 The Actor, 124
 Les Demoiselles d'Avignon, 3, 4–5,
 121–122
 Guernica (Picasso), 21
Picasso at the Lapin Agile (play, Martin), 3
Piero della Francesca, 99
Pieta (Michelangelo), 125
Pigments, 91
 autoradiography, 107
 in cave drawing, 61
 in paint, 45
 in pencils, 60
 in plants, 175
 scientific analysis, 112
Pissarro, Camille, 92, 176
Pistoletto, Michelangelo, 98
Place, art as product of, 21
Plagues, 139–141. See also Viruses
Plane mirrors, 97

Planets. See Sun and solar system
Plant Kingdom (Plantae), 146
Plaster
 painting and, 48–49
 for sculpture, 53, 56, 57
Plaster maquettes, 57
Plate tectonics, 28–29, 81, 152, 173
Plato, 171
En plein air painting, 8, 92
Pluto (celestial body), 176
Pointillism (divisionism), 93
Polar stars, 170
Pollock, Jackson, 23, 181–182
Pollution
 in art, 168
 damage, 122–123, 128
Polymers and polymerization, 44, 50, 65
Pompeii, Italy, 153
Pontormo, Jacopo, 20–21
The Pool (Thomson), 175
Poons, Larry, 102
Pop Art, 65
Porcelain ceramics, 70
Precession, of Earth's rotation, 170
Preparation, before painting, 46. See also
 specific types of paints and painting
Price, Ken, 32
Primary colors, 91
Primates, cloning of, 29–30
Principia Mathematica (Newton), 172
Printmaking, 62–65, 154
Prisms, 87, 88
Pritzker Architecture Prize, 83
Proofs, in printmaking, 62–63
Proteins, scientific examination of, 138
Protista kingdom, 145–146
Protons, 40–41
Prudential Guaranty Building, Buffalo, 72
Pseudomonas fluorescens, 123
Ptolemy, 171
Pueblo pottery, 71–72
Pulitzer Prize for Drama, 93
Pure color, 92
Pure science, 15–16
Puryear, Martin, 38
Pyramids, 75, 76–77, 79, 81

Q

Qualitative analysis, in conservation, 108
Quantitative analysis, in conservation, 108

Quantum mechanics, 6
Questions, asked by art, 24

ℜ

Radiation and radioactivity, 16. *See also* X-rays
 electromagnetic radiations, 89
 infrared (IR) radiations, 90
 solar radiations and, 90
 ultraviolet (UV) radiations, 90, 106
Rain
 in art, 175
 effects of, 164
Raking light, 105–106
Raphael Sanzio, 49, 100, 171
Rapids Above the Falls (Moran), 159
Rauschenberg, Robert, 177
Realism, 4, 21
Reductive works of art, 22
Reflection of light, 91–92, 105–106
Refraction, 88
Reggio Calabria National Museum, 124
Reinders, Jim, 169–170
Related phenomena
 light and color, 87–94
 vision and illusion, 95–102
Relief printing, 63
Relief sculpture, 57
Religious art and architecture, 79, 139
Rembrandt, 99
 attribution of works by, 111
 cadaver and anatomy study, 136
 noninvasive examination of paintings
 by, 107
 oil paint and, 50
 printmaking, 64
 self portraits, 7
Renoir, Pierre August, 92
Repair, of art works, 115–116
Replacement, chemical reaction, 42–43
Rescue and repair, 120–129
Research. *See* Experimentation; Scientific
 method
Resistant Fauna (Moore), 149
Retinas, eyes and, 95–96
Reynolds, Joshua, 19
Reza, Yasmina, 22
Riace bronzes, 123–124
Richardson, David, 138
Richardson, Jane, 138
Riley, Bridget, 102

Ringgold, Faith, 21
RNA (ribonucleic acid), 141, 142
Rock
 classification of, 152
 materials. *See* Stone materials
Rock/Paper/Scissors (Pfaff), 20, 61
Rodin, Auguste, 56–57, 107
Roentgen, Wilhelm, 137
Rogovin, Milton, 96
Roman Catholic Church, astronomy and,
 171–173
Rome, ancient
 architecture, 77–78
 human body as subject matter, 135
 mosaics, 72
 Mount Vesuvius, 153
 wall paintings, perspective in, 98
Rosenthal Center for Contemporary Art,
 Cincinnati, 82
Rotation, of Earth, 173
Rouault, Georges, 68
Rupp, Christy, 141–142
Ruskin, John, 174

⟨S

Saarinen, Eero, 81
Sacsayhuaman, ancient structures at, 77
Salts, material compounds, 43–44
Samaras, Lucas, 98
Santa Croce Church, Florence, 126
Santa Maria del Carmine, 149
Santa Maria del Fiore (cathedral), 79
Santa Maria delle Grazie, 127
The School of Athens (Raphael), 171
Science
 analysis in conservation, 105–113,
 116–117, 181–182
 branches of, 17
 caring for art, 114–119
 categories, 15–16
 ceramics in, 68–69
 contemporary, 26–33
 defined, 10
 glass and, 67
 light and color, 87–94
 of materials, 37–44
 nature of, 10–17
Scientific measurement, 14, 15
Scientific method, 11–12
Scientific names (binomial system), 144

Scientific notation, 15
Scientific theory, materials science, 41
Scientific vocabulary, 15
The Scream (Munch), 19
Screen printing. *See* Serigraphy and
 serigraphs
"Scribble drawing" (LeWitt), 61
Sculpture, 52–58, 98
 relief sculpture, 57
 in the round, 57
Sea level, 167
Seasons
 changing, 169–170
 colors and lighting, 174–176
Secco fresco, 48
Secondary colors, 91
Sedimentary rocks, 152. *See also* Limestone
Self-portraits, 7–8, 96
Serigraphy and serigraphs, 65
Seurat, Georges, 93, 154
Shadows in art, 100, 174
Sherman, Cindy, 96
Shield volcanoes, 152
SI. *See* International System of Units (SI)
Sidewalk art, 100
Silk, 8, 54, 102, 147
 composition of, 6
 in printmaking, 65
Sills, Beverly, 114
Silverthorne, Jeanne, 31
Simonides of Ceos, 45
Sistine Chapel ceiling (Michelangelo), 18,
 49, 99, 120–121
Sizings, for paper, 46
Sky
 astronomy, 169–178
 color of, 163, 167–168
 meteorology, 161–168
 as subject matter, vii, 169–178
Slabwork, ceramics, 69
Smallpox, 140–141
Snelson, Kenneth, 41
Snow, effect of light on, 176
Sodium, 41–42
Soft paste porcelain, 70
Solar Energy, Optics (Jensen), 90–91
Solar radiations, 90
The Solar Strand (SUNY Buffalo), 138
Solar system. *See* Sun and solar system
Solid states, materials, 38, 66
Solstices, summer and winter, 169–170

Solutions, 40
Solvents
 in conservation, 118, 119
 in materials, 40, 42
Somatic cell nuclear transplant. *See* Cloning
Soto, Jesús Raphael, 102
Spanish Elegy series (Motherwell), 21
Special Theory of Relativity (Einstein), 3, 4, 17
Spectroscopy and spectroscopes, in materials
 anaylsis, 108–109, 111, 112
Speed of light, 88–89
Spirulina, 146
"Spit," use in conservation, 122
St. Anthony Monastery, Isenheim, 140
St. Cecilia and an Angel (Gentileschi and
 Lanfranco), 111
St. Mark's Square, Venice, 166–167
St. Peter's Basilica, Rome, 125
St. Roche, 139
St. Sebastian, 139, 140
Stained-glass, 67–68, 79
Stanley, Wendel, 141
Staphylococcus, study of, 13–14
Starry Night over the Rhône (van Gogh), vii
Starry Night (van Gogh), 183
Stars, polar, 170
State University of New York at Buffalo,
 138, 160
Statue of Liberty, 80
Steel
 in architecture, 80, 81, 82
 for sculpture, 53
Stencils, printmaking with, 65
Stereomicroscopes, used for examination,
 107, 129
Steuben crystal, 68
Stieglitz, Alfred, 96
Stoned Moon (Rauschenberg), 177
Stonehenge, England, 169
Stone materials. *See also* Limestone; Marble
 in architecture, 74, 75–76
 moving raw material, 76, 77
 for printmaking, 64
 for sculpture, 52, 54–55
Stoneware ceramics, 70
Storm King Art Center, 162
Storms and air masses, 165–166
"String theory," 27
Study of Cirrus Clouds (Constable), 165
Subject matter, 131–178
 biodiversity, 143–150

human body, 133–142
landscape, 151–160
sky, 169–178. *See also* Sky
weather, 161–168
Subtractive color mixing, 91
Sugar metabolism, research, 11–13
Sulfur, 39–40
Sullivan, Louis, 72
Sullivan, Melanie, 183
Sumbawa, Indonesia, 167
Summer solstice, 169
Sun and solar system, 28, 176–178. *See also*
Astronomy
knowledge of solar system, 170–172
Mars, 177
Moon, Earth's, 15, 177
planetary orbits, 171–172, 174
Pluto, 176
*A Sunday Afternoon on the Island of La
Grande Jatte* (Seurat), 93
Sunday in the Park with George (play,
Sondheim and Lapine), 93
Sunrise (Hare), 164
The Supper at Emmaus (Caravaggio), 99
Supports, for painting, 46–47, 50, 51
Synthetic pigments, in paint, 45–46, 114–115

T

Taos pottery, 72
Tapestries
Bayeux tapestry, 177
color in weaving, 93, 147
Unicorn Tapestries, 147
Tapetum and *tapetum lucidum*, 96
Tectonic movement, 28–29, 81, 152, 173
Telescopes, 172, 177–178
Tempera painting, 50
Temperature changes, global, 161–162
Ten Connections between science and art,
179–183
Terra cotta tilework, 72
Tesserae, in mosaics, 72
Theoretical science, 15–16
Theories, science and, 13
Thibault, Jacques, vii
The Thinker (Rodin), 56, 107
The Third of May, 1808 (Goya), 21
Thirty-Six Views of Mt. Fuji (Hokusai), 154
Thomson, Tom, 175
Throwing, ceramics, 69

Thunderstorms, 165–166
Tiffany, Louis Comfort, 68
Time. *See also* Seasons
art as product of, 21
Geological Time Scale, 155–156
nighttime and twilight, as subject
matter, 173–174
tree rings and, 109–110
Time magazine, 4
Tissot, James, 47–48, 64, 168
Tombaugh, Clyde, 176
Tommaso di Ser Giovanni di Mone. *See*
Masaccio
Tornadoes, 165
Toulouse-Lautrec, Henri de, 65, 154
La Tour Eiffel (Eiffel Tower), 80
Tower of Babel, 75
Traini, Francesci, 139
Transmission of light, 91–92
Tree rings, 109–110
Les Tres Riches Heures (Limbourgs),
174–175
The Tribute Money (Masaccio), 101
The Triumph of Death (Traini), 139
Tromphe l'oeil, 101
Tulp, Nicolaes, 136
Turner, Joseph Mallord William, 167
Tutankhamen (Tutankhaten), Egyptian
king, 106, 134
Twachtman, John, 159
Twilight, as subject matter, 173–174
Twilight in the Wilderness (Church), 173
Tyson, Neil DeGrasse, 176

U

Ukiyo-e period, Japanese printmaking, 63,
154
Ultraviolet (UV) radiations, 90, 106
Unicorn Tapestries, 147
United Nations Environment Programme,
162
Universe, study of, 27–28. *See also* Sun and
solar system
Untitled (Big Man) (Mueck), 139
Utzon, Jørn, 82, 83

V

Vaccinations, development of, 140–141
van Eyck, Jan, 97, 107

van Gogh, Vincent, 22
 influence on, 154
 self portraits, 7
 Starry Night, 183
 Starry Night over the Rhône, vii
van Meegeren, Han, 112
van Riijn, Rembrandt. *See* Rembrandt
Van Tran, Tam, 146
van Vienen, Jan, 159
Vasarely, Victor, 65, 101–102
Vault ceilings, in architecture, 78
Velázquez, Diego, 97
Venice, Italy, 166–167
Venice Biennale, 21, 94, 102
Ventilation. *See* Climate control systems
Vermeer, Jan, 50, 97, 164
Vernal equinox, 170
Vesalius, Andreas, 136
Video art, 20–21
Vietnam Veterans' Memorial, Washington, DC, 21
View of Delft (Vermeer), 164
Viola, Bill, 20–21
The Virgin and Child with St. Anne and the Infant St. John (Leonardo da Vinci), 61
Viruses, 139–142
The Visitation (Pontormo), 20–21
Vocabulary
 of art, 24
 binomial system (Latin names), 144
 scientific, 15
Volcanoes and volcanic activity, 152–153, 167
Voltaire, Francois, 66

W

Wallace, Alfred, 144
War, damage during occupation, 128
Warhol, Andy, 65
Water, 40, 42, 44
 evaporation of, 164
 weathering and erosion, 153–154
Watercolor painting, 47
Waterford crystal, 68
Water vapor, 164
Watson, James, 6–7
Waves and wavelength, light and color, 88–90, 108, 163
Wax. *See also* Lost wax casting
 painting and, 48

 for sculpture, 53, 55
Weather, 161–168
Weather fronts and air masses, 165–166
Weathering and erosion, 153–154, 158
Weaving, color in, 93
Webster's New Universal Unabridged Dictionary, 26
Weiwei. *See* Ai Weiwei
Whistler, James McNeill, 173–174
"Who the $#%& is Jackson Pollock?" (documentary film), 181
Wildlife Images (Bateman), 149–150
Wilkins, Maurice, 7
Wilson, Edward O., 143
Wind and air
 weather and, 163–166
 weathering and erosion from, 154
Winter solstice, 169
Wood
 dendrochronology, scientific analysis, 109–110
 as material for sculpture, 52, 55
 for painting support, 47
 in printmaking, 63, 154
Words, as art medium, 94
World Trade Center, New York City, 170
Wright, Frank Lloyd, 157
Wujcik, Theo, 162
Wyeth, Andrew, 50

X

X-ray crystallography, 138
X-ray fluorescence spectrometers, 112
X-rays
 anatomy study, 137
 DNA crystals, 7
 scientific analysis, 106, 107, 112

Z

Ziggurat of Ur, 75
Zinc, in printmaking, 63
Zoroaster (philosopher), 171
Zoser, Egyptian king, 75
Zubarin, Francisco, 100

ABOUT THE
AUTHOR

MARY KIRSCH BOEHM

is a retired science teacher who has traveled extensively and experienced much of the world's great art up close and personal. She has science education degrees from both Buffalo State College and the University at Buffalo and is a docent at the Albright-Knox Art Gallery (Buffalo AKG Art Museum) and the Burchfield Penney Art Center.

Download an *Educator Resource Guide* from
www.CityofLightPublishing.com

Become a citizen of the City of Light!
Follow @CityofLightPublishing